WATERCOLOR PAINTING TECHNIQUES

EDITED BY DAVID LEWIS
INTRODUCTION BY WENDON BLAKE

WATSON-GUPTILL PUBLICATIONS, NEW YORK

Copyright © 1983 by Watson-Guptill Publications

First published 1983 in New York by Watson-Guptill Publications,
a division of Billboard Publications, Inc.,
1515 Broadway, New York, N.Y. 10036

Library of Congress Cataloging in Publication Data
Main entry under title:

Watercolor painting techniques.
 Includes index.
 1. Water-color painting—Technique. I. Lewis,
David.
ND2420.W36 1983 751.42′2 83-14496
ISBN 0-8230-5669-4 (pbk.)

Distributed in the United Kingdom by Phaidon Press Ltd., Littlegate
House, St. Ebbe's St., Oxford

Manufactured in Hong Kong

16 17 18 19 20/02 01 00 99 98

There are many people who deserve thanks for the help they gave me while working on the book, especially Don Holden, Betty Vera, and Jay Anning. Without their help, and the considerable help of others, creating *Watercolor Painting Techniques* would have been impossible. With their help, it has not only been possible, but a pleasure.

David Lewis

Contents

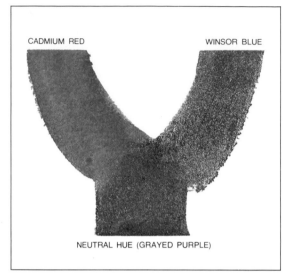

CADMIUM RED WINSOR BLUE

NEUTRAL HUE (GRAYED PURPLE)

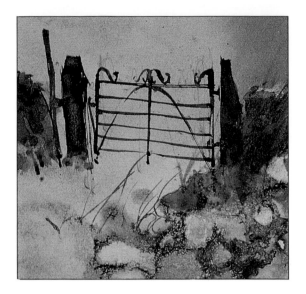

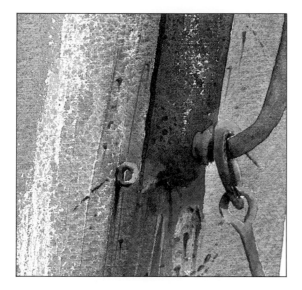
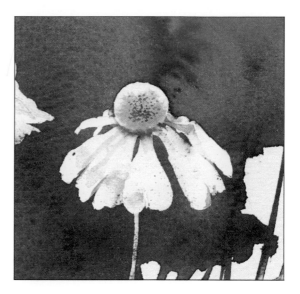

Introduction

One of the advantages of going to a good art school is the fact that you have the opportunity to study with a variety of teachers. Each artist has a way of painting and an approach to teaching that's different from all the others. As you move from one classroom to another, each new teacher gives you a fresh look at the problems of painting. Having studied with various professionals, you're not locked into one artist's way of doing things. You develop a well-rounded background that combines the ideas of many good minds.

You build a library of art instruction books in very much the same way.

You buy books by a number of distinguished artists so that you can explore the greatest possible variety of approaches to painting. Each time you read a new art instruction book, you take a fresh look at the subject, and you gradually develop the kind of well-rounded background that you hope to get in art school.

Most good how-to-paint books are written by a single artist, dealing with that artist's personal methods, style, and philosophy. And it *is* a delight to have a whole book in which you get to know one artist—the way you get to know a good teacher.

But there's also a need for a very different kind of art instruction book, like the one you're now reading: a book in which a *variety* of artists join forces. As you turn the pages, you experience something like the excitement of going from one class to another in a good art school. You get those wonderful changes of pace, those surprising insights, those shifts in perspective that always happen when a group of professional artists get together to share their knowledge of the craft. This stimulating book reminds me of those marvelous summer painting workshops that are so memorable because of the diverse personalities of the different artists who come together to shed new light on subjects we often take for granted.

This handsome book is actually the joint effort of seven of the best watercolorists in the United States and Britain. To assemble this survey of watercolor techniques, the editors of Watson-Guptill Publications have dug into eight books by these distinguished painters; pulled out chunks of enlightening text, plus illustrations and demonstrations by each artist; and created what strikes me as one of the most innovative how-to-paint books I've seen in quite a while.

Let me tell you a bit about each one of these artists and his books.

John Blockley has a special feeling for rural scenery—the shapes, colors, textures, and patterns of the countryside, whether this means natural scenery or man-made subjects like farmhouses and stone walls. Landscape has always been a favorite subject of watercolorists, and so the editors have excerpted from Blockley's book, *Country Landscapes in Watercolor*.

Richard Bolton is particularly fascinated by the textures and patterns produced by natural weathering in wood, stone, metal, and all kinds of growing things. This is the subject of his popular book, *Painting Weathered Textures in Watercolor*, from which the editors have made a lively selection.

Charles Reid paints flowers, portraits, and figures with a command of watercolor that has made him one of the most popular authors on the subject. You'll find excerpts from his *Flower Painting in Watercolor*. But it's also worth noting that Reid has written two other watercolor classics: *Portrait Painting in Watercolor* and *Figure Painting in Watercolor*.

E. John Robinson has devoted his life to capturing the movement, color, and light effects of the sea. The excerpts in this book come from *How to Paint Seascapes in Watercolor*. But Robinson has also written several important books on seascape painting in oil: *Marine Painting in Oil*, *Master Class in Seascape Painting*, and *Seascape Painters Problem Book*.

Christopher Schink's watercolors are notable for the boldness and drama of their pictorial design. So it's not surprising that his *Mastering Color and Design in Watercolor* is one of the fundamental books in the field. Excerpts from his discussions of color appear in the pages that follow.

Georg Shook has won recognition as a master of sharp-focus precision in his studies of landscape and architectural subjects. This approach to watercolor is becoming increasingly important, and the editors have chosen some selections from Shook's widely read book, *Sharp Focus Watercolor Painting*. He's also the author (with Gary Witt) of *Painting Watercolors from Photographs*.

Zoltan Szabo is one of the most famed and prolific authors of watercolor books. For this volume, the editors have dipped into *Zoltan Szabo Paints Landscapes* and *Painting Nature's Hidden Treasures*. His other books include *Landscape Painting in Watercolor*, *Creative Watercolor Techniques*, and *Zoltan Szabo: Artist at Work*.

As I'm sure you'll realize, the book you're now reading has two functions. First, you'll find an excellent survey of watercolor techniques—equally helpful if you're just getting started with watercolor or are looking for a refresher course. Second, the book will introduce you to seven of the best authors of watercolor books—artists whose books are worth reading to enlarge your command of the medium.

Wendon Blake

MATERIALS AND EQUIPMENT

There are many different kinds and brands of materials available for painting in watercolor. You may already have your favorite brushes, palettes, easels, colors, and other miscellaneous equipment. Don't throw anything out just because it isn't suggested here. This section of the book will simply give an overview of the basic materials you'll need. Colors and paints will be discussed in "Handling Color," page 27.

Brushes

Good watercolor brushes cost a fortune, especially the larger sizes, which are the most useful. Of all the things you'll need for painting in watercolor, brushes are the most important; so you should stint on everything else, if necessary, but buy the best brushes you can afford.

Watercolor brushes are made from red sable (the best brush by far), sabeline (a form of ox hair), ox hair, white nylon, camel hair, squirrel hair, and numerous other hairs. Avoid any of the brushes labeled "camel," "squirrel," etc., unless you like to paint with a mop. They get floppy and lack rigidity. The red sable is the best, but if you can't afford one, the sabeline and ox-hair brushes work quite well. Nylon brushes aren't expensive and are also acceptable.

Watercolor brushes come in two shapes: round and flat. Because large rounds are so expensive, get a larger flat instead. It will cover just as much area as a large round, but for much less money. You can also try the 1½-inch to 2-inch (approximately 4- to 5-cm) commercial bristle brushes that you can find in any hardware store. They work well for large areas.

Different manufacturers number their brushes on different scales, and so you should be careful about ordering without knowing the actual size of a particular brush. The size that is equivalent to Winsor & Newton's no. 8, which is about 1 inch (2.5 cm) long, is considered by some artists to be the best all-round size in a round sable. When you're buying a brush, always remember to test it by dipping it in water to see how it points. It should always point well when dampened. Also, never put your brushes away damp. It's not good for the brushes, and it will cause the handles to flake.

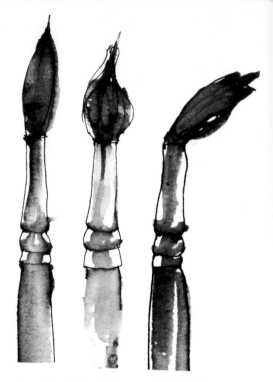

A good brush should always point well when dampened, as does the brush on the left. It shouldn't look like the one in the middle after a stroke. It should bounce back to its original shape. Also, a good brush shouldn't balloon out and become floppy like the one on the right.

These three brushes are the most useful. From left to right: a round sable with a 1-inch (2.5-cm) bristle; a 1½-inch (4-cm)-wide flat; and a 2-inch (5-cm) bristle, sometimes called a varnish brush.

Rebuilding an Old Brush

Sometimes watercolor painting is very hard on brushes, in particular the smaller sable brushes used for many of the textural effects. Because sable brushes are now very expensive, you may want to use Richard Bolton's technique for rebuilding sables and turning them into useful brushes again. The process is quite simple, although somewhat time-consuming.

1. Take an old sable brush that has worn out. Cut it down the center of the ferrule with a hacksaw and remove the hairs. These hairs will be tied together and glued at the butt end. The glue is very brittle and will chip off easily. Using a sharp knife, sever the cord holding the hairs together.

2. If the brush is large, the hairs can be separated to make three or four smaller brushes. Improvise a cone from paper and dip the hairs into it. Make sure that the hairs reach the tip of the cone; then draw the ends together with your fingers. Do this without lifting the hairs up from the tip of the cone and losing the point of the new brush. This will give the brush the sharp point needed for detailed painting. Retie with a piece of fine fishing line to hold the hairs together.

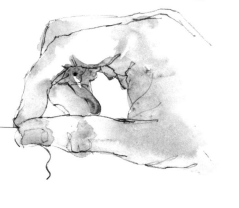

3. Rummage around and find a suitable old pen—usually an old ballpoint or felt-tip pen will do. The kind that has a separate, removable tip makes changing brush hairs very easy. If the tip is difficult to remove, use pliers or a penknife to pull or cut the tip away. To insert the brush hairs, wet them first and then push through the small hole of the tip, pulling the hairs through from the other side to the length you require.

4. You now have a new brush and have saved some money. When this brush wears out, remove the hairs and reshape them again.

Paper and Palettes

Watercolor papers are made of different materials and come in various weights and surfaces. The best papers are made from linen. Cotton is also used, but because it seems to have a very absorbent surface, it is less satisfactory than linen. Some papers have "linen" or "cotton" impressed next to the watermark, but if they don't, be sure to ask. With experience, you'll be able to tell just by the feel. Cotton paper feels softer than linen.

The weight of a paper is gauged by the weight of the whole ream. The weights range from 70 lb. to 400 lb. The 70-lb. type is really too light for anything but relatively small paintings, and the 400-lb. kind is unnecessarily heavy, unless you plan to have a real battle. For half- to full-sheet watercolors, 140-lb. to 300-lb. paper is good. The 300-lb. weight will stand up the best for a larger painting, but your choice really depends on how much punishment you plan to give it.

Watercolor paper is sold in several surfaces: rough, cold-pressed, and hot-pressed. You'll have to decide which surface you like best. The rough-surfaced papers have a great deal of texture. The cold-pressed has a fairly rough surface but probably is the best all-around paper. Many painters find hot-pressed paper too smooth, but with skill, it can be used to good advantage also. It is difficult to recommend particular paper makers, since paper is such a personal thing. The most important consideration is finding a paper you like that is readily available.

Some papers contain a good deal of sizing and tend to fight the paint. This problem can be reduced by first stretching the paper on a board, securing it with paper tape around the borders, and sponging it down before painting. Heavier papers such as the 300-lb. type can be sponged off in a bathtub without stretching them. In fact, there is really no need to stretch your paper unless you have a sizing problem. It is helpful to stretch the lighter papers to avoid buckling if you're doing a full-sheet painting. It isn't necessary to pay much attention to the right or wrong side of a paper. The right side is the side with the watermark, but both sides of good papers are equally acceptable.

You should avoid cheap metal or plastic palettes and shouldn't rely on dinner plates. A favorite palette is the folding metal type with a little finger hole. Two other recommended covered palettes are the metal O'Hara watercolor box and palette and the heavy-duty plastic John Pike palette. Another very simple and inexpensive palette is a porcelain tray known as a butcher's tray. You can put damp paper towels over your paints to keep them moist.

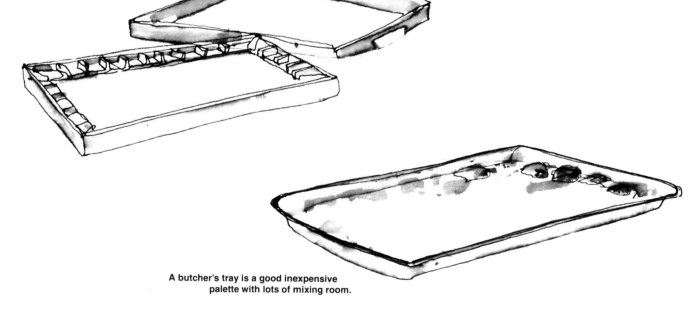

The John Pike palette is made of heavy plastic and has lots of mixing room. The cover fits snugly and keeps paint damp.

A butcher's tray is a good inexpensive palette with lots of mixing room.

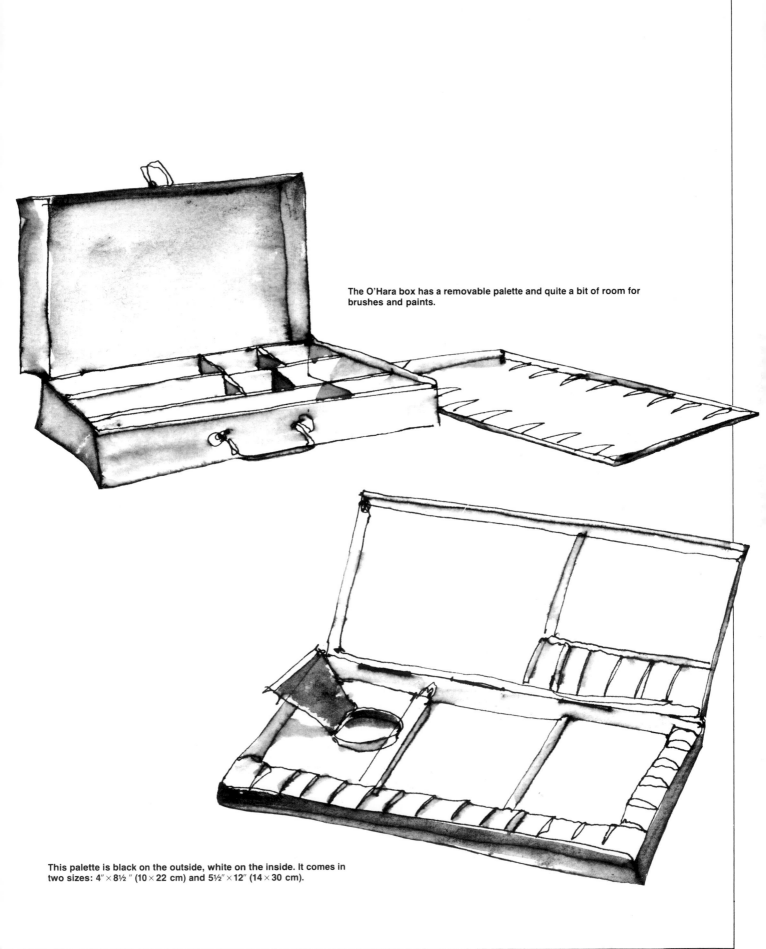

The O'Hara box has a removable palette and quite a bit of room for brushes and paints.

This palette is black on the outside, white on the inside. It comes in two sizes: 4″ × 8½ ″ (10 × 22 cm) and 5½″ × 12″ (14 × 30 cm).

Easels

Watercolor easels come in many sizes and forms, and you can feel confident in using any easel that you're able to operate. But when you buy one, insist on putting it up first—the simpler it is to set up, the better. In fact, you can even do without an easel at first—just prop your paper and board on a rock, chair, or table when you paint—until you're sure that watercolor painting is for you. You'll need some fairly firm board to support the paper. You shouldn't buy an official drawing board, since these are usually either too small for a full sheet or too heavy. Any piece of Masonite, ½-inch (1.3-cm) plywood, or even Styrofoam board would work fine. You can even have two: one for half sheets and one for full sheets.

You might find—as do many people—that working on a flat surface is best for you, in which case you won't even need an easel. On a horizontal surface, you can apply wet paint loosely without fear of the wash flowing down the paper, as it can do when the board is tilted. Also, you can decide whether you like standing or sitting best. You should get used to both, especially if you're working in a large group of people in a class or workshop where sitting on the floor may be the best way to see what you're supposed to be seeing.

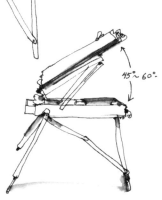

You can use the French easel with your board almost upright (top), but you'll get lots of drips. Most of the time it is best to keep your board at an angle, as shown in the lower drawing.

French easels are very good, but they're expensive.

You can make an easel out of a chair and board if you're working indoors.

Miscellaneous Materials

In addition to the materials and equipment already discussed, there are a few other items you'll find useful.

Water Container. Almost anything that doesn't leak can be used. Plastic containers offer numerous possibilities, but an old surplus canteen and cup also work well.

Tissues. You should never paint a watercolor without having a tissue at hand. You can use toilet tissue or paper towels, but it is best to avoid old towels and soiled rags.

Tape, Thumbtacks, or Clips. Any of these works well, depending on what kind of board you're using.

Erasers. The best eraser is the kneaded rubber eraser made by Eberhard Faber. It's very useful for getting rid of pencil lines, as well as for cleaning soiled and smudged paper. You should avoid hard red and white erasers, as they'll destroy the paper while erasing a line.

Brush Carriers. Brushes shouldn't be put away wet. Before you put them away, be sure they're dry—or at least dry them when you get home, if you're painting outdoors. A good carrier is a wicker or reed table mat. These are sold in art-supply stores, but you can make them yourself. Don't use cloth carriers, since they retain moisture. There are also metal boxes made especially for carrying brushes.

A surplus canteen and cup are always handy for water.

Kneaded rubber erasers are a necessity with pencil drawing.

Clamp-type clips can be bought at the hardware store.

Clips will secure your paper to your board.

Paper tape is also good for attaching the paper to your board. Pushpins can be used if your board is soft enough.

BRUSHWORK

The most important thing to remember in using a watercolor brush is that you're painting a picture, not a wall or a house. You can't just slap the paint on any old way, but generally your strokes should not all go in the same direction, either. You shouldn't smooth out the paint with your brush once it's on the paper. Also, think of more than the tip of the brush when you paint. Use the center section and the base of the brush much of the time. You should use a variety of strokes. *Variety* is the key word in painting pictures. This section suggests ways of holding and using the brush to achieve variety and control in your brushwork.

Holding the Brush

Naturally, there are many ways of holding the brush. The sketches on this page show some of the possible ways. Sometimes you can hold your brush like a pencil, but make sure this isn't the way you always hold it.

The stroke on the left is probably the most common way of using the brush, but you can also paint with the ferrule (the metal part) pressed very close to the paper, as shown on the right.

This is a good way to hold the brush: about midpoint, or 1 inch to 1½ inches (2.5 to 4 cm) above the ferrule, with your hand relaxed.

Don't hold your brush like this, that is, with your fingers at the ferrule, unless you're working on a small area and need maximum control. You shouldn't hold the brush like this until late in the painting.

Hold your brush like this early in the painting. Fingers are firm but relaxed. Remember, if you were supposed to hold the brush by the ferrule, the handle would be shorter.

Delivering the Paint

After you've experimented with ways of holding the brush, the next important step will be the process of delivering the paint to the paper. Much of the actual work is done by the water, the paint, and the paper you use, which all play as important a part as the brush. The drawings on this page show two methods that are successful for delivering paint.

Here the wrist is cocked backward and then the tip is dropped forward to touch the paper. Both methods illustrated on this page can be used on wet or dry paper. When they are used on wet paper, the paint and water do much of the work. Below, the handle of the brush is held at right angles to the hand. The wrist is rolled, and the brush is brought down on the paper. Once the brush has been dropped, very little lateral movement occurs. Use the side of the brush, not the point.

Basic Long and Short Strokes

For both long and short strokes the wrist and lower arm are held firm. Most of the movement comes from the elbow and upper arm. The hand isn't rigid, but there shouldn't be a lot of excess finger movement.

To make either long or short strokes successfully, it's important to have enough paint and water on your brush. So if you're in doubt, try some practice strokes first to make sure your paint and water are all right. The drawings on this page show the procedure for making long strokes, and those on the opposite page illustrate short strokes.

Long strokes show the leaf and petal formation of this slender flower.

The motion of a long stroke is shown here, proceeding from left to right. At the end of the stroke the brush is lifted from the paper while the arm is still moving—just like a follow-through in golf or tennis. The movement should be continuous until the end of the stroke. Don't go back for correction.

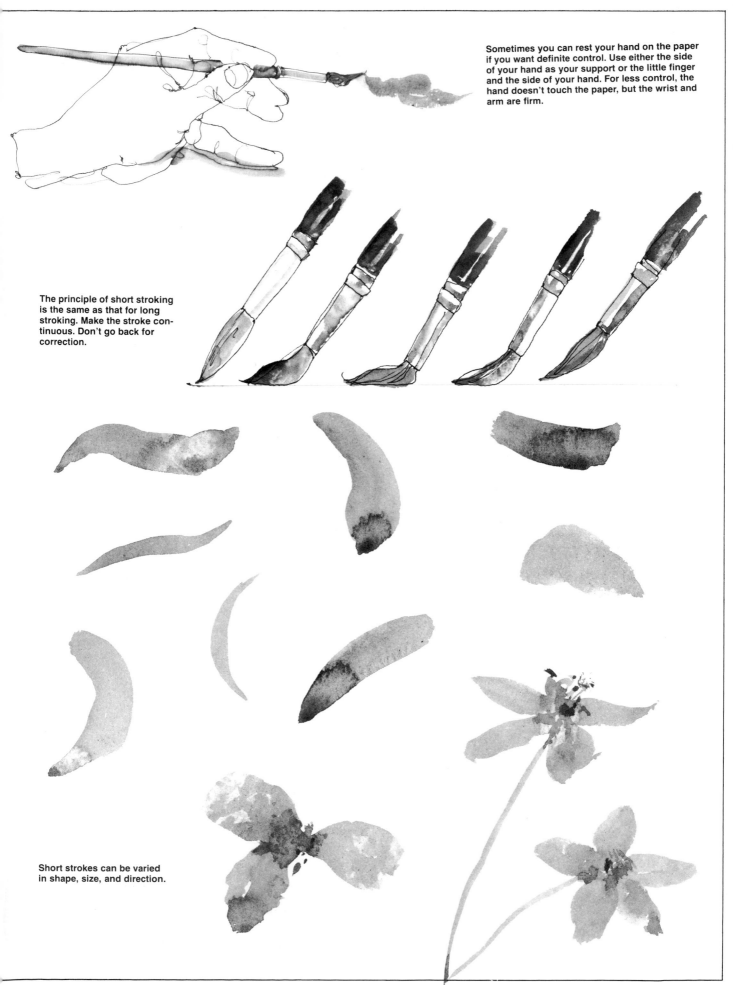

Sometimes you can rest your hand on the paper if you want definite control. Use either the side of your hand as your support or the little finger and the side of your hand. For less control, the hand doesn't touch the paper, but the wrist and arm are firm.

The principle of short stroking is the same as that for long stroking. Make the stroke continuous. Don't go back for correction.

Short strokes can be varied in shape, size, and direction.

Broad Strokes

The principles for broad strokes are the same as those for long and short ones. Keep the wrist firm, with some movement in the hand but most of the action still coming from the upper arm. The brush should be in contact with the paper most of the time, since you're working for a continuous flow. Naturally, you must pick up the brush to get water and paint—not just water, since too much water only dilutes your pigment and gives you a watery, washed-out effect. But keep your brush on the paper as much as possible. When you need more paint, go back to the palette, load up the brush, and return to the spot where you left off. Don't go back into the part you've just done to make corrections. If you have a large area to cover, do a series of the kind of blocks shown below, connecting them as you go. Some artists would do the whole area at one time, but this method isn't good if you have a very large area to cover. For that, it is best to work wet-in-wet. A broad stroke can cover a very small area or it can be quite large, and its overall shape can be long and fairly narrow or a broad mass. The technique is the same in either case.

Here the brush is being manipulated in a circular, meandering way, and the handle swivels around the base of the brush.

This is how the stroke would look. The hole left here on the right is just to show the stroke.

Ordinarily the two strokes would be connected just along the edge, as shown in the middle, but not at the center of the top stroke.

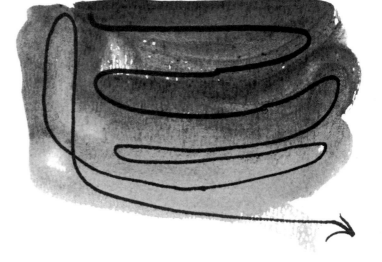

Here is a completed stroke, which starts at the top.

Connecting Strokes

Though it is recommended that you keep your brush on the paper, you can't always do this, as you must lift the brush to make new strokes; but work toward keeping the flow by connecting your strokes. There is no particular direction that the brush should take, so long as the strokes are not all the same.

The brush might make this many directional changes in a single area.

This is the way the actual wash would look.

If the strokes were not combined, they would look something like this.

Making Different Kinds of Strokes

The illustrations on these pages show some of the strokes that can be made with a watercolor brush. Practice making different kinds of strokes so that you will have greater control over your brushwork—as well as a greater variety of strokes at your command.

A wide variety of shapes can be produced, from delicate lines to heavy, broad statements.

The dragged stroke is made by using a brush starved of water.

Scrubbing the brush on its side creates a stroke with a broken line and texture.

Here, the brush has been scraped upward on its side. This technique can be used for rendering clumps of grass.

A fine-line stroke can be created by using the natural, fine-tipped shape of the brush.

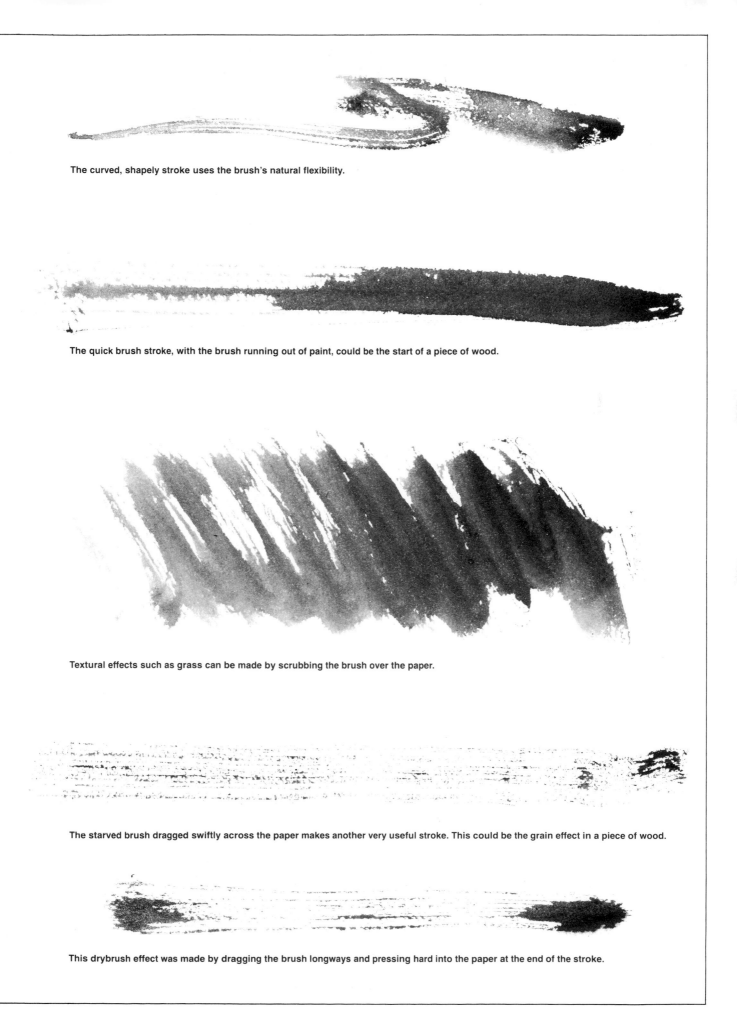

The curved, shapely stroke uses the brush's natural flexibility.

The quick brush stroke, with the brush running out of paint, could be the start of a piece of wood.

Textural effects such as grass can be made by scrubbing the brush over the paper.

The starved brush dragged swiftly across the paper makes another very useful stroke. This could be the grain effect in a piece of wood.

This drybrush effect was made by dragging the brush longways and pressing hard into the paper at the end of the stroke.

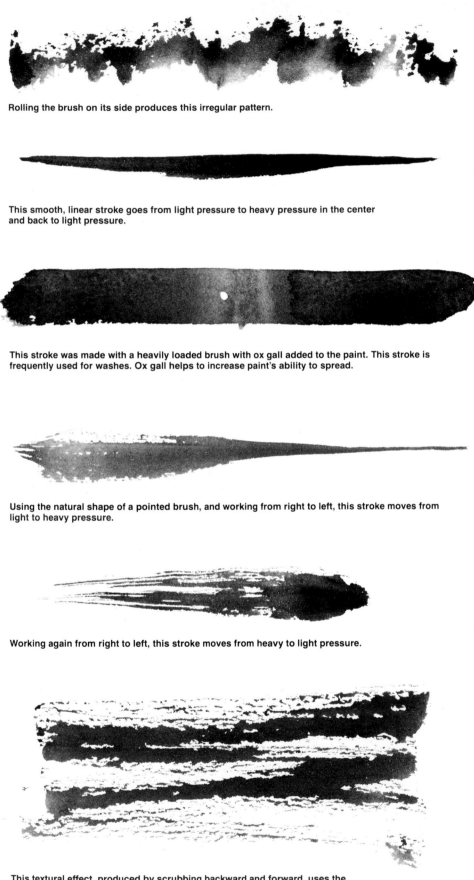

Rolling the brush on its side produces this irregular pattern.

This smooth, linear stroke goes from light pressure to heavy pressure in the center and back to light pressure.

This stroke was made with a heavily loaded brush with ox gall added to the paint. This stroke is frequently used for washes. Ox gall helps to increase paint's ability to spread.

Using the natural shape of a pointed brush, and working from right to left, this stroke moves from light to heavy pressure.

Working again from right to left, this stroke moves from heavy to light pressure.

This textural effect, produced by scrubbing backward and forward, uses the roughness of the paper.

Working Wet-in-Wet

There are many times when paint *shouldn't* be stroked onto the paper, and wet-in-wet is one of these times. But wet-in-wet shouldn't be thought of as a unique approach in watercolor painting. It *is* watercolor painting. It is also important to realize that wet-in-wet is not just dampening a large area with clear water and then dropping in color. Actually, you should be using wet-in-wet any time you go back into any wash, and you should never correct a stroke without using this technique. To correct a wet wash, it's necessary to have new pigment on the brush—not just plain water, which will dilute and muddy the paint already down. When working wet-in-wet, use the tip of the brush rather than the side, but there should be no real stroking. The work should be done by the paper, the water, and the paint.

The longer you can keep a painting wet-looking, the better. When a painting starts to look dry and scratchy, you're in trouble. Some artists soak their paper completely before painting, but for the drawing here, artist Charles Reid only dampened the surface with clear water. He then dropped paint onto the damp paper with the tip of his brush. He also used some spatter work by filling his brush from the palette and then knocking the brush against the forefinger of his free hand. While the washes were still wet, he lifted out lights with a tissue. As the paper dried, he sketched in stems and small details, but he did so before the paper was completely dry in order to keep the wet look. It's important not to make such details too dark.

HANDLING COLOR

No other element of design is as exciting or as confusing as color. This section explains how pigments can be selected and organized in a logical and systematic way, and how they can be combined to produce the widest range of hues and consistencies. It covers selecting a basic palette of colors, understanding how different types of pigments behave, and mixing the primary hues of each pigment group to produce an endless variety of hues. Special attention is given to mixing greens— a necessity for every landscape painter— and to the problems of using grays and neutrals without producing "mud." Once you understand how and why color behaves as it does, you will be able to use it more skillfully as an expressive element in your painting.

Selecting a Basic Palette

The basic palette suggested here is a selected group of pigments that will be useful to every painter. Each was chosen for its hue, permanence, and pigment consistency to provide the greatest range of color-mixing possibilities.

PRIMARIES

Primaries are those hues (red, yellow, and blue) that cannot be made by combining

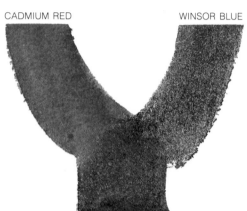

CADMIUM RED WINSOR BLUE

NEUTRAL HUE (GRAYED PURPLE)
The "wrong" primaries make a neutral secondary.

WINSOR GREEN ALIZARIN CRIMSON

NEUTRAL GRAY
Combining complements produces a neutral.

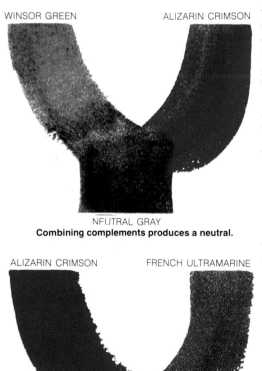

ALIZARIN CRIMSON FRENCH ULTRAMARINE

INTENSE PURPLE
The "right" primaries make an intense secondary.

other hues. A perfect primary, by definition, would be one that contained neither of the other two primaries. Because there are no true or perfect primaries available in pigment form, for a full range of color mixing it is necessary to include, at the very least, the two pigments that are the closest on each side to the true primary. For example, there are a number of reds available to watercolorists, but no true red. They all contain either a small amount of yellow (cadmium red, Winsor red) or blue (rose madder genuine, alizarin crimson) or both (Indian red). In order to mix a full range of secondaries containing red, it is necessary to include both a yellow-red and a blue-red.

SECONDARIES

Secondary hues are produced by combining two different primaries, and most secondary hues can be attained by mixing the primaries listed in this basic palette. However, a few secondary hues are included in this palette (cadmium orange, viridian, Winsor green) because they possess an intensity or pigment consistency impossible to duplicate with primary combinations.

Selecting the Right Primary.

To mix a secondary hue—say, purple—you combine two primaries, red and blue. But you must choose these primaries with care because not every red and blue on your palette will make an intense purple. For example, when cadmium red is combined with Winsor blue, the resulting mixture is not an intense secondary but a gray, neutral hue. The explanation for this is simple: both cadmium red and Winsor blue contain some yellow, the complement of purple.

How Complements Work.

Remember: the addition of its complement (the hue exactly opposite on the color wheel) to a hue will gray it, making it less intense. For example, here two complements—a red and a green—have been combined, resulting in an almost totally neutral gray. But you don't have to add a great amount of its complement to neutralize a hue. Even small amounts of a complement will reduce its intensity.

Making Intense Secondaries. To

mix an intense secondary, you must select and combine the two prim-

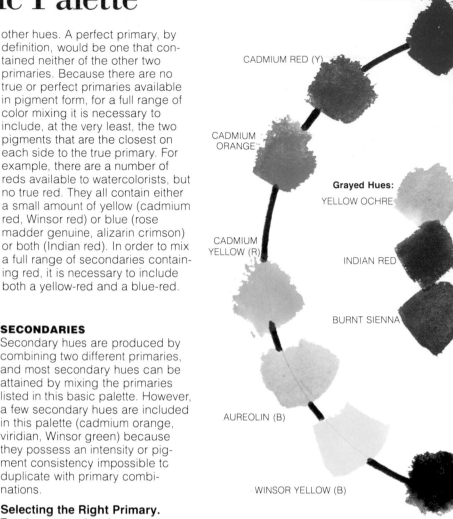

WINSOR RED (Y)

CADMIUM RED (Y)

CADMIUM ORANGE

Grayed Hues:
YELLOW OCHRE

CADMIUM YELLOW (R)

INDIAN RED

BURNT SIENNA

AUREOLIN (B)

WINSOR YELLOW (B)

WINSOR GREEN

aries closest on the color wheel to the desired hue. For example, here alizarin crimson (a red containing a small amount of blue) and French ultramarine (a blue containing a small amount of red) have been combined to make an intense purple. The reason for the intensity of the mixture is that neither of the primary hues selected contains yellow—the complement of purple.

NEUTRALS

You may have noted the absence of many of the popular neutral hues—such as burnt umber, neutral tint, Payne's gray, and Davy's gray—and modified secondaries and tertiaries—such as sap green and Hooker's green dark. Instead, if you've come to depend on one of these popular commercially mixed hues, you'll discover that it's possible to mix its equivalent easily with this basic palette. For example, here aureolin and alizarin crimson have been combined with a small amount of French ultramarine to produce a warm

ALIZARIN CRIMSON (B)

ROSE MADDER
GENUINE (B)

BASIC PALETTE
The color wheel shows primary and secondary complements. The hues in this basic palette were chosen for their position on the color wheel to provide the greatest number of mixing possibilities. Since all primary pigments contain small amounts of one or both of the other two primaries, these are shown in parentheses. For example, French ultramarine (R) is a blue containing a little red.

FRENCH
ULTRAMARINE (R)

COBALT BLUE

CERULEAN BLUE (Y)

WINSOR BLUE (Y)

RIDIAN

dark almost identical in hue, value, and intensity to burnt umber.

Commercially Mixed Neutrals. Neutral hues are made by combining the three primaries (and, in some cases, black) in varying amounts. For example, here a Payne's gray hue was mixed using aureolin, alizarin crimson, French ultramarine, and Winsor blue. Because a ready-mixed gray or neutral already contains all three primaries, any hue added to it will contain the complement of one of its components. It is therefore difficult to modify or vary a commercially mixed hue without some loss of intensity. On the other hand, mixing your own gray gives you more control. Knowing its components, you can modify it to any intensity you wish as you're preparing it.

Mixing Variations of Popular Hues. Sometimes, to avoid graying these commercially premixed hues, painters use them directly from the tube—for example, to paint a sap green field with Hooker's green dark trees under a

Payne's gray sky. But you don't need to bother with all these extra colors. Using the basic palette, it's possible to mix equivalents of these popular hues and a thousand others, varying each to capture the color and weight of your subject or inspiration. For example, here a sap green was made by combining aureolin and Winsor green, with a touch of alizarin crimson to neutralize it.

PERMANENCE
Though the myth persists, there are few artist-grade pigments available today that are truly fugitive. Christopher Schink prefers paints produced by Winsor & Newton, an English firm long recognized as the manufacturers of the highest quality artist's materials. However, many other manufacturers produce pigments of comparable quality in the more common hues—such as phthalo blue and green, viridian, burnt sienna, yellow ochre, alizarin crimson, and so forth. You should feel free to use any pigment the manufacturer recommends as permanent. Remember, no matter how stable its composition, every pigment will suffer some adverse effects when subjected to extremes of light, temperature, or moisture. But under normal conditions, all the pigments listed in the basic palette can be classified as permanent and durable.

Less Durable Pigments.
Some pigments popular with watercolorists are less durable and should be avoided or used with caution. They are:
Hooker's green light
sap green
Prussian green
gamboge
crimson lake
violet carmine

Fugitive Pigments. The few remaining fugitive pigments are:
Vandyke brown
chrome yellow
chrome lemon
mauve
carmine
rose carthame
If you wish to go ahead and use these colors anyway, you should be aware that they may fluctuate or fade. But if you want to make certain that your colors remain stable, it is best to mix equivalents for the less durable or fugitive pigments, using the colors in your basic palette.

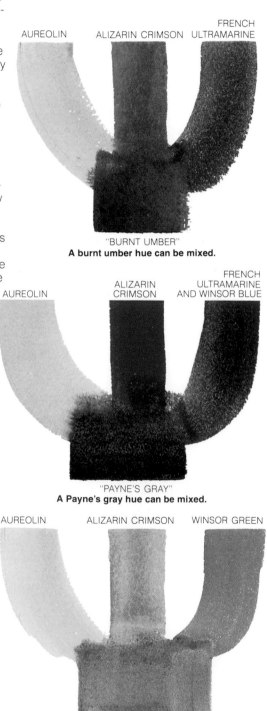

AUREOLIN ALIZARIN CRIMSON FRENCH ULTRAMARINE

"BURNT UMBER"
A burnt umber hue can be mixed.

AUREOLIN ALIZARIN CRIMSON FRENCH ULTRAMARINE AND WINSOR BLUE

"PAYNE'S GRAY"
A Payne's gray hue can be mixed.

AUREOLIN ALIZARIN CRIMSON WINSOR GREEN

"SAP GREEN"
A sap green hue can be mixed.

Understanding Pigment Qualities

TRANSPARENT NONSTAINING PIGMENTS

Transparency is a desirable and attractive characteristic of watercolor. Pigments that impart a clarity and depth of tone are particularly useful and even more so if they are also nonstaining. Nonstaining pigments can be applied in transparent layers (glazes) without sullying or staining the other pigments they contact. And because they don't stain the paper, they can be lightened or removed without ill effect. The following pigments are transparent and nonstaining.

Rose Madder Genuine. This delicate, slightly bluish red is made from the madder root. It is extremely transparent, with almost no hiding power. It does not work well for mixing darks or in combination with stains, but it is useful for subtle, transparent glazes.

Aureolin (Cobalt Yellow). This is the only nonstaining, reasonably transparent yellow available. It is cooler than cadmium yellow (leaning more toward green) and, unlike the opaque yellows, it can be used to warm darker hues without significantly affecting their transparency.

Cobalt Blue. Fairly transparent, this middle-value blue is close in hue to a perfect primary. It can be used to mix both greens and violets, but it is too light to make strong darks. Because of its transparency, it can be used in glazes to create the illusion of atmosphere or shadows.

Viridian (Verte Emeraude). This color is a very transparent bluish green. It is an intense, pure secondary color containing more blue than yellow, but no red. It can be used in combination with yellows and reds to make a great variety of natural greens in almost any value or intensity.

Burnt Sienna. This is a fairly transparent, grayed orange. It is the least neutral of the darker earth colors and can be combined with other hues without a significant loss of intensity or transparency. However, it should not be thought of as a substitute for yellow or orange.

The colors represented in this column are transparent nonstaining pigments.

ROSE MADDER GENUINE

AUREOLIN

COBALT BLUE

VIRIDIAN

BURNT SIENNA

STAINING PIGMENTS

There is a group of pigments with phenomenal strength of tone and tinctorial power that will stain not only the paper, but also any other pigment they contact. For the most part, this is a disadvantage. Once applied, these colors cannot be altered easily or removed. When used as a glaze, they will stain the underlying layers of pigment and destroy their color vibrancy. Transparent stains can be used to achieve deep, intense darks.

Winsor Blue (Phthalocyanine, Thalo, or Monastral Blue). This is a cool (leaning toward yellow), transparent dark blue with enormous power of tone, an intensity rarely seen in nature. It is a strong stain and will affect any other pigments it contacts.

Winsor Red. A slightly warm red (tending toward yellow), this color has only moderate transparency but enormous strength of tone. It is a staining pigment that has a tendency to spread in wet passages. It is too opaque and light in value to work well for darks.

Winsor Yellow. An opaque, slightly greenish yellow, it is very light in value but has enormous intensity. It should be used in the early stages of a painting. Because of its lightness and opacity, it does not work well in middle-value and dark mixtures.

Alizarin Crimson. This color is an exceedingly transparent, slightly bluish red. It has great intensity and a beautiful clarity of tone. It is dark in value, and its transparency and intensity make it an excellent choice for dark mixtures.

Winsor Green (Phthalocyanine, Thalo, or Monastral Green). This very intense, transparent green has strong staining power. It is slightly bluish and appears unnatural in its pure state. For landscape painting, it must be modified with yellows and reds.

The colors in this group have great staining power.

WINSOR RED

WINSOR YELLOW

WINSOR BLUE

ALIZARIN CRIMSON

WINSOR GREEN

OPAQUE SEDIMENTARY PIGMENTS

Opaque colors are dense, nonstaining, sedimentary pigments that obscure much of the paper or underlying pigment. Opaque pigments are effective in conveying weight and density but work less successfully in glazes. Although they are not stains, their weight makes them difficult to remove when dry.

Indian Red. This grayed earth red has enormous hiding power. It can be mixed to make natural browns of great density and weight in the medium-light to middle value range. It is not a stain, but because of its great weight, it is hard to remove when dry.

Cerulean Blue. This is a chalky, slightly greenish blue with strong hiding power. Because of its weight and sedimentary nature, it works well when used in the wet-in-wet method. At full strength, it is only medium light in value and, therefore, not a good choice for darks.

Yellow Ochre. This slightly grayed, warm earth yellow has good hiding power. It is an excellent substitute for cadmium yellow and is used extensively in landscape painting. Because of its opacity, it cannot be used to make darks without a visible loss of their transparency.

Cadmium Orange. An extremely intense true orange, it is an essential secondary because its intensity and purity of pigment cannot be attained by mixing. It possesses strong hiding power and can be used in combination with viridian and Winsor green to make rich greens.

Cadmium Yellow. An intense, warm (leaning toward red) yellow, this color possesses strong hiding power and is best used in the early stages of a painting. Because of its opacity, it cannot be used to warm middle-value or dark hues without a significant loss of their transparency.

Cadmium Red. This is a very intense yellowish red with strong hiding power. Despite its intensity, at full strength it is only a middle-value hue. If preferred, one of the other closely related cadmiums, such as cadmium red deep or scarlet, can be substituted.

French Ultramarine. A warm (leaning toward red), middle-value blue that has fair hiding power, at full strength, it appears deceptively dark. It will lighten when dry, often creating unexpected opacity or chalkiness.

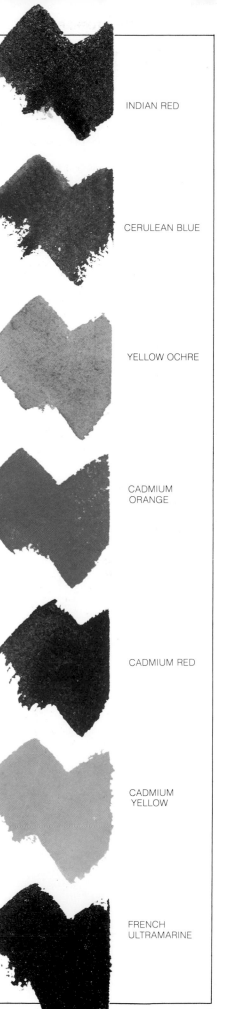

INDIAN RED

CERULEAN BLUE

YELLOW OCHRE

CADMIUM ORANGE

CADMIUM RED

CADMIUM YELLOW

FRENCH ULTRAMARINE

These are the opaque sedimentary pigments.

Mixing Variations

You don't need to buy a tube of every new or exotic pigment that comes on the market to have varied and distinguished color in your painting. With practice, you can mix an almost unlimited assortment of hues using just the primary pigments (triads) of each pigment group on the basic palette to reproduce almost any hue found in nature or in a tube.

The primary pigments in each triad are equally matched in consistency and intensity, and so when they are mixed, one pigment will not overpower another. Also, each triad (nonstaining transparent, opaque, and staining) will produce hues with distinctly different surface qualities that can be matched to the general characteristics of a subject—light and atmospheric, heavy and dense, or intense and powerful. The examples on these pages illustrate how each triad can be used to mix variations in hue. The ingredients

Mixing tertiaries with the transparent triad.

Making more tertiaries with the transparent triad.

Mixing neutrals with the transparent triad.

have been painted in varying sizes to suggest the approximate proportions of each mixture.

TRANSPARENT NONSTAINING TRIAD MIXTURES

The triad of rose madder genuine, aureolin, and cobalt blue can be mixed to produce the widest variety of intense, transparent light to middle-value hues. Mixing any two of these primaries in unequal amounts makes intense, transparent tertiaries which can be subtly shifted by increasing the amount of one of the primaries. By varying the proportions of all three primaries, you can also mix many distinctive and subtle grayed hues.

OPAQUE TRIAD MIXTURES

Because of the low intensity of the opaque primary pigments—yellow ochre, cerulean blue, and Indian red— this triad will produce only a limited number of moderately bright hues. However, many of the grayed earthlike colors made with this triad are useful in landscape painting.

STAINING TRIAD MIXTURES

A fairly large variety of hues can be produced with the staining triad— Winsor yellow, Winsor blue, and Winsor red. And, with the exception of purple hues, mixtures in a full range of intensities can be attained with these pigments, including an assortment of grayed hues.

Creating grayed secondaries with the opaque triad.

Mixing grayed secondaries with the staining triad.

Making neutral hues with the staining triad.

Mixing Greens

The greens found in nature are not made simply with a combination of yellow and blue. Their colors vary enormously, but most contain far more warmth (yellow and red) than many painters realize. By starting with pure green pigment—viridian or Winsor green—and adding varying amounts of primary colors to it, you can mix a full range of greens—from light to dark, warm to cool, intense to neutral—that approximate those seen in nature.

MIXING TRANSPARENT GREENS WITH VIRIDIAN

You'll probably find little use for viridian in its pure state, but it can be warmed with varying amounts of aureolin and rose madder genuine to produce more naturalistic transparent hues. A wide assortment of greens can be made with these three pigments. By varying their proportions, you can produce mixtures that range in hue from a light orangish green to a cool blue-green and in intensities ranging from brilliant to neutral.

Some mixtures will have a glowing transparency that can be used to suggest fresh vegetation or sunlit foliage. Other mixtures can be used to describe darker vegetation or fall foliage. By adding cobalt blue, you can also obtain a wide assortment of transparent violets, oranges, and browns with a naturalistic appearance.

MIXING OPAQUE GREENS WITH VIRIDIAN

Viridian also can be used as the basic ingredient in a large assortment of opaque greens. When combined with any of the warmer opaque pigments on the basic palette, viridian will produce mixtures of great weight and density. Cadmium yellow, yellow ochre, cadmium orange, and cadmium red can be combined with viridian to produce many opaque hues. You can use these greens to describe the density of a lush meadow or field, the weight of foliage on an oak, or the rich, warm hues of an evergreen forest.

MIXING MIDDLE-DARK GREENS WITH VIRIDIAN

A variety of middle-dark greens, both transparent and opaque, can be made by combining viridian with any of the orange-reds or reds on the basic palette. Indian red, burnt sienna, and cadmium red, to name only three, can be added to viridian. A small amount of aureolin can be added as well, to increase warmth and intensity. Varying

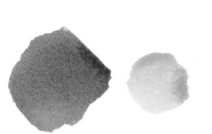

Mixing transparent greens with viridian (shown on the left as it comes from the tube) and decreasing amounts of aureolin.

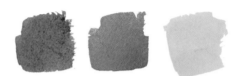

Making more transparent greens by combining viridian with aureolin and a small amount of rose madder genuine.

Viridian combined with cadmium yellow, yellow ochre, cadmium orange, and cadmium red to produce four different opaque hues.

Creating middle-dark greens by adding Indian red, burnt sienna, and cadmium red to viridian.

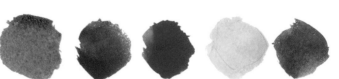

Mixing greens with Winsor green added to large amounts of (from left to right) aureolin, cadmium yellow ochre, and cadmium orange.

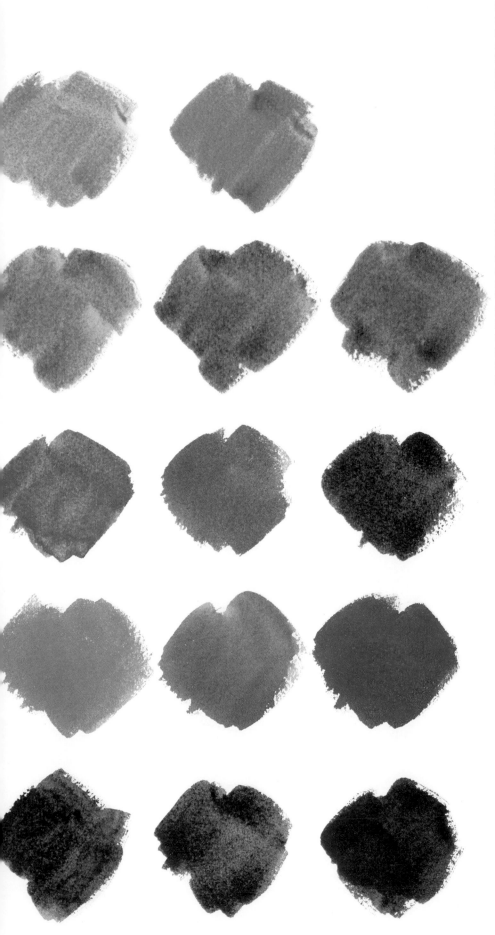

the proportions of viridian and cadmium red will enable you to create cool and warm greens. You can use variations of these combinations for darker foliage, trees in shadow, or the warm interior of a woods.

MIXING GREENS WITH WINSOR GREEN

Winsor green is a cold, dark, transparent green with enormous intensity. For realistic landscape painting, it can be modified by adding large amounts of any of the warmer pigments on the basic palette. A small amount of Winsor green can be combined with a large amount of aureolin, cadmium yellow, yellow ochre, or cadmium orange to give you light-middle and middle-value greens. You can use greens such as these to describe the intensity of lush spring foliage or a sunlit meadow or marsh, but be sure they're compatible in intensity and surface quality with the rest of your painting.

Mixing Grays

While mixing variations in hue, you may have discovered that an attractive and varied assortment of gray and neutral hues can be made by combining nearly equal amounts of all three primaries in a triad. Entirely different hues could be produced by varying the proportions of any of these mixtures. Each triad—nonstaining transparent, opaque, and staining—will produce mixtures with distinctly different pigment qualities that can be matched to the surface quality of a subject or be used as a design element in a painting to accentuate the intensity of brighter hues.

The exact hue of a gray and its effect in a painting are difficult to judge on the palette but must be seen in relation to other colors on the painting. Small areas of intense complementary color have been added in these examples to illustrate how neutral hues—mixtures you might normally discard as muddy can be used to accentuate brighter hues.

MIXING NEUTRALS WITH THE NONSTAINING TRIAD

Aureolin, rose madder genuine, and cobalt blue can be mixed to produce a series of transparent neutral hues. Begin by combining all three primaries in equal amounts, and then, for variations in hue and intensity, alter the proportions. Grays made with these pigments have great transparency and luminosity. They can be used as glazes to create atmospheric effects or to modify underlying colors.

Mixing neutrals with the nonstaining triad.

 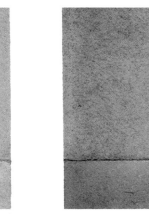

Altering the triad proportions for variety.

Mixing neutrals with the opaque triad.

MIXING NEUTRALS WITH THE OPAQUE TRIAD

The three primaries of the opaque triad—yellow ochre, cerulean blue, and Indian red—are already somewhat neutral and therefore require little mixing to become totally gray. Neutral hues made with the opaque triad have a rich consistency that is especially useful in landscape painting.

A large unrelieved area of neutral hue painted with opaque pigments can appear monotonous and muddy, but the opaque triad can be used in different ways to create subtle variations within a neutral hue. Interest can be created through a slight gradation of the hue. A granulated effect can be achieved by gently rocking the board while the wash is still wet. More abrupt shifts in hue can be made to suggest the surface variations found in natural elements of the landscape.

MIXING NEUTRALS WITH THE STAINING TRIAD

Because each of the staining pigments actually stains the other, the staining primaries—Winsor yellow, Winsor red, and Winsor blue—can be easily mixed to gray. It is difficult to judge the value of neutral hues made with stains when they're wet because they dry lighter and less intense than when first applied. The staining triad can be used to make a variety of grays and neutral hues in the middle and middle-dark value range. Neutrals can be mixed with the staining triad that are similar to popular premixed colors: Payne's gray, sepia, and neutral tint, respectively. A large assortment of useful dark grays can also be produced by combining this triad with small amounts of other pigments from your palette.

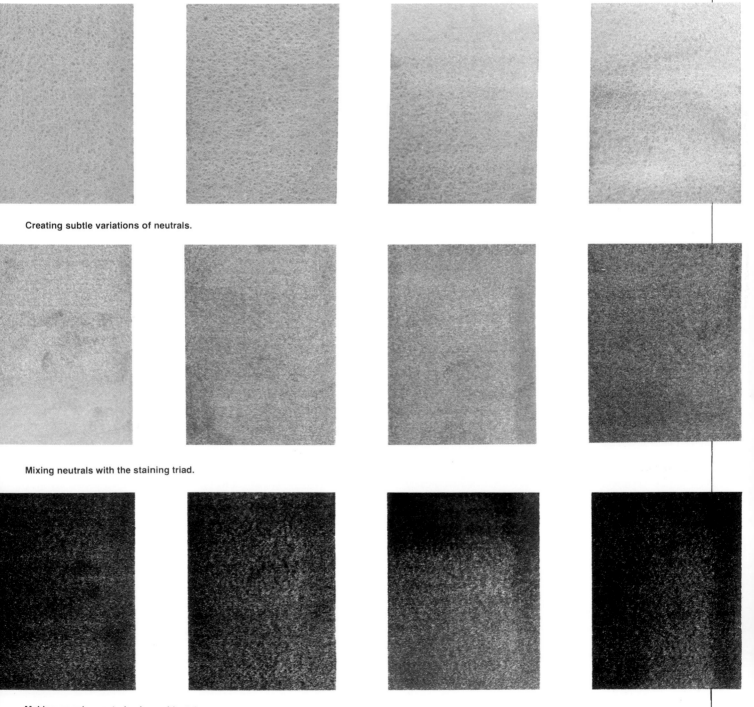

Creating subtle variations of neutrals.

Mixing neutrals with the staining triad.

Making popular neutral colors with stains.

LANDSCAPES

Every landscape artist is faced with solving similar kinds of painting problems: recession of forms in space, atmospheric perspective, changing weather conditions, the effects of different kinds of light, color relationships, compositional balance, textural appearances, and so on.

What are some of the best watercolor techniques for landscape painting? How, when, and where should they be used? And how can you strike that delicate balance between spontaneity and control in your work? The purpose of this section is to suggest some ways of finding more successful—and creative—solutions in your landscape paintings.

Creating Recession

1. When John Blockley climbed a hillside on the west coast of Scotland and looked down at the farm below, he wanted to capture the impression of receding space in his painting. He began by outlining the buildings in pencil, describing their positions so their forms would lead the eye along the continuous upper roof line from the foremost barn to the distant water. He painted the sky with a thin wash of cobalt blue to represent the cool, misty atmosphere and then gradually lightened the wash as he brought it down over the sea, whose reflective surface was lighter than the sky. When the paper was nearly dry, he painted the distant islands with a single light wash of cobalt blue.

Next he began suggesting busy foreground vegetation with a wash of pale Hooker's green, using a wet-into-wet technique to add darker tones of green mixed with burnt umber. He used loose, curving strokes to suggest organic growth but was careful to leave the barn white.

2. While the foreground was still wet, he worked more darks into it, intensifying and bringing out the rich colors of the coastal farmland with phthalo blue, Hooker's green, Payne's gray, and burnt umber to give the foreground immediacy and power. However, he prevented this area from becoming too dark and heavy by lifting color off with a brush. He also left a trail of pale Hooker's green around the barn to suggest the brightness and clarity of the scene. He worked the brush in a sweeping motion to energize the foreground and force the eye upward.

3. He began to darken the upper edge of the foreground area and to indicate grass with a finely pointed brush and a pen. Then he lifted dots of color from the front of the barn with the end of a brush handle wrapped in a rag. He defined the stones on the barn wall with a stick dipped in watercolor and a fine brush, and he washed in the side wall with Payne's gray. With a pen, he drew the lower edge of the barn roof and added some slats on the left-hand side of the gable. Then he penciled in a few more details on the buildings.

4. The artist brushed in the final colors of the buildings and islands, adding foreground details with a pen and watercolor. To suggest the busy textures and stones in the foreground, he lifted out more spots and defined some of them with a pen. He also used a pen to draw the windswept grass with a linear pattern that would

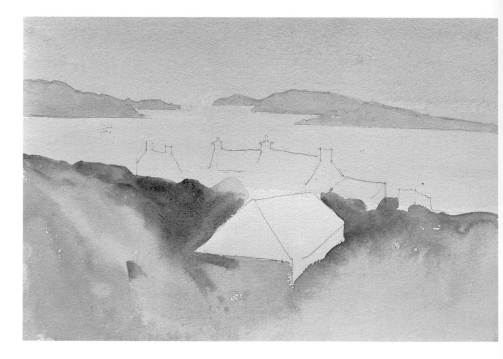

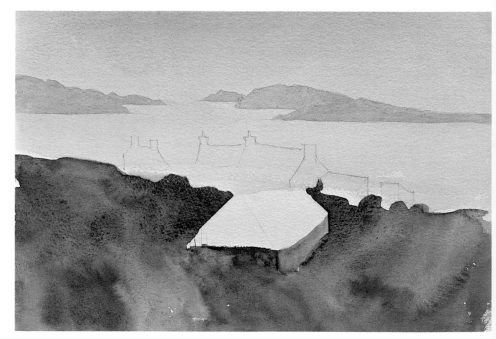

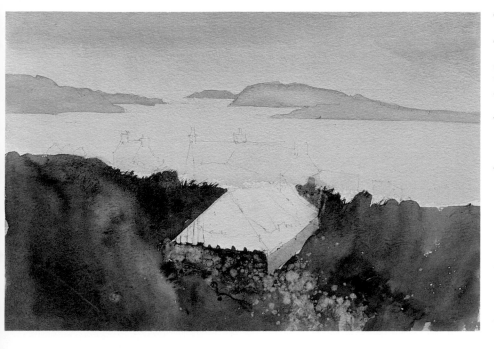

give movement to the composition. He painted the barn roof with muted colors—burnt and raw umber, phthalo blue, Payne's gray, and burnt sienna—using vertical strokes to lead the eye upward to the light-colored sea and distant hills. Using the end of his brush handle, he also scratched some white lines into the roofs and down the barn gable to guide the eye into the picture. At the left, he silhouetted four rounded haystacks against the ocean. With a very pale wash of cobalt blue, he indicated the distant islands, lightening them gradually as they receded. Mr. Blockley "obeyed the rules" of recession in this painting by having a dark foreground and a progressively lighter background. He also enhanced the recession by painting a busy, textured foreground and using only simple washes in the distance. He flouted the rules, however, by dividing his painting into light and dark values at the midpoint.

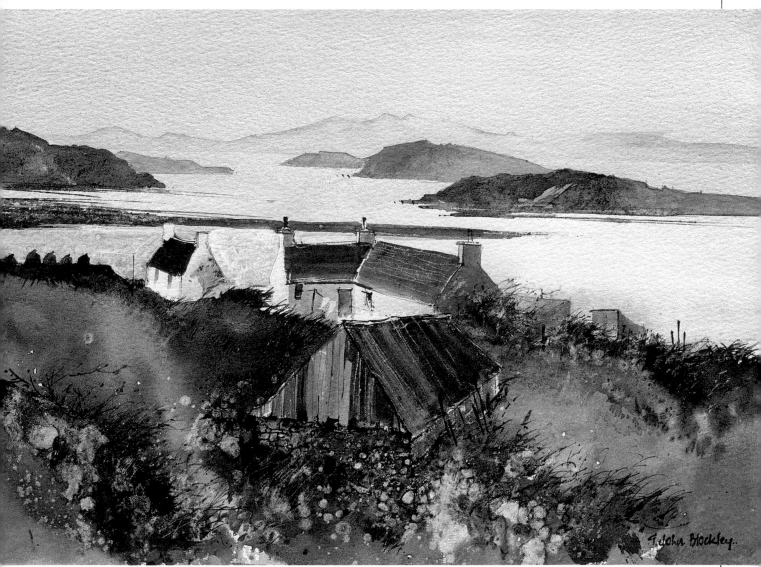

Coastal Farm, Erbusaig, 7" × 10" (18 × 26 cm), by John Blockley

Unifying a Scene with a Consistent Light

1. In this painting Mr. Blockley wanted to show a woodland farm in winter. The soft light made the clustered farmhouses blend into each other and the warm, gray tones of the distant trees melt into the low-hung clouds. To begin, the artist established the position and outline of the buildings in pencil. Then he painted the sky with a thin, diluted wash of yellow ochre and cobalt blue. The yellow warmed the sky and helped create the soft winter light he wanted to show. He covered the foreground with a fairly smooth wash of cadmium red, slighty grayed with a touch of yesterday's paint.

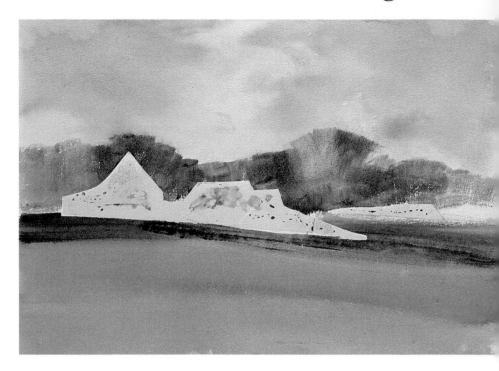

Next he needed to mask out the buildings and distant field so he could work around them, keeping their edges hard in contrast to the softly blended distant woods. To do this, he selected masking film, which he uses whenever he needs a really sharp edge because it is considerably more precise than the brushed edge of masking fluid. The plastic film comes in rolls, with a protective backing of paper that peels off and exposes the adhesive layer beneath it. Unlike masking fluid, which is applied with an old brush that must be quickly soaped out and cleaned of fluid before it dries, masking film is placed over the pencil outline and cut to the precise shape with a sharp knife and pressed onto the paper. It is sufficiently adhesive to stay in place while you paint but peels off easily when you're finished with it.

When Mr. Blockley had masked out the buildings, he painted the rounded treetops into the still-damp sky wash with downward strokes of burnt umber muted with Payne's gray, using a ½-inch (1.3-cm) sable brush. He also added dark, horizontal strokes of paint to the base of the farm.

2. At this point he worked fairly quickly. He swept more layers of Payne's gray and burnt umber into the foreground, following the contours of the land. He also added a little aureolin yellow to the foreground while it was still damp to begin to establish the patch of dried grass. In contrast to his smooth treatment of the field, he built up the tones of the background trees against the buildings with darker washes of Payne's gray and burnt umber. Then, working while the paper was still damp so their shapes would melt into the sky, he began to form the tall trees on the left by dragging a round sable brush sideways over the almost-dry paper.

3. While the paper was still damp, he drew the trunks and delicate, spreading branches of the tall trees with a very fine brush. Next he redampened the foreground so that the final layer of colors would blend in softly, and with long strokes he added deeper tones of burnt umber and Payne's gray. He allowed the cadmium red underwash to show through and tried not to paint the darks too heavily, since he wanted to create a mellow, not harsh, mood. When the paper was dry, he peeled the masking film away and tinted the buildings with a wash of yellow ochre. Then he drew the foreground grasses with a pen and opaque white gouache lightly tinted with yellow ochre. With a pen dipped in watercolor, he drew the fence with freely waving lines.

In this painting, Mr. Blockley was able to suggest separate buildings while still preserving the feeling that they were bathed in a consistent winter light. Detail was kept mainly within the enclosing wash. The artist was careful not to make the ochre grasses in the foreground as bright as the buildings. In this way the eye is led by their lines and color to the buildings beyond, and the color is echoed in the distant sky to suggest the wintry warmth of the scene. The vertical thrust of the foreground weeds and the gentle fanning diagonals of the tilled earth draw the eye to the farmhouse on the left, where silhouetted figures and farming equipment have been indicated with a few dots and flicks of the pen to suggest some activity around the farm. The sharpness of some of the twigs and grass blades contrasts with the softness of the land and trees and suggests the nippy air.

Winter Woodland, 8" × 11½"
(21 × 30 cm), by John Blockley

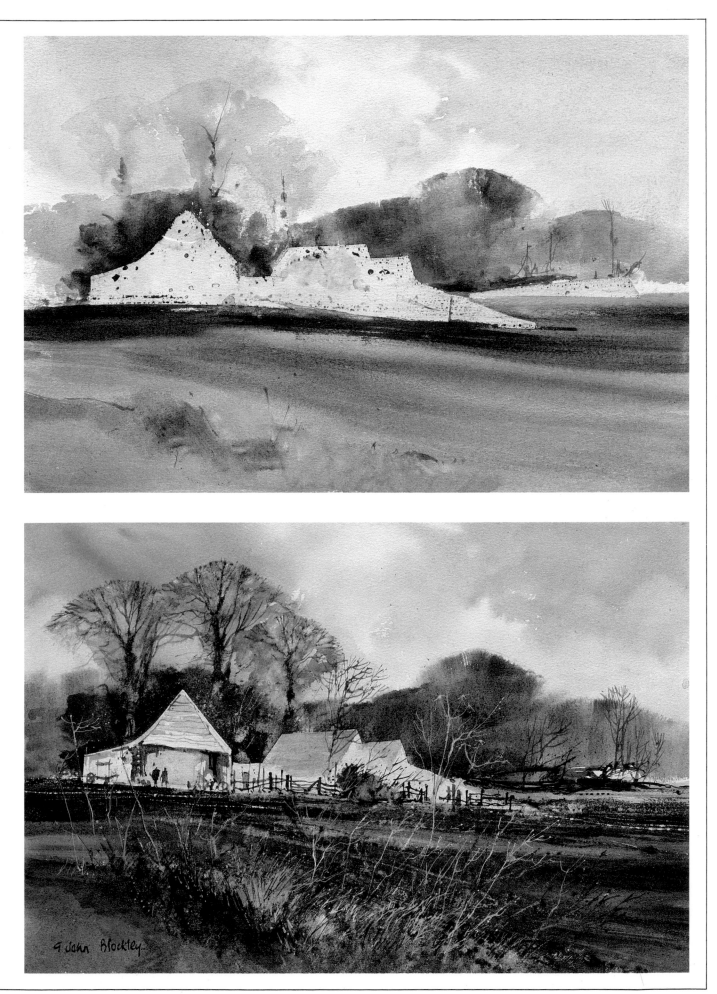

Working from Dark to Light

1. The artist was attracted to a gray cottage he saw looming out of the mist in the wet countryside, and he wanted to convey a sense of the changing weather. He also wanted to explore contrasting textures—the hard edges of the house and stone wall that were gradually becoming distinct, and the soft, water-soaked ground and background forms still hidden in the mist. He began by outlining the cottage lightly with pencil. Since it was to be the center of interest, he carefully considered its size and position on the paper. The other elements in the scene were secondary and would develop as the painting progressed, and so he did not sketch them now. Once he had settled on the placement of the cottage, he retraced the outline with masking fluid and a round brush and filled in its shape. Now he was free to paint the background and foreground with wet washes without worrying about keeping the cottage area clean.

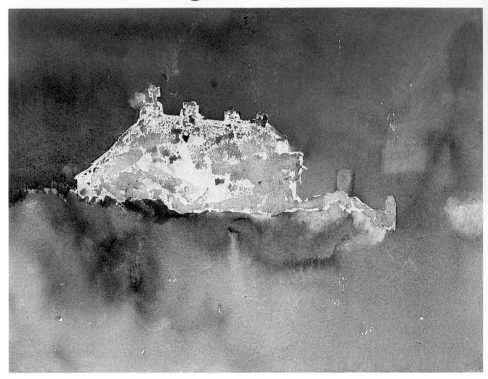

Quickly he brushed color over the paper, starting with the sky, using Payne's gray slightly modified with phthalo blue. As he carried this color to the bottom of the painting, he added raw sienna and a little burnt umber as a base for the wall and ground. The sky was deliberately made much darker then he eventually wanted it to be because of the blotting process he planned to use. (Note: John Blockley never wets the paper with water alone but always washes color over the paper to moisten it and then adds more color to the wash—or he starts with one color mixture on top of the paper and changes the color as he progresses downward, and then works into it. He believes that if you're going to work wet-into-wet, you might as well work one wet color into another, instead of into plain water.)

2. In this painting, the artist decided to work from dark to light by means of a procedure in which light, soft forms would be blotted out from a preliminary wash of dark color. While the background wash was still wet, he immediately blotted the sky area with a cotton rag to lighten it, leaving darker areas where he would suggest secondary forms—such as a tree behind the chimneys and the barn to the left of the cottage. By pressing the rag unevenly in spots on the upper left, he suggested breaking clouds. By blotting the sky more gently and evenly on the right, he created another type of softness. Since forms blotted in this way emerge softly from the background, or seem to melt into it, this technique was perfect for producing the in-focus/out-of-focus character of the scene. The effect is very different from the one he would have gotten with a brush because of the cloth's uneven absorption of color.

The subtractive process is unusual in that normally in working from dark to light, the main dark is stated as a positive shape and then is surrounded by paler tones. But here, by starting with a dark wash and then lightening it to suggest secondary items, the artist didn't actually paint a tree or a barn. Instead, he let these forms emerge slowly from the background wash. The softly blurred shapes also intensify the sensation of mist. The painting thus emerged through a continuous process of adding and subtracting wet color. A word of advice about blotting out: You must act decisively, even though you can't see what you're doing under the rag. Timid blotting gives a worried look to the painting—so be bold. It's better to make mistakes than to be afraid to take a risk.

As the artist blocked in the secondary elements, he began to add more color. He lightened the blue of the background barn on the left, blocked out shapes of the buildings on the right, and added burnt sienna to the blue wash. Then he darkened the blue where the tree would be and strengthened the left foreground with washes of phthalo blue, burnt sienna, and yellow ochre.

3. When the paper was dry, Mr. Blockley rubbed off the masking fluid with his finger, exposing the white shape of the cottage. Then he started to develop the painting, further describing the tree and barn on the left and beginning to draw detail in the cottage and foreground wall. He also toned down the color in the left foreground. Throughout the painting, he constantly adjusted colors and tones by adding or lifting out. (Note: There is a difference in tone between stages two and three because these stages were painted separately, and it is difficult to match a wash exactly.)

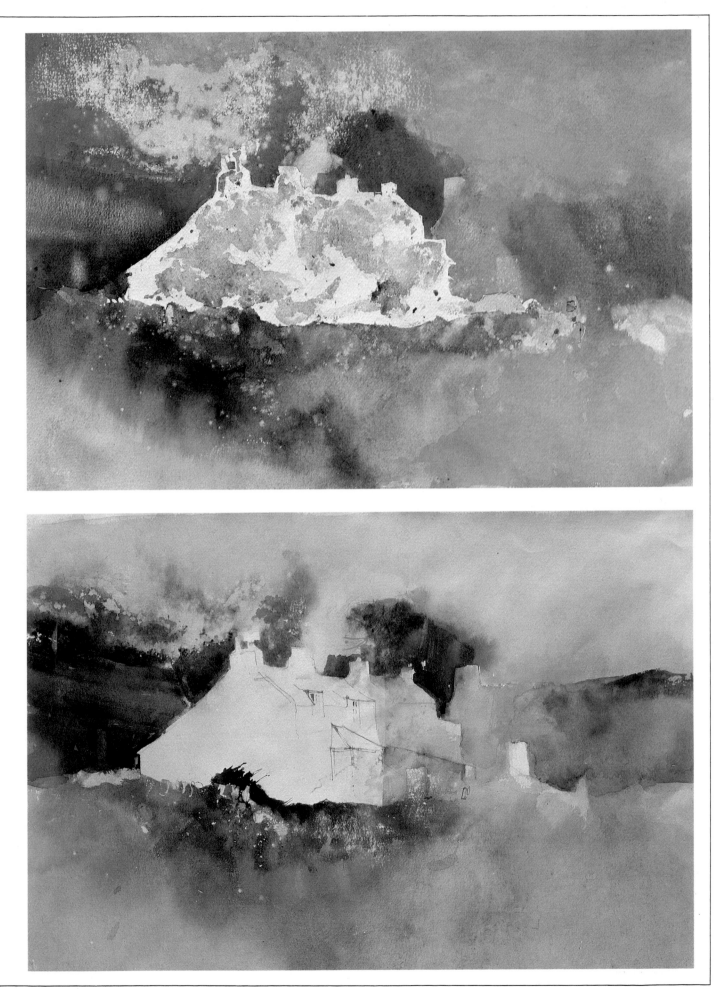

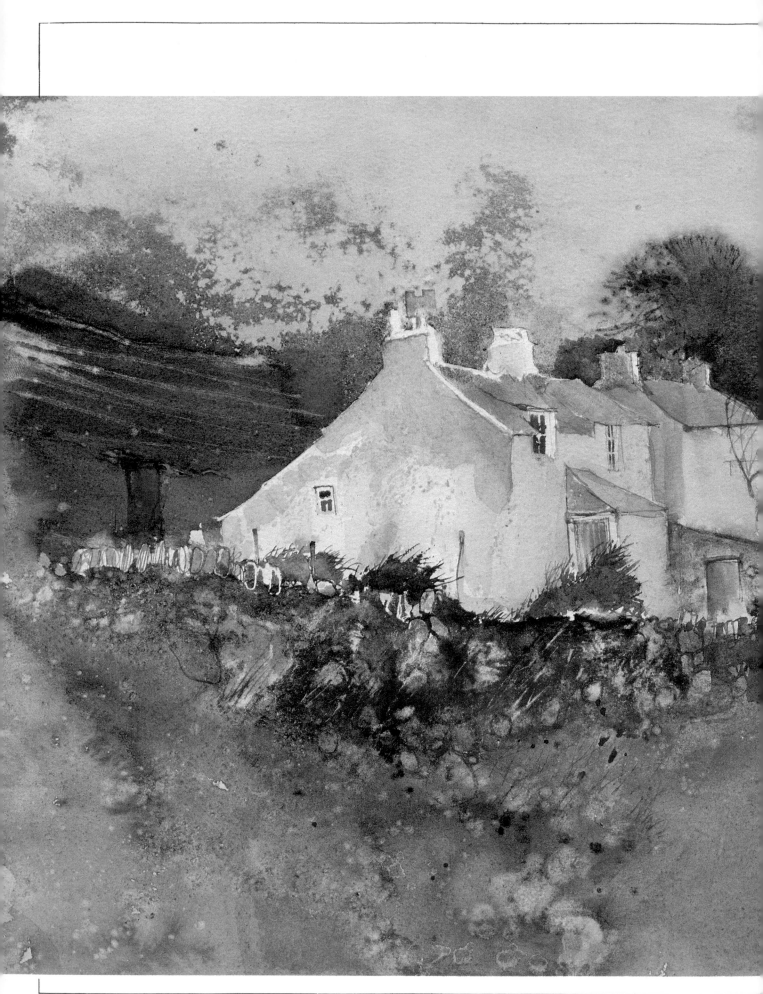

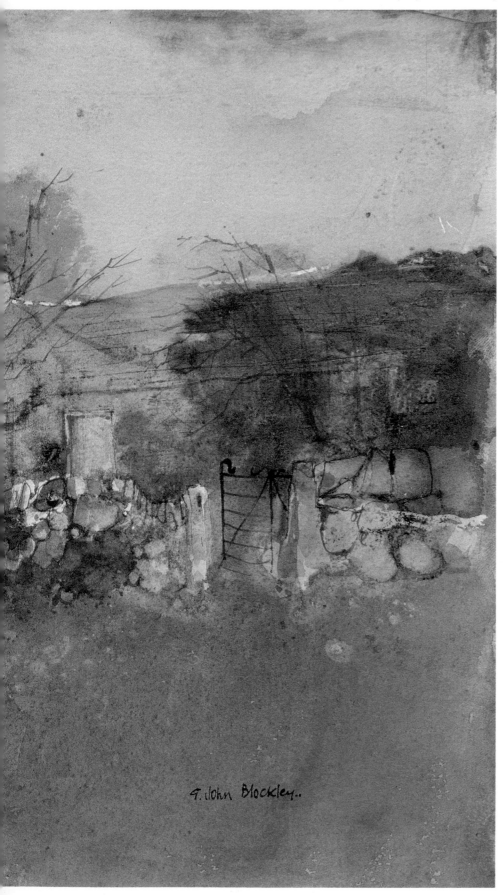

After the Rain, 12″ × 16″ (31 × 41 cm), by John Blockley

4. Now the artist fully developed the painting, adding details and more areas of color, creating different textures, and seeking an intriguing balance between the clarity of the cottage structure and the soft wetness of the natural environment. He added some tone to the cottage walls and hints of cadmium red to the chimney and doors. He placed a few brush strokes of color here and there to move the eye to different areas of the picture—the sky, the building on the right, the cottage details. With a stick dipped in paint, he drew tree branches in front of the cottage and on the right, as well as some twigs in the left foreground. Then he scratched a few lines on the barn roof with the end of his brush handle to give it a weathered appearance. Finally, he defined the stones in the wall and the iron gate with a finely pointed brush.

Rain-washed subjects call for special tonal judgments, and the whole concept behind this painting was based on a sensitive analysis of tone and edge values. The overall bulk of the building is light, with variations of light within it. Flickers of light occur at roof edges, on chimneys, and on windows. Sometimes light seems to be intensified along the corners and edges of building details. The painting was planned with just these few bright, light values in mind. To achieve this, the cottages were planned as a shade lighter than the sky, which has just a few intensely light passages. The artist saw the lines of bright light as sharp-edged and thus drew them with a knife edge dipped in masking fluid. He lowered the value of the light slightly elsewhere with broad color washes and kept the rest of the painting soft relative to the bright lights by working wet-into-wet and by blotting, keeping detail generally subdued.

Emphasizing an Area of Interest

This painting shows how somber color can be used to emphasize brighter color. The cadmium red ground on the lower slopes of the hillside (which were plowed for growing potatoes) was the artist's main interest. To make it appear even brighter, he placed it between the bright green of the foreground and the somber gray of the hill beyond.

He kept the sky a middle-value tone, so that the pink would be the lightest color and attract attention immediately. He further distinguished that area by drawing the lines of the plowed fields spiraling up the hill contour, using a pen dipped in watercolor.

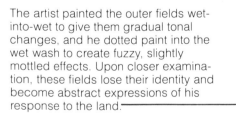

Pembrokeshire Potato Fields, 10" × 14" (26 × 36 cm), by John Blockley

The artist painted the outer fields wet-into-wet to give them gradual tonal changes, and he dotted paint into the wet wash to create fuzzy, slightly mottled effects. Upon closer examination, these fields lose their identity and become abstract expressions of his response to the land.

The crisp lines stand out clearly on the light-colored fields; they contrast with the soft-edged surrounding areas and thus again emphasize the pink field. The lines also provide graphic interest and lead the eye into the distance. This simple strategy of containing the brightest, lightest tones and the most precise drawing in one part of the painting to call attention to it was completely planned in the artist's mind before he started to paint. In your own painting, try selecting one aspect of a subject and relating all other areas to it. Also, strengthen your principal area of interest with a few specific features—buildings, trees, a hard-edged skyline—and leave large areas of comparative emptiness elsewhere to focus attention on the main features.

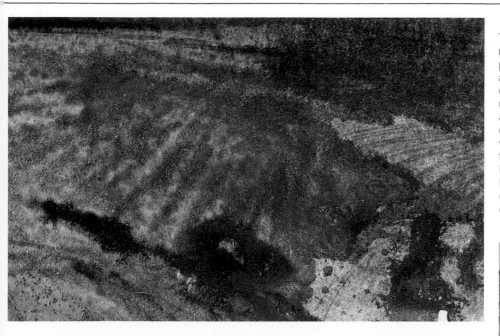

This detail shows how Mr. Blockley used wet-into-wet washes in transparent layers to build up this secondary, soft, moody area. He originally drew a structure of dark lines in the upper field, but then subdued it with an overlay of cadmium red. The bits of dark sediment resulting from his waterproof-ink technique add surface texture to the soft green ground. The linear movements here are gentle and lethargic: generous curves, slow undulations, and veiled lines spreading outward.

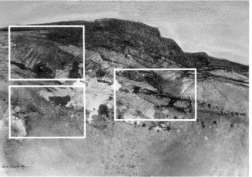

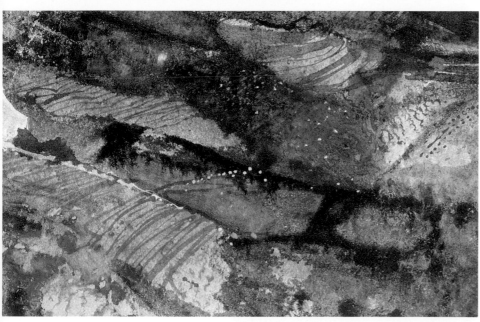

Over an initial wash of warm pink, the artist blended layers of rich colors, letting the pink show through. Then, while the paper was still wet, he used the end of his brush handle to draw the heavy, dark lines and soft dots. To get the light red veinlike streaks in the gold area, he brushed water over the paper, then drew watercolor into the surface of the water with a pen. He also tilted the paper to force some of the paint to spread downward for an organic effect. The many different lines give this area movement and energy.

Soft spots of light in amorphous shapes give a dreamy character to the foreground. The artist created these spots by blotting the area with repeated touches of a rag wrapped around his finger. To get harder edges, he let the wash underneath dry before laying on the next one and blended the soft edges while the washes were wet. As a delicate accent, he loosely drew lines around the small circular shapes with a fine brush.

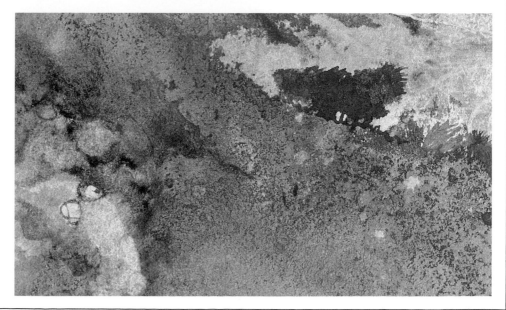

Handling a Dark Center of Interest

The cottage and the lane that led to it made a strong right angle, which the artist emphasized by surrounding them with dark tones. He also painted organic patterns in the foreground and added subtle textures in the background and foreground to soften the rectangular composition and contrast with the linearity of the main elements.

Mr. Blockley established the warmth of the composition by brushing diluted cadmium red over the entire foreground, and then he painted the cottage with Payne's gray, plus a touch of cadmium red and Hooker's green on the roof. (In reality, the roof was a strong slate blue, but he understated it so the entire cottage would stand out against the dark background.) He kept the background simple, with a hint of speckled texture of Hooker's green and India ink. He deliberately darkened the background to give maximum contrast to the cottage and lane.

The artist directed the ink into different formations that suggested the changing moods and textures of the mountain by depositing it in varying strengths on the paper and by varying the wetness of the paper and changing its slant. In some places the ink dried in large pieces because he held the paper almost still; in others, the ink separated into fine particles because he rocked the paper gently as it dried. He even pressed his thumb into the damp paint for additional texture. The starburst on the left was made with the end of a brush handle, dipped in ink and touched into the center of a circular float of water; the ink flared to the edge of the water in an unpredictable way.

It is a challenge to create a painting where the center of interest is in the dark passages rather than the usual light areas. Try this for yourself sometime. How would you direct attention to these dark areas?

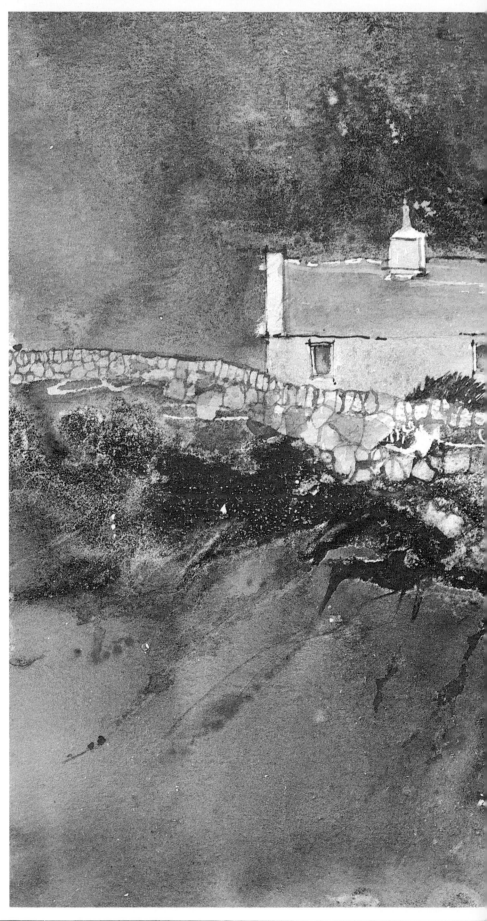

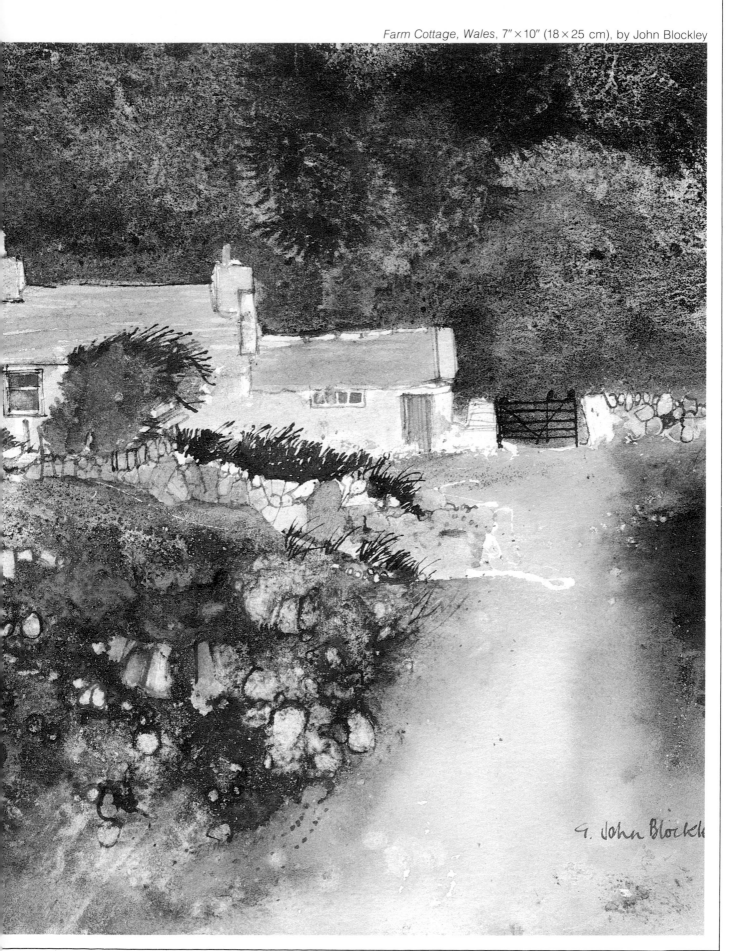

G. John Blockle

Interpreting Atmospheric Conditions

Mountain Textures and Colors on a Clear Day. The paintings on this page and the next are interpretations of the same subject under different weather conditions. John Blockley painted this view on a day when the mountaintops were clear of clouds and the smooth faces of the huge, vertical rocks reflected the light. He concentrated on the detail of these rock faces and deliberately subdued the treatment of the smaller rock debris on the lower slope of the mountain. The painting was done with washes of color that ranged from the intense colors of the wet foreground to the delicate, blue-gray color of the distant mountains.

The unifying upper boundary is provided by the Payne's gray and cobalt blue wash of the distant mountains and by the burnt umber on the right. The umber ties the picture together and encircles the light-reflecting rock. Note how the light value of the two rock formations makes then stand out against the darks as areas of main interest.

The dark tones begin in the upper right-hand corner and fall from there to sweep across the foreground like a protective arm curved around the massive rocks.

Llanberis Pass 1, 15″ × 21″ (38 × 54 cm), by John Blockley

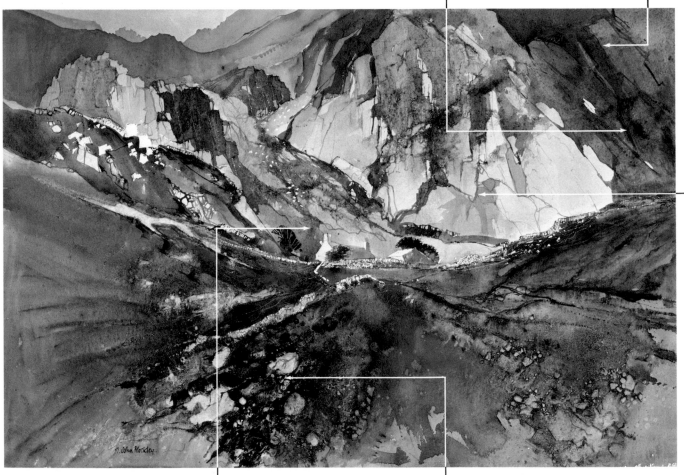

The yellow ochre color of the central area radiates like a star over the landscape, while the green of the foreground glides from left to right in a curve that supports the major rock formations.

The artist obtained the fine-grained texture in the foreground with his waterproof-ink technique and drew soft brown streaks on the left with a stick while the washes were still wet.

The hard-edged outlines of the rock faces were drawn with pen and diluted watercolor after the washes were applied.

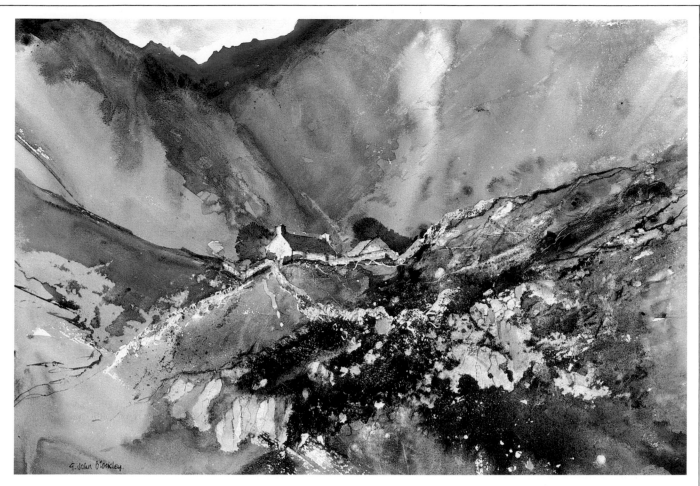

Llanberis Pass 2, 15" × 21" (38 × 54 cm), by John Blockley

Mountain Colors and Textures on a Misty Day. In contrast to the painting opposite, in this view rain clouds drift down the mountain face and rock details are lost in mist. The artist painted the mountaintop wet-into-wet to create this atmospheric effect. On the other hand, where the air is clear—below the farm, where the rock debris slopes steeply downward—he used strong tonal contrasts of black and the palest of grays as a foil to the atmospheric treatment of the higher areas. This time it is the darks rather than the lights that signal the areas of interest: first, the large patch of gritty foreground rocks; second, the silhouette of the mountain-tops; and lastly, the cottage with its dark roof.

Mr. Blockley deliberately simplified the background to increase the soft, atmospheric effect while keeping the foreground elaborately textured because it is closer to the viewer. A pale wash of cobalt blue with a touch of yellow ochre gave the sky its color and provided a cool underwash for the mountainside and the foreground. He worked the soft grays, blues, and browns of the mountain into it, adding hints of yellow ochre and cadmium red to the land. A broad stroke of burnt sienna defines the foreground slope on the left and rises in a supportive curve that acts as a backbone to the composition. The artist blotted the foreground with a rag to suggest coarse earth textures and indicated a long, cloud-like shape on the mountain wall with a moist brush. He obtained the harsh, dark textures of the center of interest, the foreground rock debris, with his watercolor-ink technique.

Symmetry and balance are less evident in this composition than in the painting on the opposite page. The strong movement here is a zigzag that descends from the bright sky to the cottage and then runs left and right in the foreground. This angular movement, in addition to the jagged lines of the central ridge and the diagonal stone walls, gives the picture a sense of unrest and evokes the changeability of the weather.

It is a good test of your skill as a watercolorist to see how many ways you can interpret the same subject. Try painting an indoor subject from different angles or under different types (and colors) of lights. Paint an outdoor subject under different lighting and weather conditions, or at different times of day. If you were to paint a scene suggesting a rapidly changing weather pattern, how would you do it? Whatever your subject, look for its essential characteristics at these particular times and try to express them in your painting.

Capturing a Hazy Atmosphere with Warm an

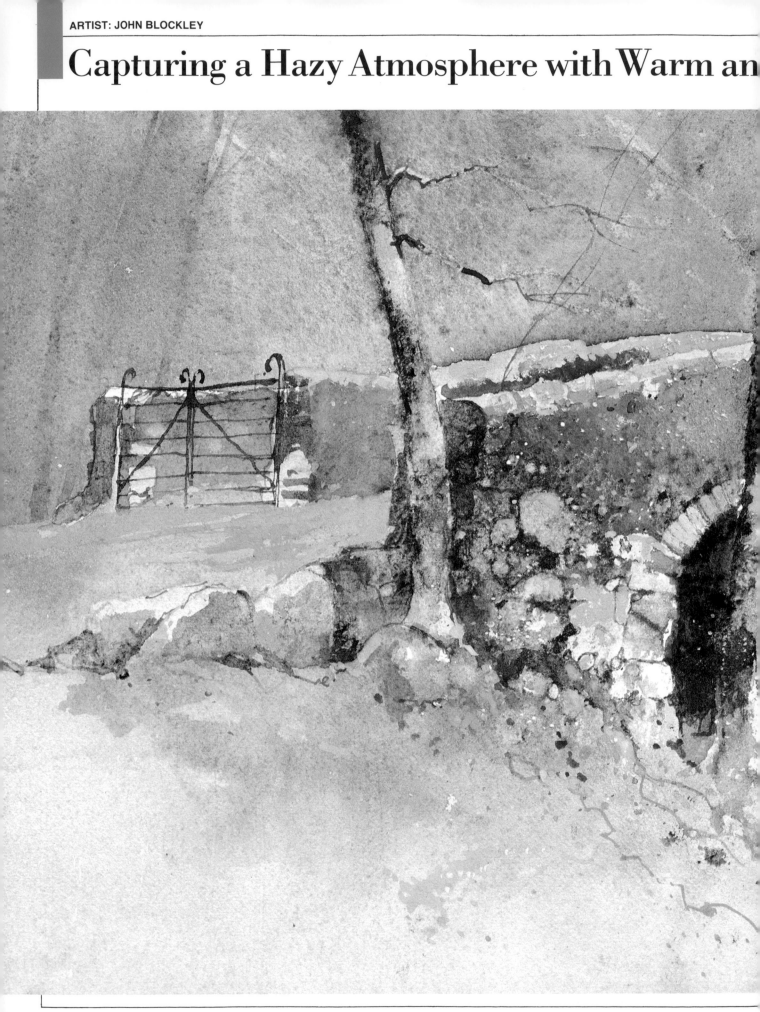

Cool Color

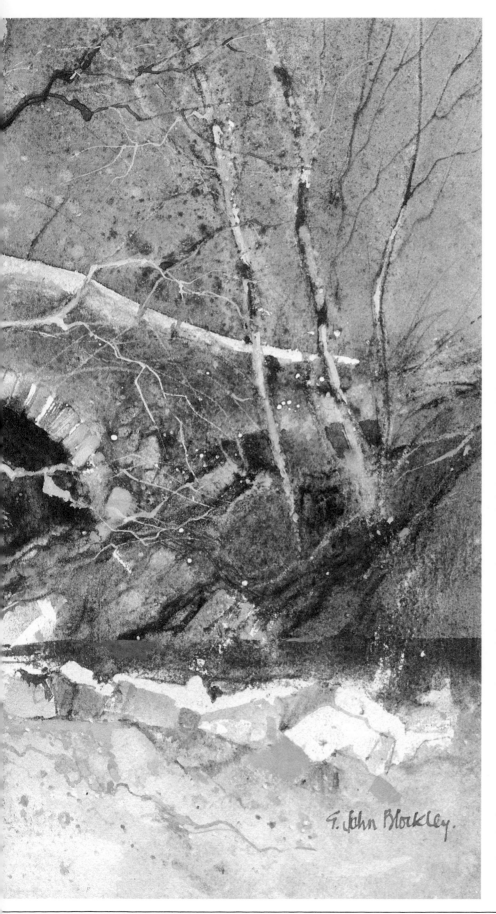

John Blockley wanted to capture the hazy atmosphere of early morning and show how the rough textures of a rustic bridge complemented that softness. To do this, he limited the number of hard edges, confining them mainly to the top of the bridge, the arch, and the tops of a few boulders. (He masked them out before he started.) He was careful not to get carried away with the texture of the bridge stonework, but used it discreetly, mainly in the nearer part of the bridge. The artist had previously tried a vertical format, with the bridge high in the painting, but decided that a horizontal format was better suited to the quiet, softer treatment he wanted. The foreground trees cutting across the bridge would provide sufficient vertical interest.

Mr. Blockley painted the background and foreground with wet-in-wet washes of diluted cadmium red and Payne's gray; he painted the bridge with hints of raw sienna mixed with the Payne's gray to make a gray-green. After the washes were dry he strengthened the darks and added definition by drawing with the brush. Then he rubbed the masking fluid away and tinted the stones and branches. He strengthened the bridge by painting its upper edge and the arch below with touches of gouache.

You can evoke a misty atmosphere in a landscape by interplaying hard edges against soft ones. Reserve the hardest edges for the nearest objects, and keep the brightest and darkest tones for the foreground. Also play warm tones against cool ones to express the light, keeping the most distant hues soft and light.

Farm Bridge, 8″ × 12″ (20 × 31 cm), by John Blockley

Painting Coarse Terrain with Granular Washe

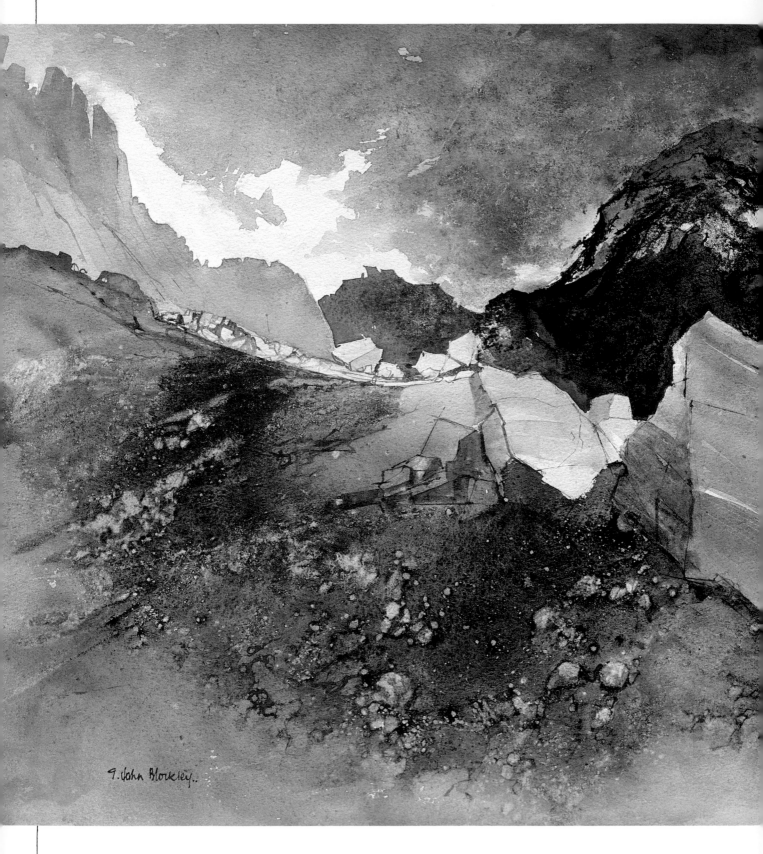

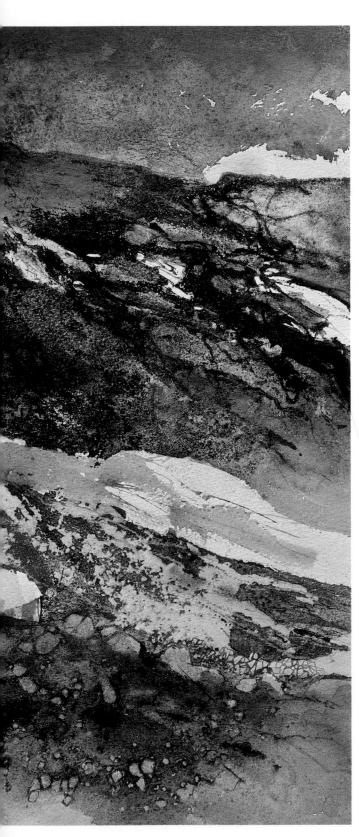

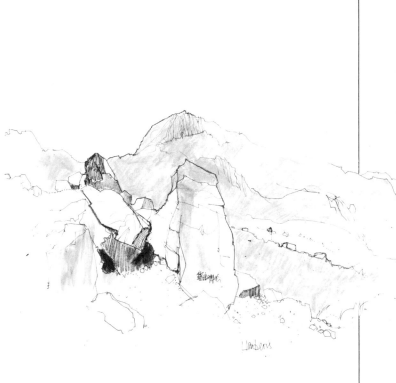

The coarse textures of the mountain, emphasized by the smoothness of the rock slabs, attracted the artist to this scene. The fallen rocks varied from fist-sized stones to the huge sentinel standing in front. Since it was raining, he huddled under a rock to make a drawing from which he later developed this painting.

First he covered the big foreground rock with masking film, cut out with a sharp blade, because he wanted a precise, hard edge on the rock. Then he painted the sky and mountain with Payne's gray—with lampblack and burnt sienna added for traces of warmth. He obtained soft foreground textures by blotting the still-damp washes with a rag wrapped around the end of a brush handle or with his fingertip. He also produced a faintly mottled surface on the dark mountain by momentarily lowering a piece of absorbent newspaper onto the nearly dry paint. To simplify the composition, he omitted a number of boulders from this painting and included only those that would lead the eye deeper into the picture toward the light patch of sky in the distance. He drew the dark lichen that clung to the slopes with a stick dipped in lampblack watercolor and then brushed a black wash in a curved path over the mountain, subduing the rich colors underneath and creating a consistent dark backdrop for the light, hard-edged slab in front. The string of hard-edged rocks crossing the painting diagonally provides a link between the large rock and the jagged mountaintop.

When you paint a landscape in the rain, it is not easy to show that it is raining. One thing to consider is the direction of the brush strokes in suggesting rain. You should also try using stiff-bristled brushes. Remember that some edges will be hard and others soft. These are called lost-and-found edges.

Llanberis Rocks, 15″ × 21″ (38 × 54 cm), by John Blockley

Representing Rainy Weather

Rain on Leaves and Weeds. On these pages, Zoltan Szabo shows some useful techniques for capturing the effects of rain in a watercolor painting. In the study at right, Mr. Szabo painted the light silhouette washes of the leaves first. This color is still visible within the raindrops. After it dried, he masked out the beads of water with latex and modeled the texture of the leaves. Finally he removed the latex and shaded each raindrop.

Downpour. Below, the artist roughed in his sketch first, without the raindrops. Then he wet and blot-lifted out the soft splashes and streaks of the falling raindrops from the dry paper. Later he used the sharp corner of a razor blade to scrape out two or three long, light streaks and gouge out the round highlights where the splashes hit the ground.

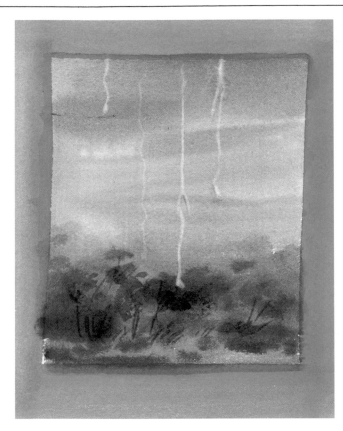

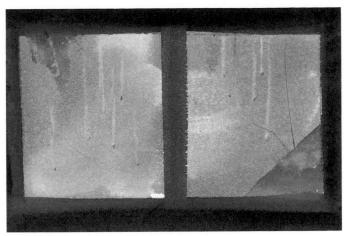

Raindrops on Clean Windowpanes. In the picture above, left, Mr. Szabo painted the outdoor colors to suggest clean glass. Next he dropped clean water onto the dry surface and blew it downward. Then he wiped out the path of each droplet of water and added the shadow to the raindrop.

Raindrops on Dirty Windowpanes. On the dirty windows above, he painted a textured wash of sepia and French ultramarine. At the lower right-hand corner, where the glass is missing, he painted a touch of nature outside.

Raindrops in a Puddle. After he painted the puddle below, the artist let the edges remain as drybrushed spots that appeared shiny on the dry paper. Next he drybrushed the mud texture around the puddle; then he wet and blot-lifted out the ripples in the water and the long lines of the falling raindrops.

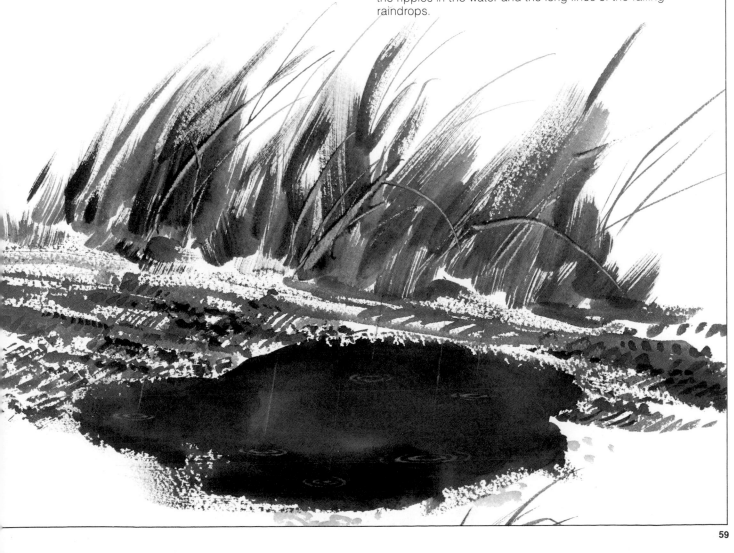

Capturing the Effects of Diffused and Reflected Light

Misty Bouquet, 15″ × 22″ (38 × 56 cm), by Zoltan Szabo

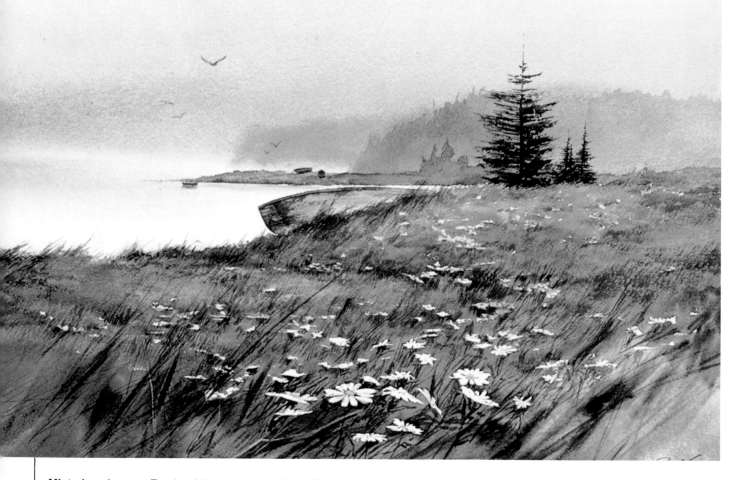

Misty Landscape. To give this scene a feeling of distance, the artist used descending values, starting with the lightest and coolest colors. On wet paper, he painted the sky with a pale wash of French ultramarine, burnt sienna, and Winsor blue, and then added a little cerulean blue to this mixture for the most distant point. After the paper dried, he silhouetted each successive layer of trees a little darker and with more definition.

Mr. Szabo painted the large field with a wet-on-dry technique. Starting from the top, he quickly brushed on the color, carrying the pools of paint downward with additional brushloads of pigment fast enough to prevent their edges from drying. Wherever the brush skipped white spots, he left them. The closer he got to the foreground, the more carefully he handled the shapes. He painted around the closest daisies, leaving their silhouettes white. After this value wash was dry, he drybrushed in the delicate dark spruces and added the daisies and other details.

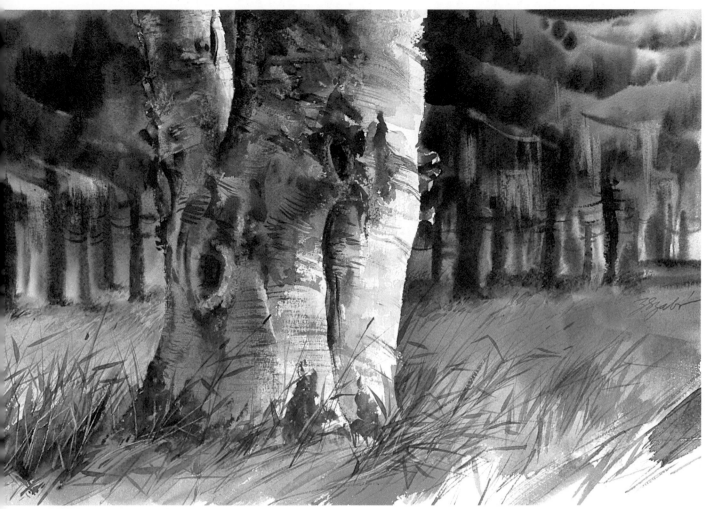

Lone Performer, 15″ × 22″ (38 × 56 cm), by Zoltan Szabo

Reflected Forest Light. Soft lighting and playful texture complement one another in this watercolor. As shown in the detail below, the shaded side of the large tree contains a variety of luminous colors resulting from reflected light. Zoltan Szabo applied a rich blend of new gamboge, burnt sienna, Winsor blue, and sepia to dry paper with a large, soft, flat brush. He lightened the wash considerably on the lit side of the birch at the right and let some white paper show. He began painting the ragged bark and scar textures with soft modeling on the damp paper, followed by drybrush strokes. Next he painted the dark old spruce trees in the background with a wet-in-wet technique using Winsor blue, burnt sienna, and sepia in various combinations. With a tissue he wiped out the moss hanging from the branches. The lush, brightly lit grass in the middle and foreground is mainly a combination of new gamboge, Winsor blue, and burnt sienna. At the foot of the tree, the artist drybrushed some richly textured grass in darker shades of the same color and knifed out the light weeds while the washes were still damp.

Painting Frost and Ice

1. Frost-covered trees at the edge of a frozen pond are one of the most magical of all landscape subjects. To start this painting, the artist wet the paper thoroughly with clear water. Then, with a firm 2-inch (5-cm) bristle brush, he painted the large background shapes with French ultramarine, cerulean blue, and a little raw sienna. He mixed each brushful of paint separately so that the colors would become gradually cooler toward the bottom, where they're dominated by cerulean blue. For the ice at the lower edge of the painting, he used raw sienna and cerulean blue. As the background was beginning to dry—and was losing its shine—he painted in the frosty branches with a no. 5 round sable and clear water. He worked very swiftly to prevent the water from gushing out of control.

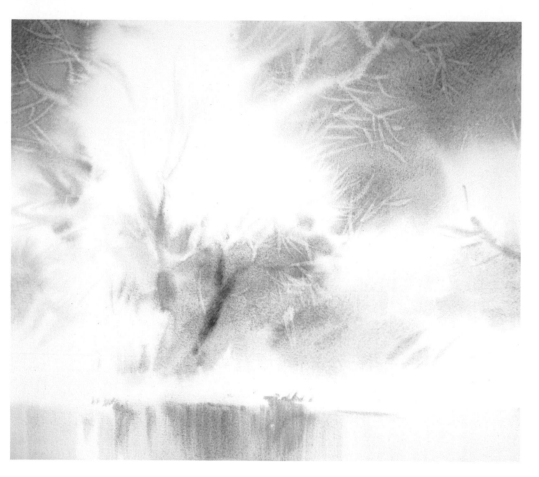

2. When the first stage was completely dry, Mr. Szabo worked along the shore line with sharp strokes and hard-edged washes to suggest a lot more frosty foliage. He darkened some of the pale tones, such as the shape in the upper right, with delicate washes, blending them softly at the edges to avoid hardening the shapes of the trees. He continued working with the same colors used in step 1, but he sneaked some greener mixtures (with more raw sienna) into the trees and weeds. Now they began to echo the color of the ice, which otherwise would have been isolated from the rest of the painting.

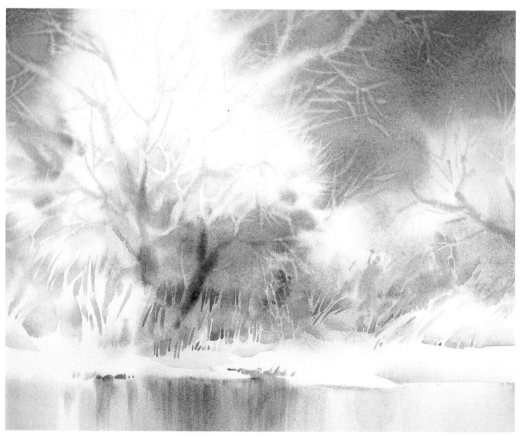

3. Working with warm darks, the artist began to concentrate on the center of interest, strengthening the lower portions of the larger tree. He made this mixture of sepia with cerulean blue and a little burnt sienna. He continued to add more darks along the shore line to suggest weeds and shrubs. Notice how a few bluish weeds curve under the weight of the frost. To lift out more frosty branches, he used a wet bristle brush, scrubbing and then blotting the dark background wash. Slender dark branches began to appear amid the upper foliage, but he kept them inconspicuous so they wouldn't conflict with the focal point of the picture.

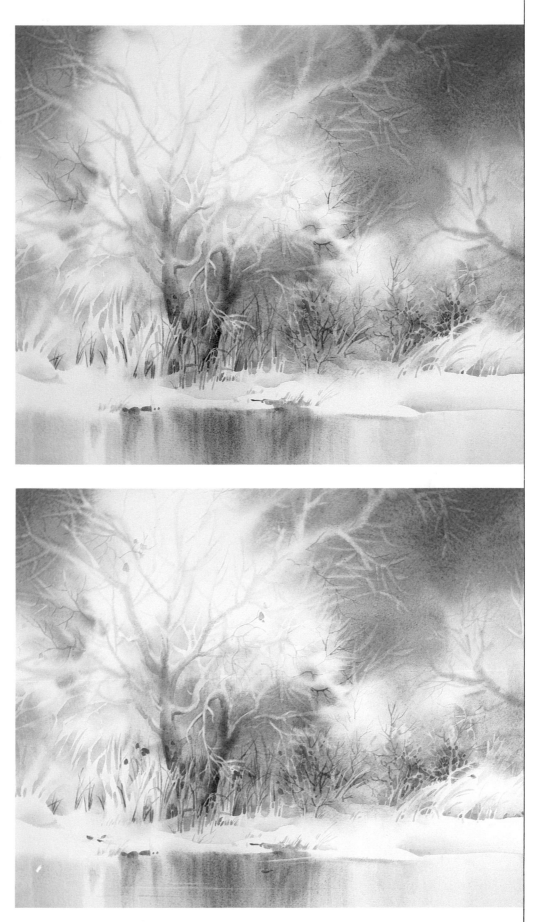

4. Mr. Szabo finished the painting by adding just a few more refinements, such as the lacy twigs, painted with a small rigger brush loaded with sepia and cerulean blue. For just a suggestion of color contrast, he sprinkled the warm tones of some leftover leaves onto the bigger tree, as well as on the snow and ice. Until this stage, the artist had been painting the ice with vertical strokes. Now he lifted out some light horizontal lines across the vertical strokes. Study the finished painting and you'll see that there's very little detail. The sharply defined brushwork is all concentrated along the shore line at the center of interest. The rest of the picture consists almost entirely of large, soft-edged shapes.

Handling Snowy Scenes

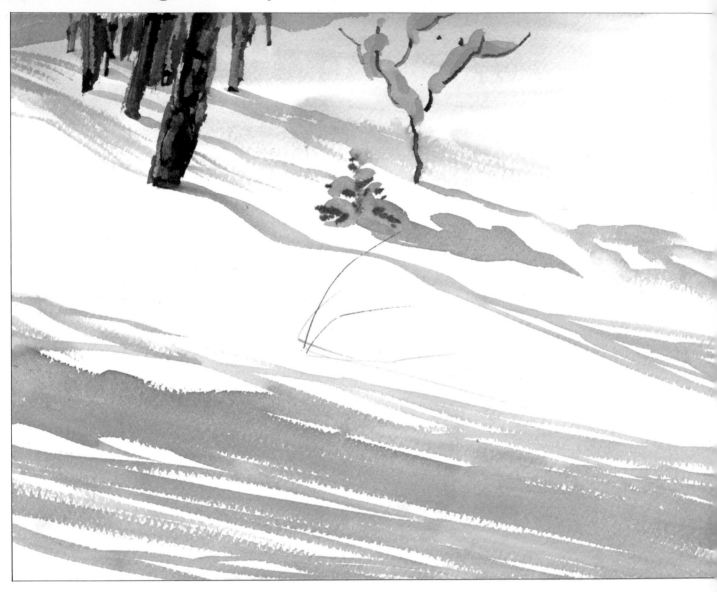

Bright, Sunlit Snow. (Above) On a bright and sunny day, the shadows are sharp and follow the curving surface of the snow. The color of the shadows—here the artist has added Antwerp blue to them—is bluer.

Shadows on Snow. (Right) The trees are blurred here, indicating a hazy sun. The cast shadows are a gray-blue mixed from burnt sienna and French ultramarine.

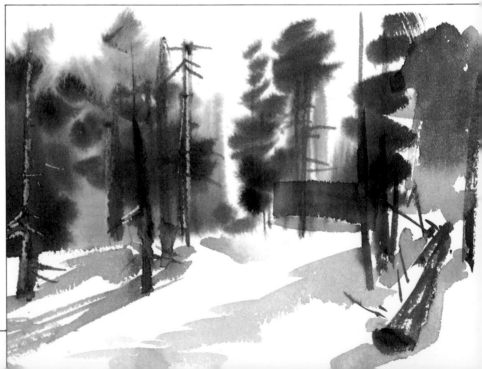

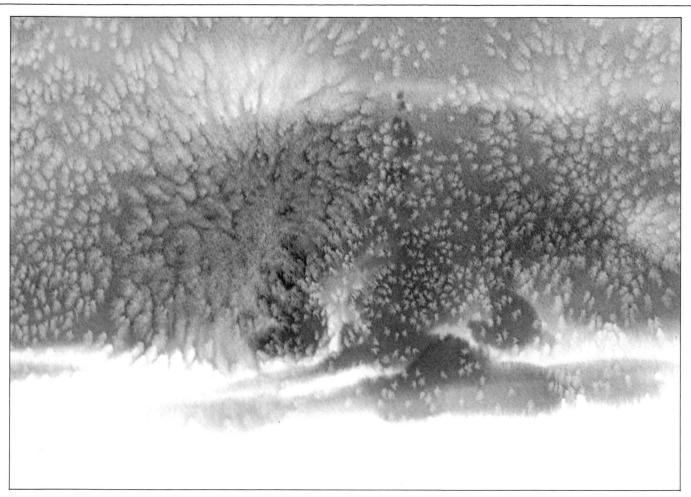

Blizzard. Sprinkling salt into a wet wash is an excellent method of creating the impression of falling snow. In this painting, the artist has used salt liberally to capture the feeling of a blizzard in which most of the elements of the landscape are obliterated by the heavy snowfall. First he painted the background wet-in-wet with Antwerp blue, burnt sienna, and French ultramarine. Then he sprinkled the salt into the wash while it was still wet and shiny.

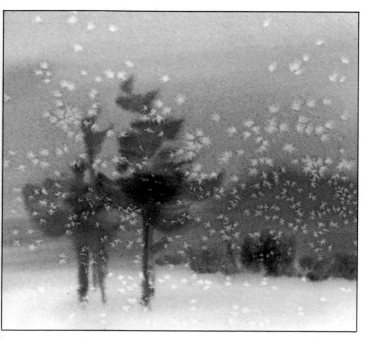

Lightly Falling Snow. In this painting Zoltan Szabo used French ultramarine and burnt sienna for the hill and added a little Antwerp blue to the misty pines with a wet-in-wet technique. He sprinkled salt into the wash a little before the wash had lost its shine.

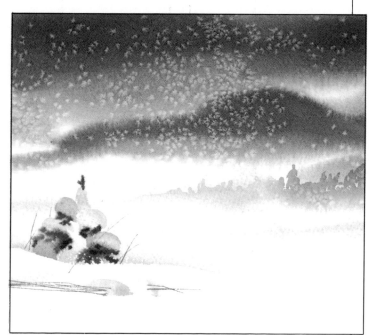

Falling Snow and Spruce Tree. When the artist applied salt to the wet-in-wet background of this painting, it was drier than the painting on the left, and the snowflakes are smaller because the salt didn't dissolve for as long a time. He painted the spruce and weed when the paper had dried.

Balancing Complex and Simple Areas in a Composition

Iron Gate, 6½″ × 8½″ (17 × 22 cm), by John Blockley

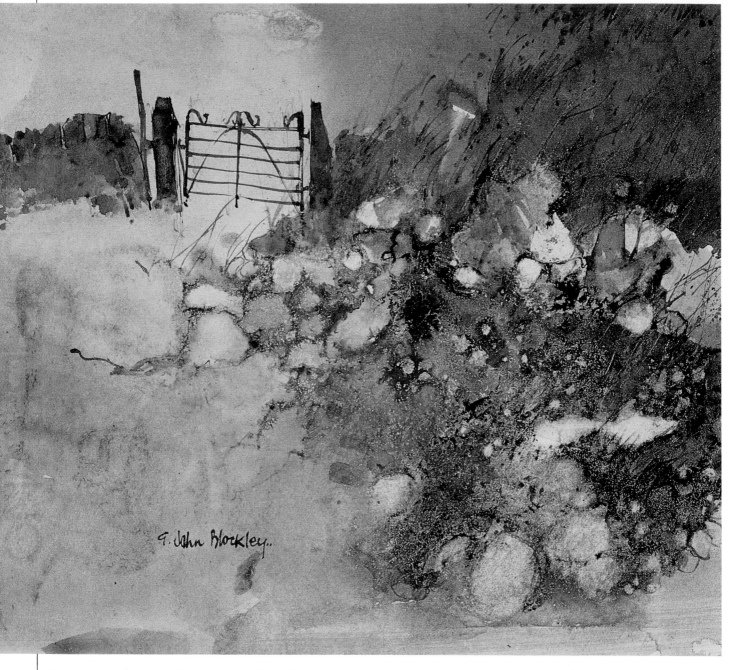

Asymmetrical Composition. The gate hung between two stone gateposts, and the ground fell away steeply on one side. To create a buildup of interest toward the gate, the artist placed it high on the paper and divided the large foreground into a quiet and an active area so they would balance each other and not take attention from the center of interest, the small gate at top. In the patterned foreground area on the right, he hinted at grass, lichen, and the coarse texture of the stone-reinforced bank. In contrast, he kept the area on the left smooth and bare, almost marbled in appearance—and he chose a hard, smooth-surfaced paper

to help achieve that texture. He drew the gate itself in a few simple lines with a fine brush and watercolor—sometimes he substitutes pen and ink—adding interesting details, such as the way the metal curled decoratively on top and the positions of the hinges and the latch, to make the painting convincing.

To paint a simple scene such as this, you must balance the single area of interest against the rest of the painting. To keep the larger areas from being dull, color or texture them in a subtle, yet appealing way.

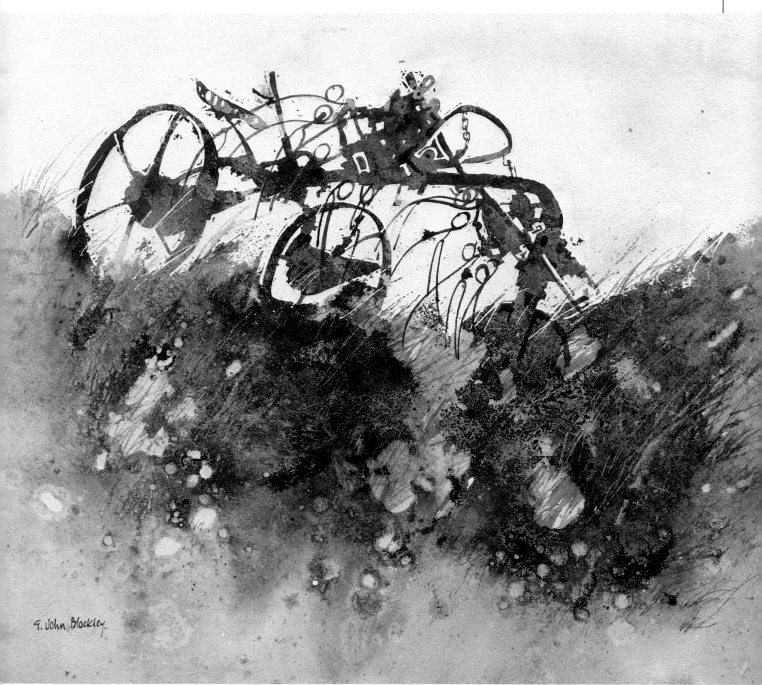

Masking Negative Shapes. John Blockley was immediately attracted to this old hay-raking machine, which reminded him of a pattern in relief—like a woodcut—with the surrounding negative space chiseled away to leave the image standing out against the stark sky. The rusty machine stood on an area of high ground, and so he lay down in the long grass to draw it, thereby emphasizing its interesting, strong silhouette against the clear sky. When he came to paint it, he decided to use a process that would give him that sharp-edged quality: first he masked out the surrounding negative spaces (the sky and background) with masking fluid, leaving white paper for the rake. Then he quickly painted the complicated lines of the machine, working the paint toward the outer edges of the masked areas by brushing many short strokes across the width of the machine (instead of the normal way of painting each line smoothly, with a long stroke). These uneven strokes, applied at right angles to the edge of the masking fluid, resulted in an edge that is subtly different in quality from one painted continuously. He also deliberately left bits of paper showing through when he masked the sky so that when he applied the paint to the machine, slivers of color caught in the sky area, evoking even more strongly the look of a hand-carved wood-block or linoleum print.

Mr. Blockley purposely kept the foreground soft by painting it wet-into-wet to serve as a foil to the hard edges of the machinery. He also blotted out soft spots in the foreground that repeated the movements and shapes of the sky patches and metal rings of the hay rake. He repeated the flowing motions of the prongs in the tall, waving grass to tie the painting together and emphasize the rhythmic feeling the rake evoked.

The method employed in this painting can be used to paint any simple object—a kitchen chair, for example. Just mask out the negative shapes in an interesting way, and then apply the paint as Mr. Blockley did here to see if you like the effect.

TEXTURES

This section is intended to help you discover how to develop a strong graphic style in your work by exploring the distinctive surface textures to be found everywhere: peeling paint, rusty metal, weathered roof tiles, twisted tree trunks and vegetation, reflections in water, ripe fruit in a rustic basket, frost patterns, and the evocative reflections on a transparent pane of glass. To paint them you need to use imagination and foresight, reasonably good drawing, and confident brushwork. Probably the most important of these assets is positive brushwork, and if you are having difficulty with it, you may want to review the exercises on pages 15–25.

Faded and Peeling Paint

1. To achieve the mottled effects of a well-worn wall, Richard Bolton gently rubbed clear candle wax over the paper. He showered fine drops of masking fluid from a brush and then, pressing the side of the brush against the paper, emphasized the prominent textures of the crumbling stonework.

Mr. Bolton briskly applied washes of Naples yellow and alizarin carmine over the wax above the door and then stippled the area with ultramarine blue and burnt sienna. After masking out the bars, he painted the window's interior with a vibrant black mixed from indigo and bright red. Then he removed the masking fluid and painted the bars by blending cobalt blue and cadmium orange on the paper. Beneath the window he loosely applied yellow ochre and raw umber, and then added cobalt blue to the wet wash.

2. Now to the major task of the door. The wood effect was rendered with cobalt blue, burnt sienna, and cadmium orange. Loosely brushing in the basic tone of the wood, Mr. Bolton left highlights of white paper showing through to add vibrancy to the grain. The rusty color at the base of the door was brushed in with burnt sienna, using an almost-dry brush in an upward movement so that the paint was applied in a speckled manner. As the upper part of the door was in shadow, the artist darkened the wash to reflect this. Here and there a razor blade was effective at picking out the grain of the wood in this dark area. After rubbing away the masking fluid, he painted in the iron bars of the door as he did the window, mixing blues and oranges. Firmer shapes were created by adding dark shadows after the bars were dry and also outlining with a dry, pointed brush the bolts that held the bars in place. The black interiors behind the bars were built up with indigo and bright red. Rubbing the masking fluid away beneath the door created an interesting strong texture.

3. When the masking fluid was removed from the stonework, lots of small highlights appeared. The artist overpainted some of them in other colors, and some he turned into holes in the wall by dabbing dark colors on top, leaving a rim of white highlights. Continuing like this, he added tones and colors until he felt he had caught the texture of the wall.

Until this stage the predominating colors were warm, and the artist felt that the lower sections needed a cool cobalt blue. The strong red horizontal worked well in contrast with the blue, and he paralleled this red along the bottom with a pale band of raw umber. To emphasize the dark shadows beneath the door, he touched the light area with bits of color and repeated the door colors on the front of the step. He also suggested a few cobblestones at the base but allowed the edges to fade off softly, in contrast with the sharpness of the rest of the picture.

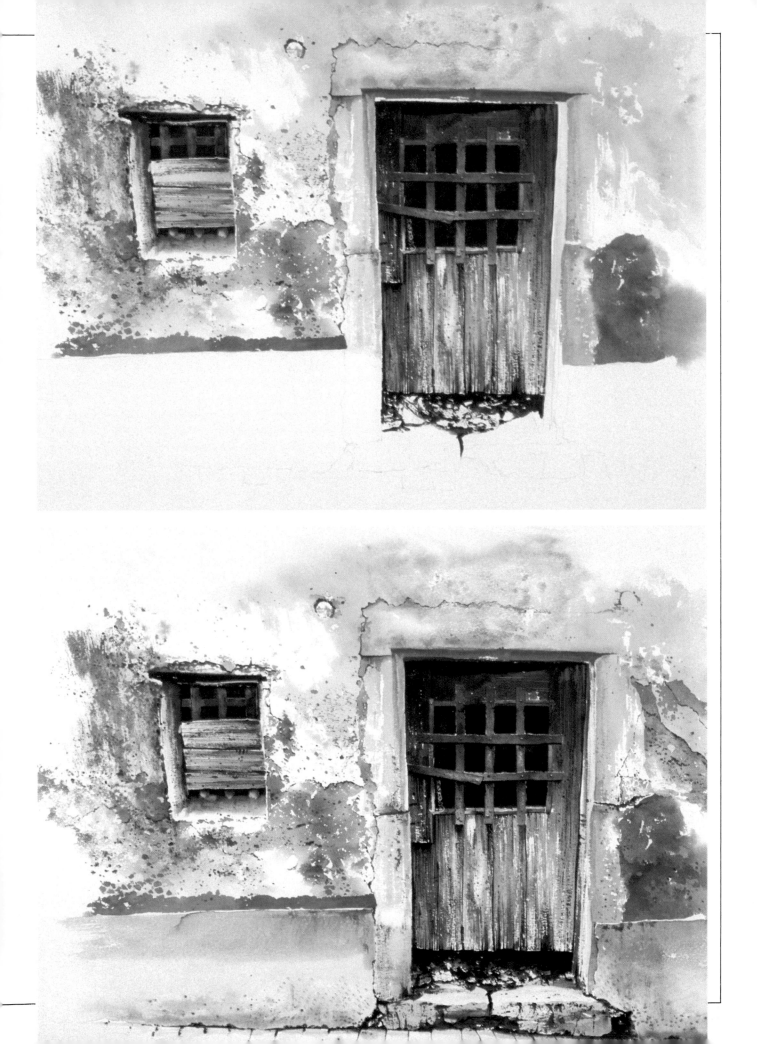

Irregular Wood Surfaces

The patchwork quality of this old shed originally attracted Richard Bolton to it. He decided to emphasize the strong horizontals and verticals created by the patched wood. A strong color contrast, created with drybrush technique, would give vitality to the form. The artist also wanted to create a feeling of the special texture present in the decaying wood with its wormholes, flaking paint, rust, and cracks. To anchor the right side of the shed, which otherwise might seem about to collapse off the page, he would use the pitchfork, bucket, and the surrounding weeds to balance and soften the rather stark composition.

Getting down to work, the artist first painted in light base coats to indicate the planks. Cobalt blue and cadmium orange were the colors used most frequently, although some of the timbers are almost a pure sap green. To keep the colors vivid and fresh, he changed the water often and used a paper towel to catch extra water that could dilute the color.

On the sap green timbers he used stripes of cobalt blue to suggest the grain. For the rest of the brushwork he used a strong mixture of burnt sienna and sap green. Dragging a dry brush along the direction of the grain, he left behind a speckled, broken paint surface where the paint had clung to the rough surface of the paper. As the shed was in strong light, he used a dark mixture of cadmium red and Prussian blue for the shadows. Occasionally, he used the hard, dry point of the brush to produce dots and other texture marks. While the paint was still wet, he scratched in some grain effects with the corner of a single-edged razor blade.

Before painting the bucket, whose soft colors echoed the shed's, and the pitchfork, which anchored the shed to the left, he used masking fluid to cover the area. Then he painted in the delicate blades of grass with quick, light strokes. Before removing the fluid from the bucket and the pitchfork, he masked in the bucket's handle. To a fairly wet blue-gray wash on the bucket, he let a weak mixture of burnt sienna and cadmium orange indicate the subtle effects of rust. The spade's handle is a mixture of Naples yellow, cobalt blue, and burnt sienna.

To capture the effect of rust acting on iron, Mr. Bolton used two techniques: first he dampened the surface with either clear water or a light wash of cobalt blue. While the surface was still wet, he dabbed it with a fine brush of burnt sienna, varying this with Indian red, cadmium orange, and even alizarin carmine in moderation. As these colors dispersed softly onto the paper, they stained the surface much as rust does.

Then, when the paper had dried, the artist scrubbed these same colors, with an almost dry brush, into the paper, working them around and scraping the brush downward to imitate the spreading effect of the rust. Smudging the paint with your fingertip is another way to make the rust appear to run. The iron ridges were indicated with quick drybrush strokes that left just enough paint on the paper to make the ridge obvious. Highlights were produced by rewetting small areas and dabbing the paint away with a paper towel.

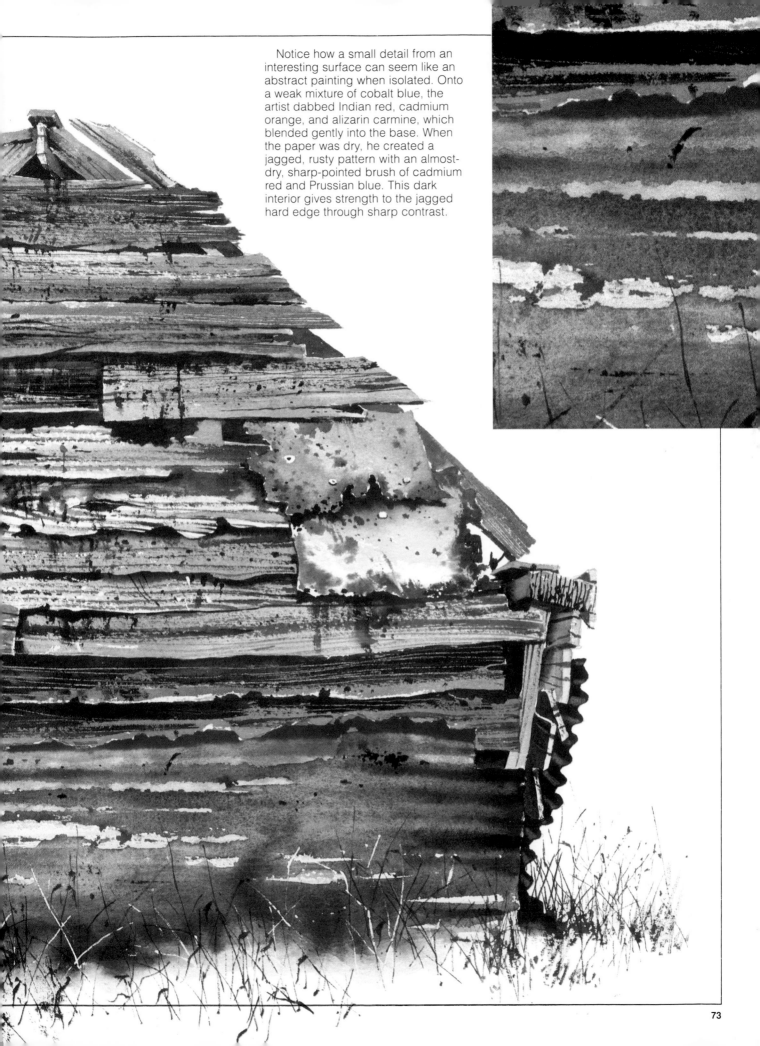

Notice how a small detail from an interesting surface can seem like an abstract painting when isolated. Onto a weak mixture of cobalt blue, the artist dabbed Indian red, cadmium orange, and alizarin carmine, which blended gently into the base. When the paper was dry, he created a jagged, rusty pattern with an almost-dry, sharp-pointed brush of cadmium red and Prussian blue. This dark interior gives strength to the jagged hard edge through sharp contrast.

Rust-Stained Surfaces and Weathered Tiles

Rust-Stained Wood. The charm of this study lies in the contrast between the casual, loose approach of the woodwork and the tightly controlled painting of the door latch and padlock. Any subject this carefully detailed needs to be drawn in first in pencil and then masked over. The artist completely masked out the handle, hook, latch, and padlock with masking fluid so that he could paint the wood freely without worrying about painting over the fine details. He wanted some feeling of texture in the wood, and so he first rubbed the paper with candle wax, which would cause it to resist paint in places and add to the overall surface interest. The paper must also have the correct surface to give the rough, granulated effect. Mr. Bolton used the reverse side of the paper because he didn't like the regular surface pattern on the right side. When using this technique yourself, don't put wax over the masking fluid or you'll not be able to remove it. Use your finger to remove the masking fluid, as an eraser or sponge will take the pencil lines with it.

Next Mr. Bolton added a loose, watery wash of cobalt blue, cadmium orange, and burnt sienna, which he briskly applied with a 1-inch (2.5-cm) flat sable, letting the half-waxed pigments streak and marble on their own. He let the brush run dry on the left, suggesting further woodwork. The right-hand hard edge was achieved by one quick stroke, insuring a straight line. He also wanted rust stains and flecks of granulation, which he picked out when the wash was dry. The brightness of cadmium orange gives a good rusty look, and alizarin carmine was used for the dark effects.

At the top of the latch plate is a patch of ultramarine blue. The artist blended it with burnt sienna at the sides and then worked it downward. Cadmium orange appears just below the top part of the handle, and alizarin carmine and ultramarine blue were added and blended farther down the plate. For the door handle, the artist used cobalt blue running into burnt sienna; the cobalt was continued down the arc of the handle until it faded again into burnt sienna. For the most precise details on the metal hardware, he again used burnt sienna and picked out the darktoned nail holes, knife marks, and random indentations with a quick brush stroke. As a final touch, he used the edge of a razor blade to scratch in highlights.

Richard Bolton really enjoyed fussing with the padlock, and that pleasure shows through. After drawing it in carefully at an interesting angle, using the suspending hook to push it away from the door, he applied masking fluid to keep it and the highlights that form the curving top clear of paint. To get the very dark color he wanted, he used two coats of ultramarine blue, burnt sienna, and alizarine carmine together. For the keyhole, he used cadmium orange with ultramarine blue near the top to give it shadow. The keyhole shape is an interesting contrast to the overall shape of the lock, especially as it is shown here, framed by the rectangular plate that surrounds it.

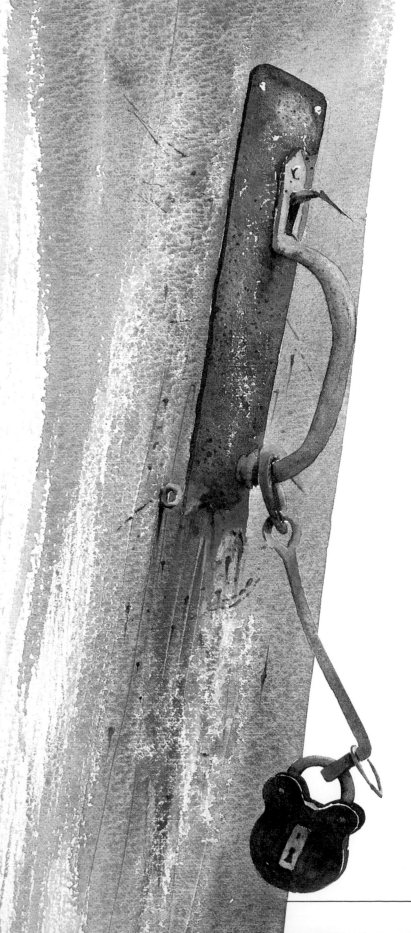

Weathered Clay Tiles and Corrugated Iron. Although this shed was very decrepit, the roof tiles had clung together admirably and so intrigued the artist that he spent more time painting them than any other part of the picture. (Don't equate the time spent with final results, however; often, laboring over an area will make it look dull and overworked.) The curving verticals and horizontals give a harmonious contrast to the flat elements below the roof. The way the tiles were set, one flowing beneath another, created a more complex pattern of curves than that of tiles merely placed side by side. Carefully examining the basic structure, rather than assuming what it looks like, will often reveal dynamic movement. Mr. Bolton emphasized the close interlocking of the tiles with thick bands of color, providing a stability that other elements of the shack do not have.

The tiles were all different colors— some were very yellow, others bright pink—and so it was necessary to treat them individually to capture this soft color scheme. The artist used practically every color on his palette to produce these colors, but the main ones were alizarin carmine for the rosy tiles; and cadmium orange, yellow ochre, and burnt sienna for the yellow tiles. Alizarin carmine, having a strong blue tone, creates a refreshingly cool red among the warmer yellows. For the bits of mold he used sap green and burnt sienna.

Texture was produced by adding a series of thin washes and then dabbing away the colors with a paper towel to get the overall even tone he wanted. The light was coming from the right, and so he used cobalt blue on the left side of many of the tiles to give them form. For the rougher textures he used a dry brush to create an interesting contrast to the smooth feeling the tiles convey.

Instead of ignoring the graffiti the artist incorporated it into the design, using the letters to give interest to the two flat sheets of iron and at the same time to unify them. He printed the letters with masking fluid, which he rubbed away once the surrounding area had been painted. The white of the characters emphasizes the subtle colors of the shed and contributes to the overall pattern of lights. The light tones of the rusty metal blend with the warm tones of the roof, creating a harmonious overall pattern.

Wood and Vegetation

Old sheds make interesting subjects for paintings, and the twisted willow struggling to grow in front of this one was an added attraction. The whole scene provided a rich variety of color and texture, from the dilapidated old shed to the shapely rounded cabbages of the foreground.

Richard Bolton worked from the back to the front of the picture: first he painted the trees behind the shed, then the shed itself, the willow tree, the grass, and last of all, the cabbages. Splitting the painting into sections like this enabled him to focus on one small area at a time. A light pencil drawing on the paper helped him to keep proportions stable as he worked.

The artist used a rich mixture of Prussian blue and burnt sienna to make the dark, hollow center of the willow tree; then he concentrated on the twisting trunk with the same colors laid over a wash underneath. He enhanced the texture of the bark by lifting out some lighter stripes with a tissue and by grazing the surface with a razor blade when it was dry.

Finally, some very thin dark lines went down the line of the trunk to emphasize the twist.

The rich colors of the middle ground were the result of blending washes of burnt sienna, cadmium orange, and alizarin carmine. The artist dabbed away excess water with a tissue, creating soft light patterns at the same time. To avoid hard edges forming while a wash area dries out, it may be necessary to rewet some areas to keep their outlines soft.

Very little masking out was needed. Mr. Bolton achieved the tracery of veins on the cabbages by careful brushwork instead of using masking fluid. Much of this work involved painting the shadows and dark areas underneath the leaves and then adding the ribs on the leaves to create their form. The ribbing in dark shadow at the top center was the negative shape left by a second wash laid into the first while it was still wet. The ribbing on the leaf in the front was made with the wrong end of a brush by dragging it through the almost-dry paint, leaving lighter stripes with dark edges.

Pale alizarin carmine was used to paint the area between the ribs on the heart of the largest cabbage, and by gently curving these washes around the front of the cabbage, the artist made it fat and full. He darkened the underside of the top of the leaf and left the top rim completely white.

Dried Weeds and Shadows Against Wood

1. The most inconspicuous subject can often produce a charming abstraction, like these weeds casting their shadows on some wooden boards. After the artist masked out the dried weeds, he painted the texture of the old wood, using a firm ¾-inch (2-cm) bristle brush richly loaded with very dark sepia. Because there was so much erratic texture in the worn finish of the wood, he was able to work very loosely, making the cracks as dark as possible—darker than they would look in the finished painting. The wood grain was painted with a split brush— that is, the artist pressed the damp hairs of the brush gently against the palm of his hand to separate them so they would make clusters of parallel lines when he moved the brush across the paper.

2. Mr. Szabo painted the natural color of the wood in dark tones, as if the entire surface were in shadow. This tone would later be wiped away to create the pattern of the shadows. When the color was lifted away, it would give the wood a much more convincing appearance of age than freshly painted color. This dark wash was a blend of raw sienna, burnt sienna, brown madder, and French ultramarine. The artist blended these colors on the paper with a 1-inch (2.5-cm) sable brush. After the paint had dried, he lifted off the Maskoid with sticky tape. The dark shadow wash softened the drybrush texture that had been applied in the first stage, and it was now less insistent. When the Maskoid came off, the hanging weeds formed a lively silhouette with lots of variety in the length and direction of the strokes.

3. Next Mr. Szabo painted the weeds with raw sienna, burnt sienna, and Antwerp blue. The pale, warm color overlapped the thin white shapes and soaked into the surrounding shadow. To give the weeds a three-dimensional appearance, he did a little modeling, introducing slightly darker values. The artist painted the strip of rusty metal at the top with brown madder, raw sienna, burnt sienna, and some French ultramarine. He overlapped drybrush strokes of different color mixtures to emphasize the crusty texture. The single rusty nail at the lower right was painted with the same colors. To produce this kind of ragged drybrush stroke, it's helpful to work with the side of the brush rather than the tip.

4. To finish the painting, the artist used a firm bristle brush and plenty of water to lift off *almost* all the shadow on the wood, working methodically around the slender shadows cast by the weeds. Because of the distance between the weeds and the wood, these shadows have soft edges. That is why the artist lifted away the darks *around* the shadows instead of painting those shadows on a light surface where they would have sharper edges. Beneath the upper weeds, he added some crisp shadow lines with dark color after the lift-out operation. Then he painted the dark cracks with pure sepia. The nails in the wall were painted with burnt sienna. To suggest the rusty drip marks beneath the nails, he wet the surface and brushed on raw sienna and brown madder.

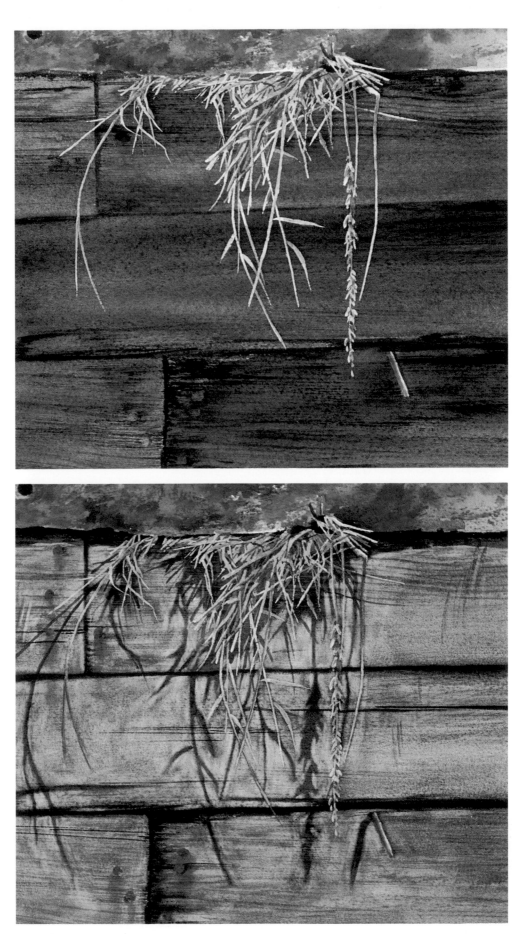

Windows and Interior Textures

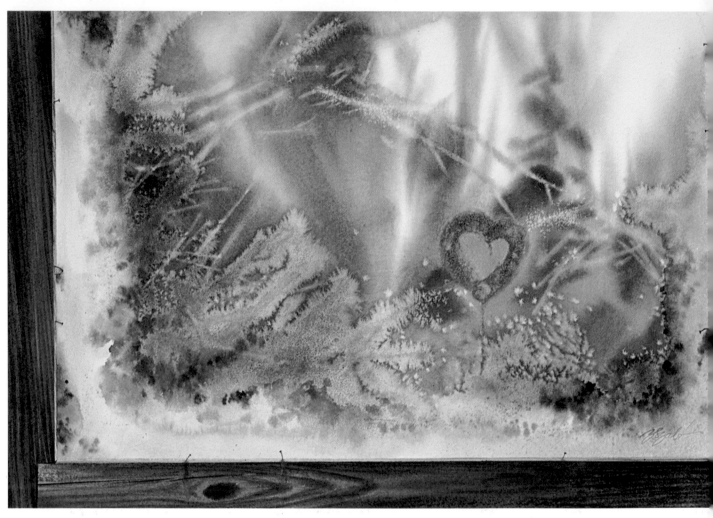

Valentine Card, 15″ × 22″ (38 × 56 cm), by Zoltan Szabo

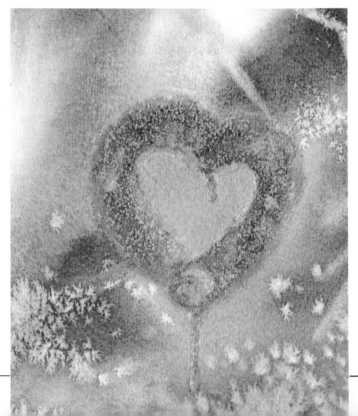

Frost Patterns on Glass. The artist began this painting by masking out the window frame with masking tape. Then he wet the whole area of the windowpane and painted in the distant, blurred forest with brown madder, burnt sienna, and Antwerp blue, leaving the area near the bottom and two sides a little lighter. As this wash was settling, he sprinkled on concentrated amounts of salt. After the salting, he added more color splatters of cerulean blue, burnt sienna, and Antwerp blue into the active salt texture. While this wash was drying, he removed the masking tape and finished the wood-grain design with a combination of drybrush and wet-and-blot techniques, using brown madder, raw sienna, and Antwerp blue. The carefully painted, almost formal wood grain creates a striking contrast with the frosted pane. Mr. Szabo concluded by adding a few bent, rusty nails and some rusty stains below them.

The abstract frost pattern is the result of splattering fresh color onto the salted wash before it dried. The cerulean blue and burnt sienna, which do not blend compatibly, separated in the wash as the artist had intended. When the paper was thoroughly dry, the artist painted the heart shape with cerulean blue, burnt sienna, and Antwerp blue, imitating the movement of a finger on frosted glass. He sprinkled salt into it while it was still wet, including the shape of the running droplet of water. When the salt dried, it made this shape resemble a refrozen surface. The next day Mr. Szabo scrubbed off the dry salt and exposed the finished texture.

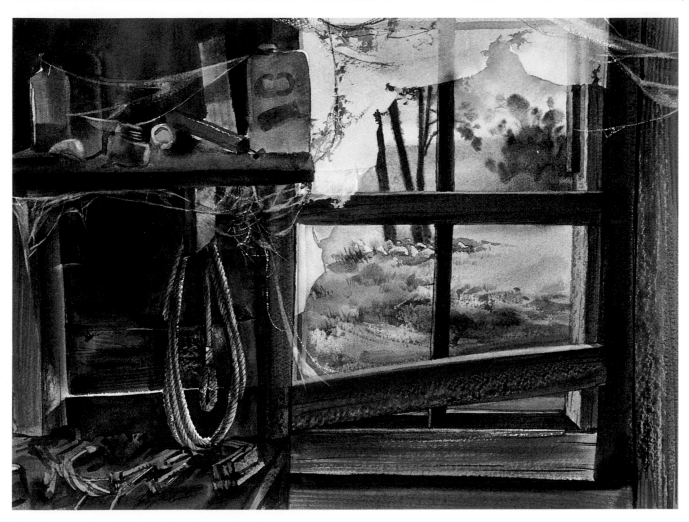

A Look at the Past, 15″ × 22″ (38 × 56 cm), by Zoltan Szabo

Textural Contrasts. Painting this extremely complex subject, which includes windows with a view of the outdoors, demanded simplification of the interior detail. The artist began with clean, light, wet-in-wet modeling of the outside scene. Then he sharply defined the edges of the torn plastic curtain and the area of the window frame except for the center bars, which he painted at the same time as the wall.

Next he painted the boards, the cluttered objects on the shelf, and the window frame, moving from one dry area to another to prevent the shapes from blending into each other while they were wet. So that the shelf objects wouldn't distract, he painted them in subdued, close-valued colors.

When the artist painted the dark values of the wooden wall, he left the shape of the dangling rope pure white, but he knifed out the metallic clutter on the lower left and gave it a quick glaze of burnt sienna afterward. He painted the loops of rope one at a time, using a light and a dark wash, and scratched the twisted lines into this wet wash with the sharp tip of his brush handle.

The soft modeling of the wood and the dangling rope offers a contrast in texture to the brittle, jagged, knifed-out metallic shapes below. The wood grain and the design of the rope are painted more carefully than the rest of the painting because they are important in the composition. The rusty shapes only hint at being objects, since greater definition there would be distracting.

Mr. Szabo glazed on the light color of the plastic curtain and painted a continuation of the window's center bars behind the plastic in a lighter value. He let the shape of the cobwebs unite separate forms, choosing a wet-and-blot technique to design their soft shapes and accenting them with razor-blade scratches when the paper had dried.

Transparent and Reflective Glass

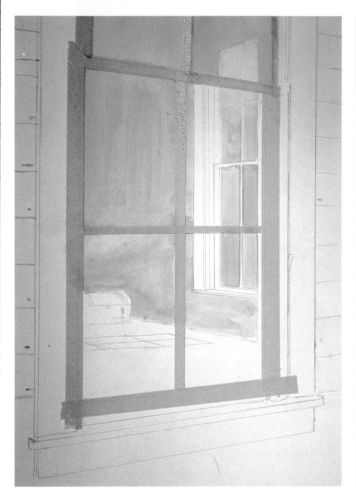

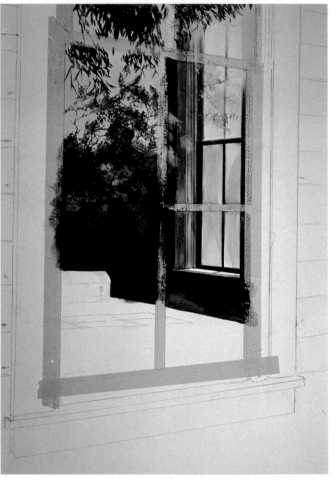

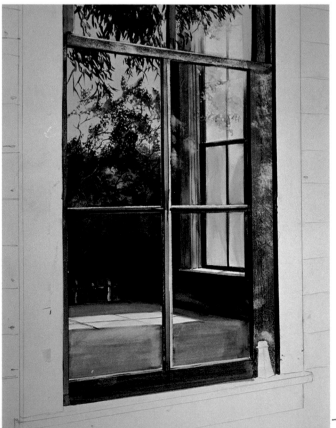

1. A room seen through a reflective window is a challenge to paint because two focal planes are involved: the front wall and window, and the interior of the room. Since the second plane is seen through the first, it must be rendered softly if the illusion of depth and mystery is to be effective. The artist chose Strathmore Hi Plate Illustration Board for this painting because its nonabsorbent hot-pressed surface would permit lifting out highlights to capture the brilliant, reflective quality of the glass. He began by making a preliminary drawing with an HB pencil. Then he applied masking tape to the window frame, cutting thinner strips of tape for the dividers between the panes of glass. Now he laid a light wash of diluted Winsor blue over most of the window area with a ¾-inch (2-cm) chisel-edged brush. He carefully painted around the rear window frame, since Winsor blue is a staining color and cannot be lifted out very well. Next he blocked in the rear windowpanes with a ¼-inch (.6-cm) chisel-edged brush, making them darker than the front panes with a mixture of Prussian blue and Davy's gray.

2. (Opposite page, top) Mr. Shook established the darkest darks in the painting by blocking in the shadows on the rear wall and by painting in the reflections of foliage on the front glass, again being careful not to paint over the rear window frame. He used a Kolinsky brush loaded with a mixture of Vandyke brown and Prussian blue for both procedures. He filled in the rear window using a ¼-inch chisel-edged brush loaded with Vandyke brown, burnt sienna, and Winsor blue. He added details with a Kolinsky brush loaded with Vandyke brown and Prussian blue.

3. (Opposite page, bottom) He removed the masking tape and blocked in the front window frame with a mixture of Davy's gray, burnt sienna, and Winsor blue. Then he used a Kolinsky brush to lift out highlights with clear water and add shadows with Vandyke brown and Prussian blue. He used his ¾-inch brush and a subtle wash of Vandyke brown and Prussian blue for the interior floor, being careful to paint around the sunlit area. He added the trunk with burnt sienna in a Kolinsky brush and incised details with the end of the handle.

The artist blocked in the exterior wall with Davy's gray in a ¾-inch chisel-edged brush and blotted it with a wet paper towel. To balance the color temperatures of the interior, he pulled a warm wash of burnt sienna across some of the boards and diluted Winsor blue over others. Then he blotted the wet pigment again to complete the illusion of weathered wood. Finally, he added detail and deep shadows to the far window and front wall. He added more shadows and further details, using Prussian blue and Vandyke brown in a ¼-inch chisel-edged brush. Then he flicked clear water onto the clapboard siding and quickly wiped the surface with a dry paper towel to lend it additional texture.

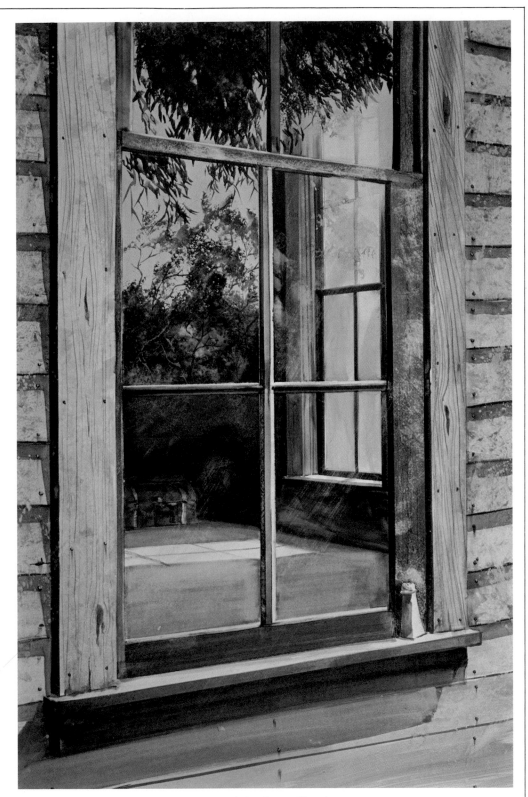

The Other Window, 20″ × 30″ (50 × 76 cm), by Georg Shook

4. The artist added the final touches, using a Kolinsky brush loaded with burnt sienna to detail the wood graining on the window frame and dabbing the same pointed brush along the siding to indicate nails. To get the shimmer of sunlight on glass, he lifted highlights from the window with the edge of a ¾-inch chisel-edged brush dipped in clear water and blotted the area dry. He used the same brush loaded with Prussian blue and Vandyke brown to further develop the shadows on the siding. Finally, he used a Kolinsky brush to strengthen the reflections of the front window with a mixture of Prussian blue and Vandyke brown.

Fruit and Baskets

1. After making some preliminary sketches of a rural fruit stand, the artist decided to paint it at close range with emphasis on a single bushel basket. He began by making a detailed drawing on hot-pressed illustration board with a 2B pencil. Then he painted in the background to establish the darkest value in the picture's tonal range. He loaded a ¾-inch (2-cm) chisel-edged brush with a mixture of Prussian blue and Vandyke brown and quickly blocked in the wall, picking up a small amount of burnt sienna now and then to add interest to an otherwise muted tone.

2. He used the same chisel-edged brush loaded with a mixture of yellow ochre and a smaller amount of burnt sienna to block in the two baskets. While the pigment was still wet, he blotted the area with a wet paper towel to establish the texture of wood.

3. Using a ¾-inch chisel-edged brush, the artist blocked in the wooden shelf with a mixture of raw umber and yellow ochre. Then he used the same brush, thoroughly cleaned, to add shadow and contour to both baskets with a wash of Winsor blue and burnt sienna. A pointed sable brush loaded with burnt sienna was used to add detailing to the shelf and both baskets, as well as to paint the bands around both baskets. He also painted the box on the right, using yellow ochre mixed with a small amount of burnt sienna in a ¾-inch chisel-edged brush.

4. Mr. Shook blended raw sienna and raw umber in a ¾-inch chisel-edged brush to paint the peanut bags and the sack behind the box. He blocked in the peanuts with the same colors and a pointed sable. To reduce emphasis on the apples in the rear basket, he painted them green instead of their actual red color. He blocked in their shapes with diluted cadmium yellow and then, picking up a small amount of olive green in the ¾-inch brush, began to form the apples by painting over the yellow. This rewet the color underneath and lifted some of it out, creating highlights of yellow against various blends of yellow and green. The brush strokes shaped and formed the apples as color mixing occurred on the surface of the paper. Then the artist accented details on both baskets and added shadows to the bag, peanut sacks, and box.

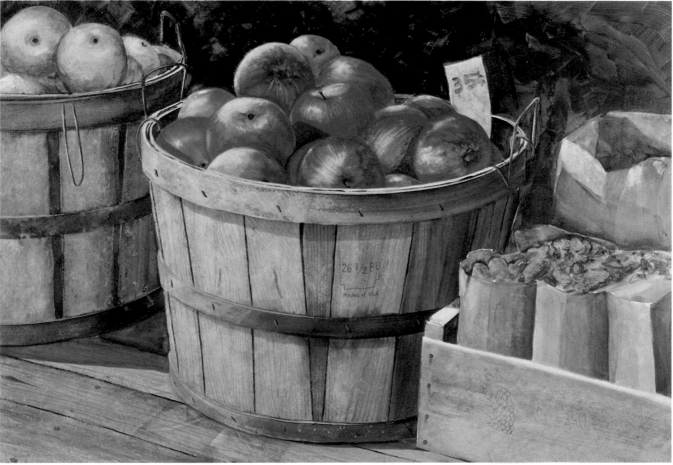

Bushel of Apples, 20″ × 30″ (50 × 76 cm), by Georg Shook

5. With fluid strokes of his chisel-edged brush, the artist blocked in the contours of the apples in the center basket with cadmium yellow. Then he intensified the shadows on the basket's rim and deepened the cracks in the shelf with a blend of Prussian blue and Vandyke brown in a pointed sable. He strengthened the contrast on the paper bags and sack by lifting highlights with the chisel-edged brush dipped in clear water and then blotting with a dry paper towel. He also lifted a bit of color from the green apples.

Returning to the center of interest, he began painting each apple cadmium red with a lightly loaded ¾-inch brush. As the brush picked up some of the underpainting, the yellow bled through the red. Occasionally, Mr. Shook pulled the brush across a damp paper towel to remove excess pigment so that each stroke not only laid down color but also modeled the apple with subtle gradations of tone. Finally, he used a mixture of Prussian blue, Vandyke brown, and olive green to detail the stems and ends of the apples, and then lettered in the price.

Machinery Reflected in Water

Traction engines are far too prized to be found in a setting like this now, though Richard Bolton can remember seeing the rusting hulks standing in the corners of a field when he was young. For this scene he relied on memory and a few photos he had taken before these engines were all auctioned off. Because this traction engine is a fairly complicated bit of machinery, he made a light pencil sketch on the paper before painting. Edges were blocked out with masking fluid before the smooth background wash was laid in. A thin dry brush was used for the detail and the shadows.

The dramatic reflections here are the result of frequent floods in the flat country-side where Mr. Bolton has found much good painting material. Usually the floodwaters are quite still and reflect images like a mirror. To paint reflections with any sense of reality, you must understand what reflections are. This is not as simple as it might appear. Areas of reflection here are cut out by the grass banks, and totally new views are given of the objects being painted, as shown by the view of the underside of the engine. While all of this may sound obvious, getting it down on paper can be quite a task. The artist achieved this effect by turning the painting around continually and looking at it upside down, which helped him to see errors in the perception before they got out of hand.

When painting such a bold subject, it's very easy to allow the picture to become heavy, especially in the treatment of the traction engine. And so here, Mr. Bolton paid particular attention to keeping the colors light and subtle, using darker colors only where they were really needed, as in the foreground grass and the shadows on the traction engine. Textures are an important consideration in this painting: the dark grass has been scraped repeatedly with the corner of a razor blade; and rust patches on the engine have been painted in with burnt sienna, as have patches of dirt on the wheels. Images mirror one another in interesting ways; the artist has allowed the tree trunk on the right to reflect the image of the engine's stack, much as the water itself does below.

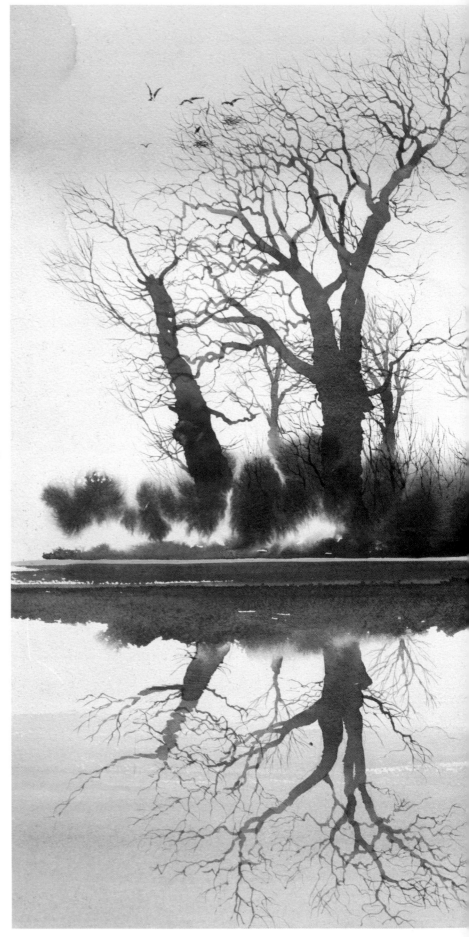

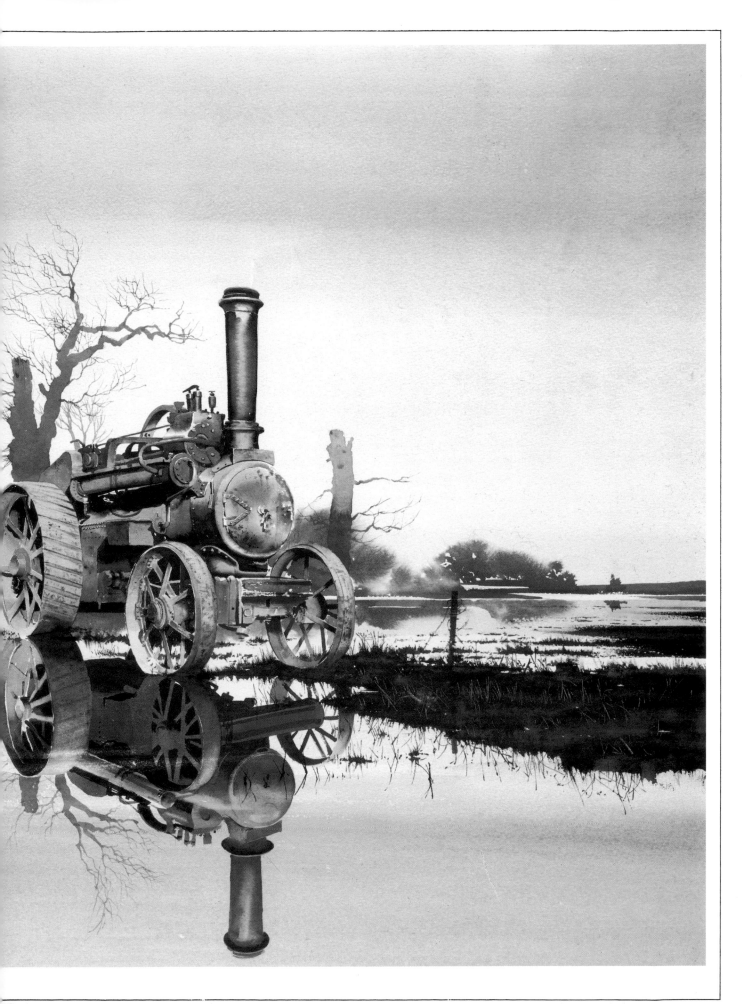

Beached Boat Hulls, Flotsam, and Jetsam

Richard Bolton likes to paint subjects like this fishing boat in drydock. The scene is packed with interesting textures, such as the rust breaking through the paint on the hull, bits of old rusty metal, driftwood, and pebbles, which all add to the feeling of long use and heavy wear from the rough seas.

Dominating the painting is the hull of *RX 35*, with particular attention being given to the wooden side, with its rust patches and other surface weathering. The boat is kept from being overpowering because of the many supports, lines, and deck gear that break the expanse and relate it to its surroundings.

The hull is pock-marked, stained, and weather-beaten. Its deep red coloring was mixed from an uneven mixture of Indian red, bright red, and cobalt blue. Underneath the hull, the shadow is a mixture of ultramarine blue and indigo. The artist felt this area was not dark enough, and so he painted some black ink into the wet

mixture. While all this was still damp, he painted in the colors of the sand, which mixed with the paint from the hull's underside, blending together in a natural shadowy way rather than a hard line. When the hull was dry, he smudged in some burnt sienna, using drybrush to streak the paint downward to create a vivid rust caused by exposure to salt water. The dark horizontal lines running along the side of the ship are inconsistent strokes of a dark mixture of the base color. The light, broken-textured streaks that give the hull shape were put in *lightly* with a razor blade dragged along on its side. ——

This mass of foliage is a rich combination of ultramarine blue, indigo, and black ink, but the color is really quite unimportant compared to the overall texture of the leaves. The artist built up this tree by developing a group of dabbed-in brush marks. Try this for yourself and aim to achieve interest by varying the shape and size of each mark, and varying the density of marks in each group. ————

The artist laid a very fine wash of Naples yellow along the top edge of the hull and the *RX 35*. Before painting the boat red, he masked out the letters and numbers on the bow, taking care not to draw them too accurately or with great typographic precision. When the red hull was dry, he removed the masking fluid from the letters, dirtied them up a bit with some scratchy rust-colored paint, and then used Prussian blue to paint in the dark background behind the *RX 35*, to give a weather-beaten look. ————

RX 35

CLOSE-UPS IN NATURE

Too many watercolorists pass by countless numbers of small, magical subjects that are hidden in the quiet corners of nature—the delicate tracery of weeds and grasses, the shapes and colors of wildflowers nestled among rocks, the pattern of the cracks in a tree stump or a boulder. These intimate glimpses of natural beauty can have extraordinary poetry, and they provide a whole new range of subject matter for the watercolorist to explore.

In these pages you will find a variety of techniques for painting nature's details at close range—including how to reorganize, simplify, and dramatize them in your paintings.

Wild Mushrooms

1. The artist began this painting by establishing the mushrooms with new gamboge, burnt sienna, and brown madder. Then he added a few bright touches of complementary color to suggest some small leaves and weeds; these were mixtures of cerulean blue, French ultramarine, and new gamboge. He also spattered some of these cool mixtures on the bare paper and then used a ragged drybrush stroke to suggest the texture of moss.

2. The mushrooms were masked out with carefully cut pieces of tape, and the artist protected the few leaves with liquid latex. Now he could work very freely, painting an abstract texture over the background. He worked on the dry surface of the paper with a large, soft brush, allowing wet areas to run together, but he also tried to keep some sharp lights and darks. He spattered lively warm and cool colors over the surface to suggest clutter on the forest floor.

3. Before removing the liquid latex and tape, Mr. Szabo finished the entire background. He glazed dark but luminous washes over the forest floor and connected some of the abstract linear shapes to suggest branchlike forms. He used his palette-knife blade to paint a lot of dark twigs. When all this was dry, he removed the protective mask. He studied the value contrasts and strengthened some of the darks.

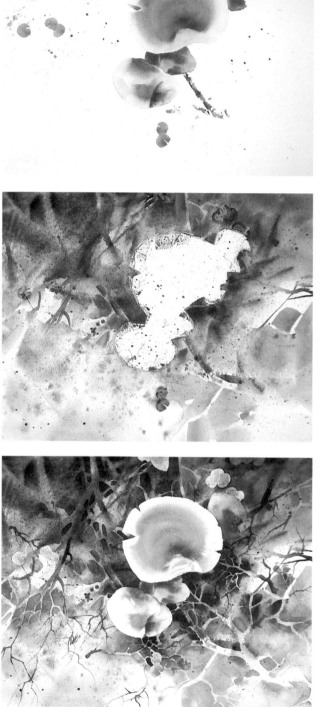

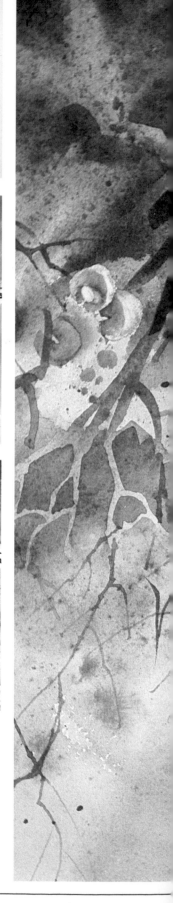

4. The artist wanted more color on the mushrooms, and so he glazed one more coat of new gamboge and brown madder over their shapes and then wiped off the highlights with a bristle brush. Finally he lifted out the droplets of water and modeled their shapes with a few darker touches. The final painting owes a great deal to the contrast between the simple shapes of the mushrooms and the complex, wiry pattern of the shadowy forest floor.

Forest Cocktail, 14½″ × 22″ (37 × 56 cm), by Zoltan Szabo

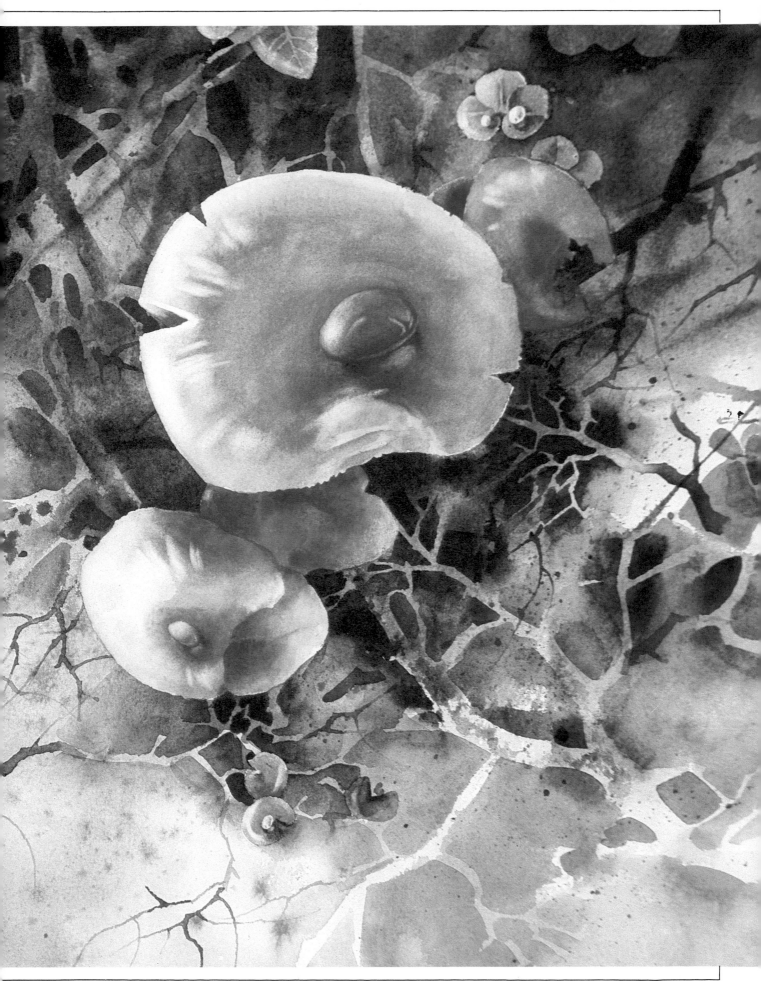

Wildflowers Among Rocks

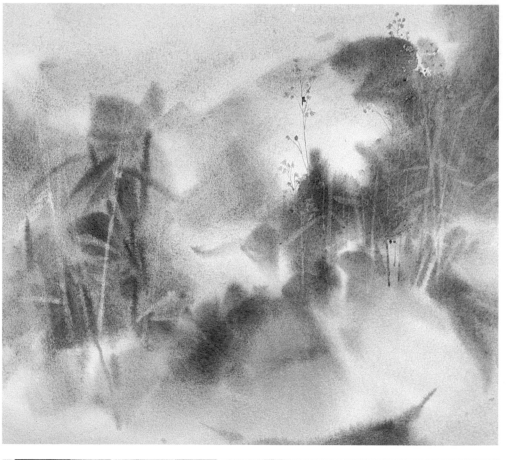

1. The best method for painting background washes around tiny, complex flowers is masking them out first. Zoltan Szabo began by applying liquid latex with the tip of his palette knife and moving the edge of the blade along the paper to indicate the thin stems. Then, after wetting the paper, he painted the large shapes with mixtures of cerulean blue, new gamboge, burnt sienna, and a little Winsor blue. Cerulean blue dominated the foliage, while the rocks were mainly new gamboge and burnt sienna. When the washes started to lose their shine, the artist painted the light weeds and their leaves with clear water, moving his brush upward from the rocks. These vertical strokes formed a bridge between the upper and lower parts of the picture.

2. Mr. Szabo painted in the large, overhanging leaves next. These would be an important design element because they would emphasize the tiny scale of the flowers. (The liquid latex still covered the flowers at this stage.) He introduced a few dark weeds and then created some paler weeds at the left with negative painting. With spattered paint and a few touches of drybrush, he suggested moss on the rocks. Some more spatters and small drybrush strokes were placed in the foreground, where they would become pebbles later. Just a few dark touches sharpened the edges of the foreground rocks, along with a pool of darkness for the deep crack underneath the main rock.

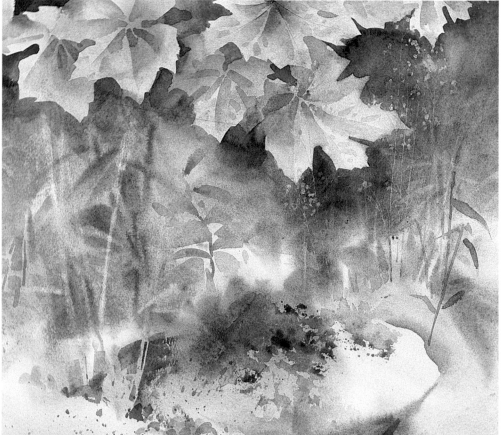

3. Before removing the mask from the tiny flowers, the artist built up the background darks around the leaves and added more dark strokes for weeds beneath the leaves. Very dark weeds overlapping lighter ones increased the illusion of depth. Before going further, the artist removed the mask. The white lace of the fragile flowers was exposed, and he could judge the values more accurately. To strengthen the contrasts at the center of interest, he built up more darks around and between the little flowers. The only notes of pure white against the darks and middle tones of the weedy background, the tiny flowers command attention as if in a spotlight.

4. The faintest touches of cerulean blue were used to hint at shadow planes on the blossoms. The stems were glazed with a very pale wash of new gamboge. As the brush, loaded with new gamboge, touched the bluish background, some of the yellow stems turned toward green. Then the artist built up the final texture on the rocks, adding sepia to Winsor blue for the strongest darks. The mossy texture on the boulders was the result of lots of small, very loose drybrush strokes. With the tip of the brush, he added cracks to the rocks. The final touches were a few more weeds peeking through the ground and the cracks in the rocks.

The Sheltered Ones, 15″ × 22″ (38 × 56 cm), by Zoltan Szabo

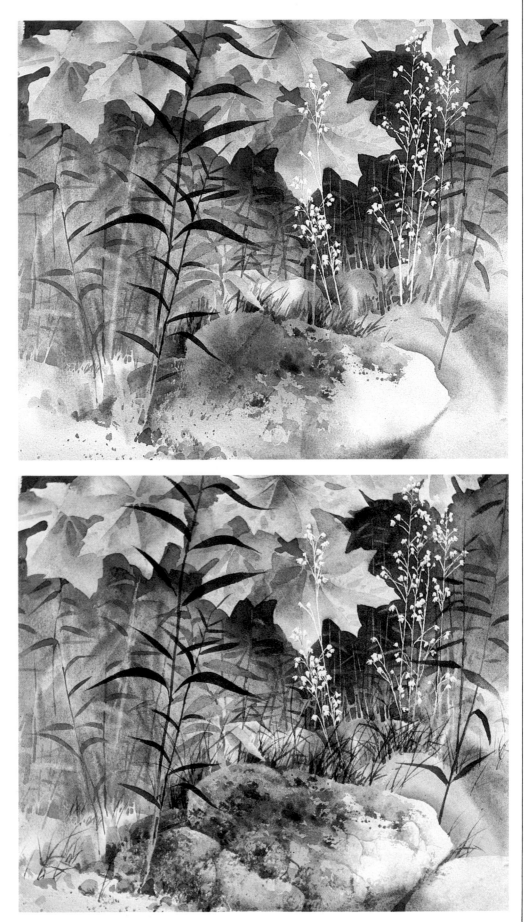

Cobweb and Weeds

1. Wetting the paper with pure water, the artist brushed on a bright, rich wash of new gamboge mixed with brown madder, to establish the sunlit area. For the darker, cooler background, he brushed on various mixtures of these two colors, plus burnt sienna, manganese blue, Winsor blue, and French ultramarine. These colors would serve as his full palette for this painting. He applied these washes rapidly, while the paper was still wet, with a 2-inch (5-cm) soft nylon brush. The brush contained only enough water to dissolve the pigment, since the wet paper contributed all the extra water needed for blending. The artist maintained a soft but distinct line where the cool, shadowy background ends and the sunlit foreground begins.

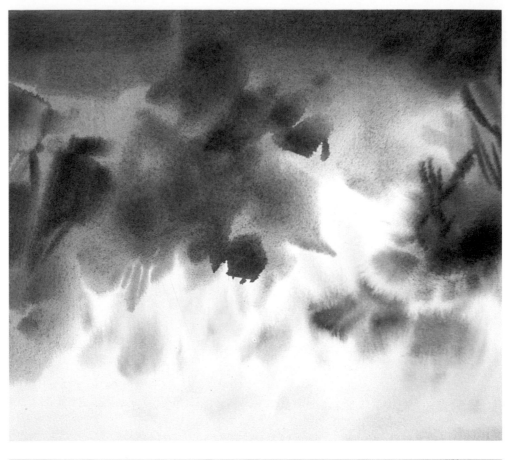

2. When the first stage was bone dry, he used paper stencils to lift off the color for a few leaves. (This is particularly obvious where pale leaf shapes appear in the dark background.) He also began to define the edge of the cobweb with carefully placed darks. And he began to glaze the leaf shapes with transparent colors, both warm and cool. Where the design demanded them, he retained sharp edges on the forms, but he "lost" the other sides of the forms with soft, wet transitions. Observe this in many of the leaves, which may be hard-edged at one end but melt away softly at the other.

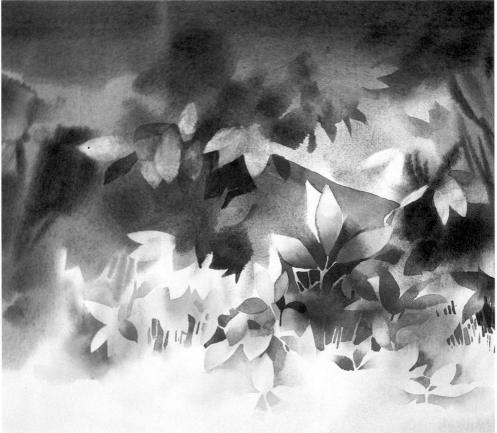

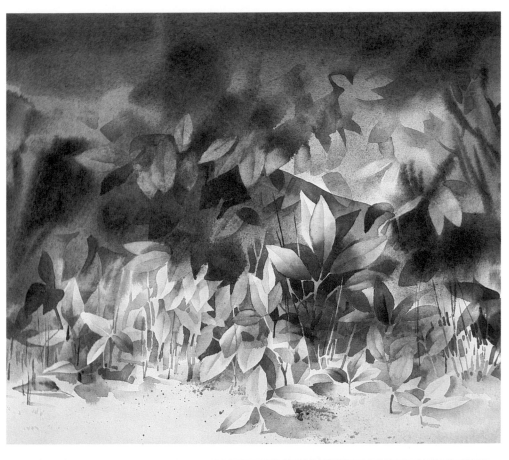

3. Mr. Szabo continued to develop the weeds in the sunny foreground, isolating and defining the pale shapes with small, dark touches. He built up the colors of the leaves with bright, transparent glazes. At this stage, he was also working on the details within the leafy forms, as well as the patches of shadow cast by one leaf upon another. Just a little more detail was added to the blurred background, but not enough to take attention away from the foreground.

4. Now the artist regained some contrast by adding more darks, particularly in the background. Then he carefully wet and blotted out the shape of the cobweb. When this area was dry, he painted the breaks in the web with dark touches, suggesting background shapes peeking through. The thin threads were executed by first painting darks right up to them and then scraping out a few crisp lines with the corner of a razor blade. Notice that he didn't reduce the web to pure white but allowed some of the underlying color to remain, giving the impression that you can see the shadowy background through the web.

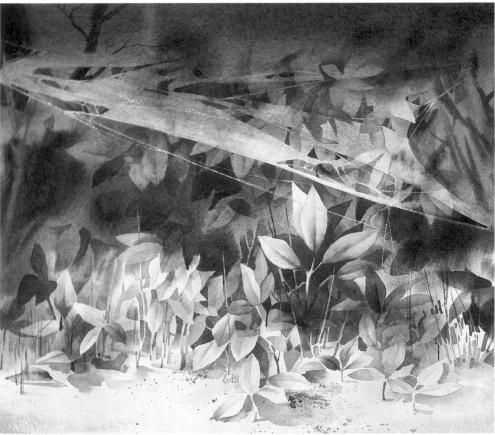

Housing Shortage, 14½″ × 22″ (37 × 56 cm), by Zoltan Szabo

Spiderweb

1. A spiderweb is one of nature's most amazing abstractions. In this painting, the artist's strategy was to begin by painting the background, the tree trunk, and the leaves that would frame the web. Working on wet paper, he brushed in the cool color of the leaves in the foreground with cerulean blue, new gamboge, and French ultramarine. The dark background was painted with Winsor blue, alizarin crimson, and some burnt sienna while the paper was still wet, and a much paler version of this same mixture was used to suggest the trunk at the left. As the foreground washes began to dry, the artist painted the last few background darks at the edge of the leaves, where the shapes are more distinct. The key to working on wet paper, as Mr. Szabo did here, is keeping an eye on the drying time.

2. Working with medium values, the artist painted the clusters of foliage with French ultramarine and new gamboge. Where the strokes overlapped, edges blended softly to hold all the details together and add an element of unity to the shrubs. He didn't try to paint individual leaves; instead, he let the natural shapes of the strokes suggest the leaves. He also allowed lots of sunny gaps between the darker strokes to suggest light coming through the leaves. And he resisted the temptation to add more than a few twigs.

3. Behind the sunlit foliage in the foreground, the artist built up the dark branches and shrubs in shadow with Winsor blue, alizarin crimson, and burnt sienna. He kept these shapes a simple silhouette, placing touches of this mixture in the gaps between the foreground foliage, so that the dark shape wouldn't be isolated in the background. At the center of the painting, a twig slants upward into the sunlight. He defined its shape with negative painting, placing darks around the bright silhouette in a lively, unpredictable pattern. He silhouetted a few dark, bare branches against the sky but resisted the temptation to add too many, for fear of distracting the viewer. He also didn't want these dark branches to conflict with the spiderweb, which would come next.

4. When the sheet was bone dry, the artist used the sharp tip of a new razor blade to scratch out the white lines of the web with firm, rapid movements. He didn't dig deeply into the paper but pressed just hard enough to make scratches that could be seen from a distance. As the blade moved over the textured watercolor paper, the rough surface broke up the scratches.

With a small, wet bristle brush, the artist lifted out the tiny leaf caught in the web, let it dry, and painted it with a bright mixture of new gamboge and alizarin crimson. The center of the web was now silhouetted against the darkest area of the distant leaves. The filaments of the web are not mechanically smooth; instead, they have a ragged look that suggests the flickering light of the forest, or perhaps droplets of moisture.

Homebody, 11″ × 14½″ (28 × 37 cm), by Zoltan Szabo

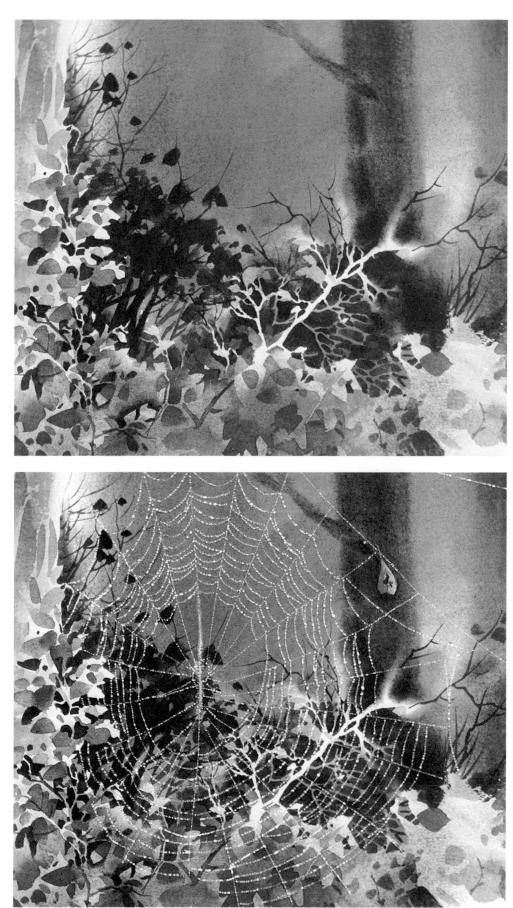

Frosty Evergreens

1. Frost produces startling patterns on evergreen branches. On a sheet of wet paper, the artist quickly painted a series of cool shapes with a soft 2-inch (5-cm) brush. His colors were cerulean blue, Antwerp blue, and touches of raw sienna and burnt sienna. Before the shine of the wet paint disappeared, he spattered the picture with a little clear water and salt at the same time. As this wash dried, a characteristic texture emerged: tiny, starlike shapes. (For maximum contrast, you must have dark paint behind these shapes.) The dark strokes held their forms on the wet paper because his brush contained rich color without too much water, and he did very little blending.

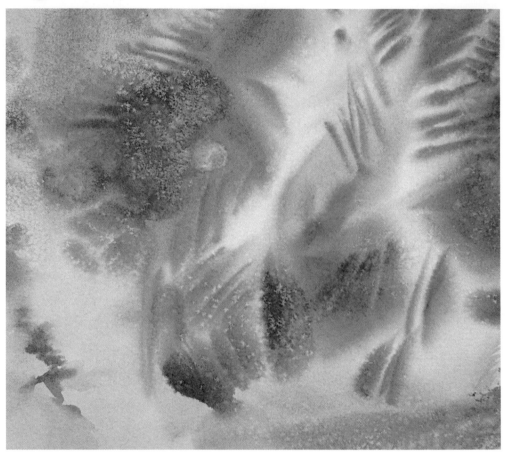

2. When the first stage was dry, he added a little new gamboge and deepened the value of the original mixture. Now he painted in stronger, darker shapes with lost and found edges. Each time he arrived at a shape that he liked, he sprinkled salt into it for that frosty texture. Although the painting still looked very abstract, he remained constantly aware of the need to balance lights and darks, as well as positive and negative shapes. Each time he darkened a value, the adjacent white area looked brighter.

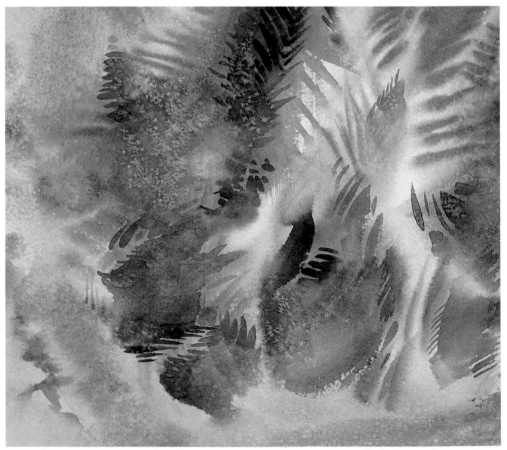

3. At this point, the artist began to link up the negative shapes to unify the painting. Wherever the shapes were dark enough, he used a well-worn short-haired no. 4 bristle brush with a good edge to scrub off the frosty white fernlike shapes. He blotted away the wet color with a tissue. More of these small fernlike shapes appeared as he added dark strokes. Now, for the first time, there was enough realistic detail to suggest the branches and foliage of the evergreens.

4. The artist strengthened the darks (particularly the shadowy hollow beneath the center) with mixtures that were mainly sepia and cerulean blue. Still more darks appeared along the lower edge. As he placed these touches on the paper, he sprinkled more salt on them. Now the dark foreground gave a more solid base to the painting and led the eye into the landscape, not just around it.

Although this watercolor was based on something Mr. Szabo actually saw, he felt free to improvise, letting the shapes take over and allowing the brush strokes to suggest ideas and rhythms. He redesigned pictorial elements to produce a satisfying abstraction. The frosty shapes were produced with various techniques. Many of the pale, spiky strokes were lifted out by a small bristle brush that never got down to the bare paper but always left a delicate stain of color. Throwing salt crystals onto the wet painting surface created frosty flecks. When you scatter salt, you've got to decide just how hard to throw it and how far your hand should be from the painting. Do you want to concentrate those crystals or spread them around?

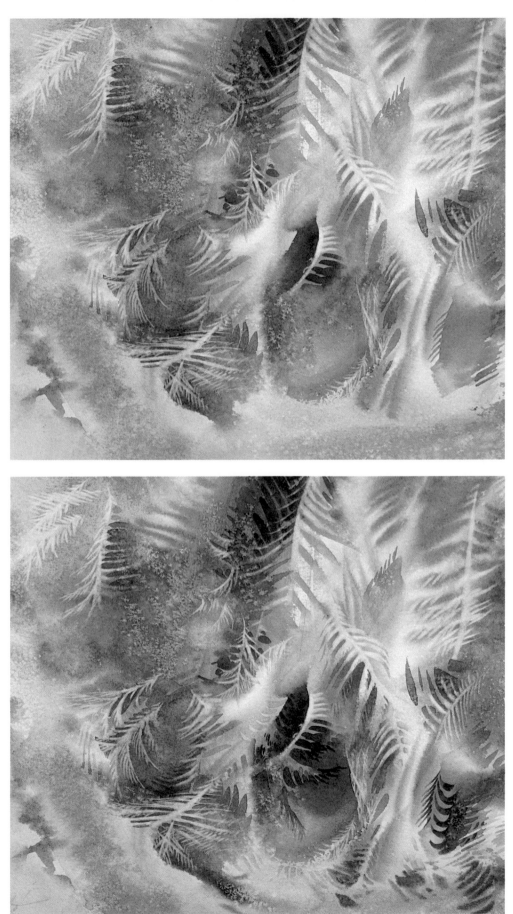

Winter Sorcery, 11″ × 14½″ (28 × 37 cm), by Zoltan Szabo

Fallen Leaves

1. The artist started this painting with the colorful focal point, concentrating on the leaves at this early stage because he wanted to get their shapes, placement, sizes, and relationships exactly right. He also knew that his colors would be cleanest if he worked on pure white paper, before any other colors were applied. The leaves were painted with the simplest watercolor technique: a series of clear, transparent washes, gradually building up color from light to dark.

2. To protect the bright leaves from further brushwork, Mr. Szabo covered them with Maskoid. That's why they look so dark here. Now he could work freely, brushing in the weeds with various mixtures of Antwerp blue, raw sienna, and French ultramarine. The drybrushed clumps were done with a flat 1-inch (2.5-cm) bristle brush. Notice the negative painting in the foreground, where he painted the darks around the bright shapes of the weeds. Bare paper at either side suggests the fact that the ground is covered with snow.

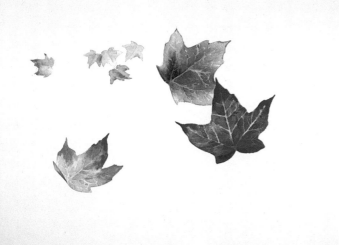

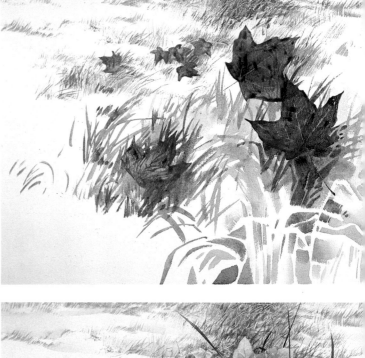

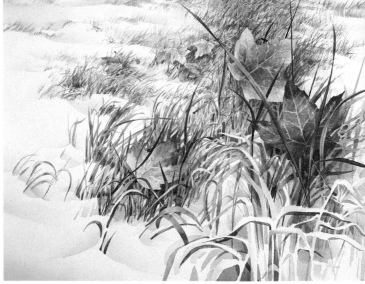

3. Mr. Szabo continued to develop the detail of the weeds by adding more dark strokes, particularly around the bigger, brighter leaves in the foreground. These strokes indicate the shadowy undersides of the graceful, snow-covered weeds at the very bottom of the painting. Now he stripped off the liquid latex because he wanted to be sure that he could judge the values of the leaves and weeds more accurately. From this point on, he would have to be more careful as he worked around the leaves.

4. He established the final value relationships, adding dark touches throughout the weeds for more contrast with the leaves. He carried dark strokes over the leaves to suggest additional weeds. He also carried the dark patch at the top of the picture down to the edge of the topmost leaf to emphasize the light silhouette. In the previous two stages, he had been working on the subtle modeling of the snow surrounding the weeds and leaves, so that the negative spaces of the bare paper would be converted into snowdrifts with hints of shadow.

3
Notice how the artist has left plenty of blank paper at either side of the center of interest. —

1
The dark details of the weeds are carefully woven around, and sometimes across, the leaves in order to frame the warm, bright colors. The artist planned each stroke before he touched the paper, so that all the strokes would have a gentle, rhythmic feeling. —

2
Within the darks and middle tones of the weeds, the artist has left lots of bare paper for negative shapes that suggest snow lying on top of the blades, as well as on the ground beyond. It's important not to overdo this kind of detail, and so he concentrated all this intricate brushwork at the center of the picture, merely suggesting the distant weeds with drybrush touches and a bit of scraping. —

Grasses

Autumn Grass. (Right) The artist started painting the grass wet-in-wet, his brush strokes getting sharper as the paint dried. He knifed out some thin, light stems and glazed on a few darker, well-formed blades of grass in the foreground. His colors were yellow ochre, raw sienna, burnt sienna, Antwerp blue, and sepia.

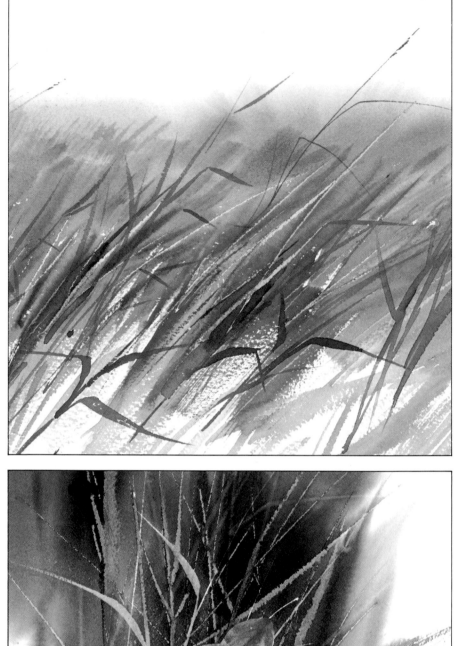

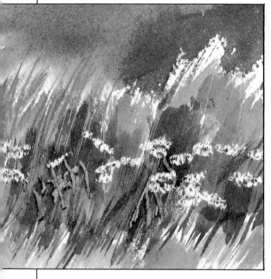

Summer Grass and Daisies. (Above) The artist used paraffin wax to mask out the shapes of the daisies around a few orange dots that later formed their centers. His drybrush glazes of Antwerp blue, raw sienna, and burnt sienna just slipped over the waxed white spots. Finally, he knifed out a few light flower stems from the dark grass.

Dried Leaves and Grass. Zoltan Szabo used Miskit to mask out the fallen leaf and a few sharper blades of grass, and he wet-painted the background with burnt sienna, Antwerp blue, and French ultramarine. He knifed out some of the weed shapes. After the surface had dried, he removed the latex and painted a sketchy indication of the leaves and grass with yellow ochre, burnt sienna, and Antwerp blue.

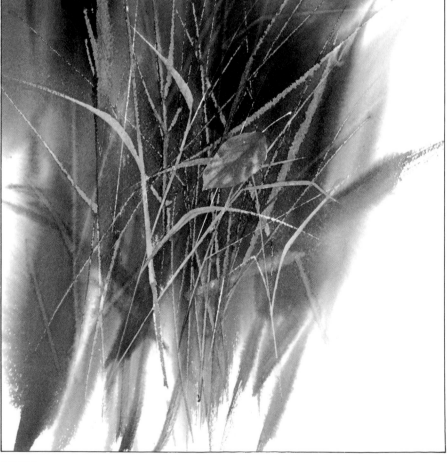

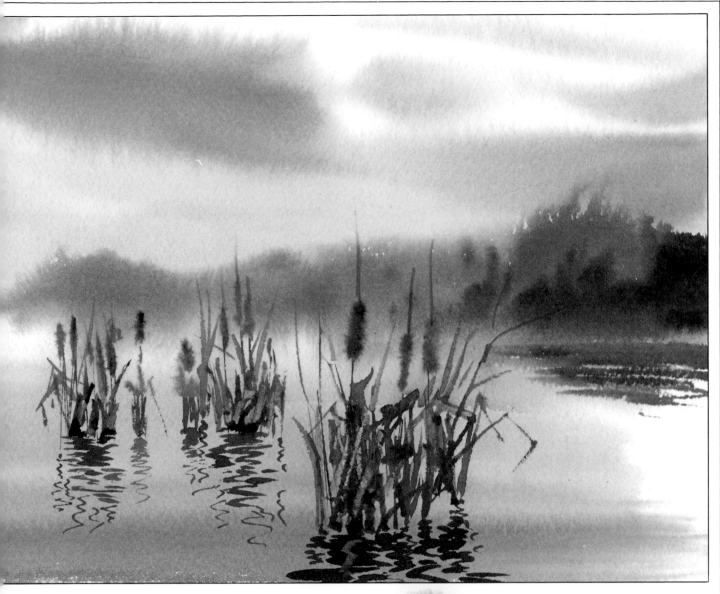

Swamp. (Above) In the swamp scene, he painted the clusters of cattails into a wet background, adding the stems and leaves along with the reflections after the surface dried.

Cattail Heads. (Left) The artist painted the head of a single cattail on damp paper with a bristle brush and rich paint, but without excess water. Its soft edges blurred instantly. He modeled the inner area quickly while the paint was still wet.

Variations in Cattails. Here are several cattails painted with sepia and burnt sepia. Split-second differences in timing and moisture explain the slight variations among them.

Rock Surfaces

Granite Rock in Grass. The jagged granite rock was modeled with a bristle brush and a knife. The dark negative spaces at the base of the rock contrast sharply with the dry yellow ochre grass.

Angular Rocks, Knifed Out. (Above) The artist brushed on a medium-dark wash of a varied combination of burnt sienna, French ultramarine, cerulean blue, and sepia. He knifed out the highlighted jagged edges and then roughly knifed and scratched out the top edge of the dark side of the rock and added sepia for more contrast.

Angular Rocks, Brushed On. (Right) Mr. Szabo painted the silhouette of the granite block with a flat 1-inch (2.5-cm) sable brush, using French ultramarine and burnt sienna. He scratched in the cracks with the tip of his brush handle while the wash was still wet. After the wash dried, he glazed on the shadowed sides of the rock.

Glacial Rock, Sponge-Textured. The artist wet-modeled the texture of the rock by sponging dark values of sepia into a basic wash of raw sienna, burnt sienna, and French ultramarine. Afterward, he lifted out light spots with a clean, squeezed-out, thirsty sponge. He painted the grass, the cadmium orange flowers, and the cracks, and knifed out the lightest blades of grass from the still-damp background.

Glacial Rocks. The stony surface of the rock on the left shows dark color sponged on over a light background. The rock below shows dark color lifted off with a thirsty sponge.

Mottled Rock in Grass. (Bottom) In painting a rock in grass, the artist added the grass while the base of the rock was still damp. He then modeled the subtle wet blend of colors on the rock with a sponge.

Rocks and Weeds

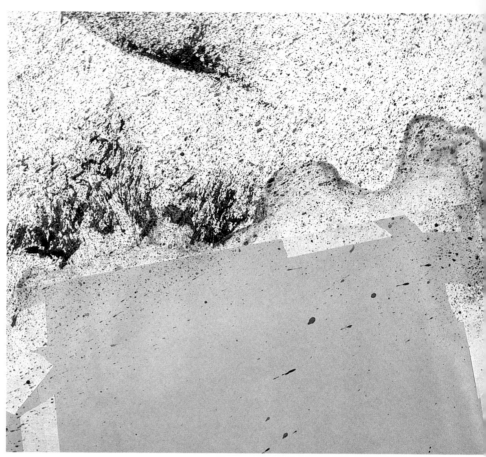

1. Before beginning to paint, the artist wanted to protect a sunlit area of the painting, and so he painted the tops of the foreground rocks with liquid latex and then masked the insides of the shapes with ordinary brown wrapping paper and masking tape. Now he was ready to execute the rocks in the rest of the picture. With a large bristle brush, he spattered several layers of sepia and cerulean blue over them. He controlled the density of the spatter around and within the rocky shapes in order to accentuate their emerging forms. (Mr. Szabo generally uses a big bristle brush for spattering, but many watercolorists prefer to use a tooth-brush—dragging a stiff plastic ruler or credit card over the bristles.) Then he drybrushed the crevices in the rocks with this same mixture.

2. When the spattered and drybrushed passages were absolutely dry, the artist covered the entire area with a deep, luminous wash of French ultra-marine, cerulean blue, sepia, and burnt sienna. He wanted to be sure that he wouldn't scrub off too much of the color applied in the beginning, and so he used a soft, 2-inch (5-cm) brush. He didn't mind if the color softened a little, but he wanted to be certain that the texture survived. Notice that he darkened this cool wash around the edges of the distant rocks in order to make them look more three-dimensional.

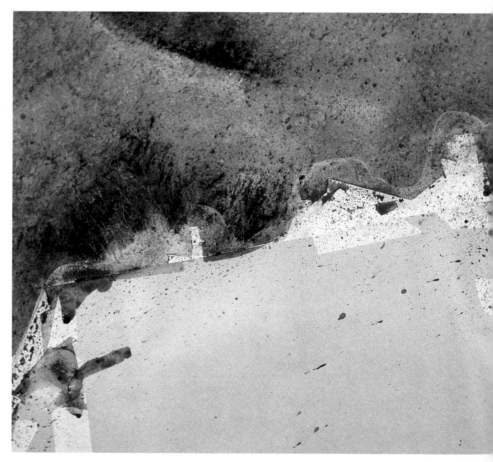

3. Now Mr. Szabo stripped the protective coat off the foreground rocks and covered the entire background with scrap paper and tape. (Because it's less sticky than masking tape, drafting tape is preferable—if you can get it. You can see how he trimmed the tape and placed it around the edges of the foreground rocks so the silhouette would be exactly right.) On the foreground rocks, he painted out a few sunlit clumps of weeds with Maskoid, since he expected to spatter this whole area. Now he painted in the larger shadow shapes on the foreground rocks with burnt sienna and cerulean blue. These two colors tend to separate and dry to a granular texture that looks especially good on rocks. Wherever he added a slightly darker value, he added a little French ultramarine.

4. To strengthen the texture of the foreground rocks, the artist spattered the shaded and the sunlit areas. He applied burnt sienna and raw sienna separately. Then he combined burnt sienna and cerulean blue for another spattered layer. Finally, he spattered a mixture of sepia and cerulean blue. When these spatters were dry, he washed new gamboge and burnt sienna over the entire area. When the background mask was removed, there was a beautiful contrast between the sunny foreground rocks and the cool, remote, rocky textures in the distance. Mr. Szabo also peeled away the masks on the little clumps of weeds and completed all the details with small strokes and a bit of drybrush in the darker values. Wherever he wanted to lighten the rocks, he scrubbed with a wet bristle brush and then blotted off the loose color.

Little Braggers, 15″ × 22″ (38 × 56 cm), by Zoltan Szabo

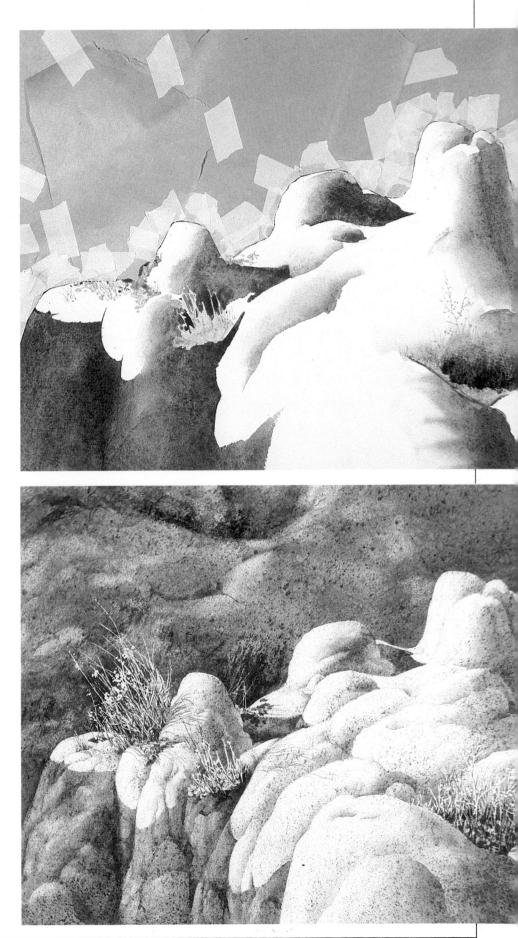

FLOWERS

Flowers, with their great variety of forms and colors, make fascinating watercolor subjects. Yet it is often difficult to paint their complex details without losing sight of the painting as a whole. This section demonstrates some useful approaches to the problems of painting flowers: capturing the essential character of a flower; painting blooms at different stages of maturity; painting close-ups; articulating white blossoms against background colors; maintaining vibrant color in deep-hued flowers; unifying the colors of a mixed bouquet; connecting flowers with their surroundings; and capturing the rapidly changing light and shade on flowers in strong sunlight.

Describing a Flower's Character

Poppy. It is important to capture the essence of a flower without getting too bogged down in unnecessary details. Surroundings should be kept simple to keep the viewer's attention focused on the important center of interest. Zoltan Szabo has painted the exuberant California poppy with decisive strokes of vermilion, cadmium orange, and alizarin crimson for the brilliant petals and a mixture of Antwerp blue and raw sienna for its wobbly stems and leaves. Upward drybrush strokes for the grass locate the flower in its surroundings.

Water Lily. Here the artist has unified the color of the lily pads and their luminous, watery environment by using the same colors for both: raw sienna, new gamboge, Antwerp blue, and burnt sienna. He painted the dark wash around the lily pads and then added the reflections in the water with a still darker value of the same mixture. For the delicate bloom, he used a light mix of French ultramarine, burnt sienna, and a little raw sienna. The quavery vertical reflections are quieted by the carefully placed horizontal lily pads.

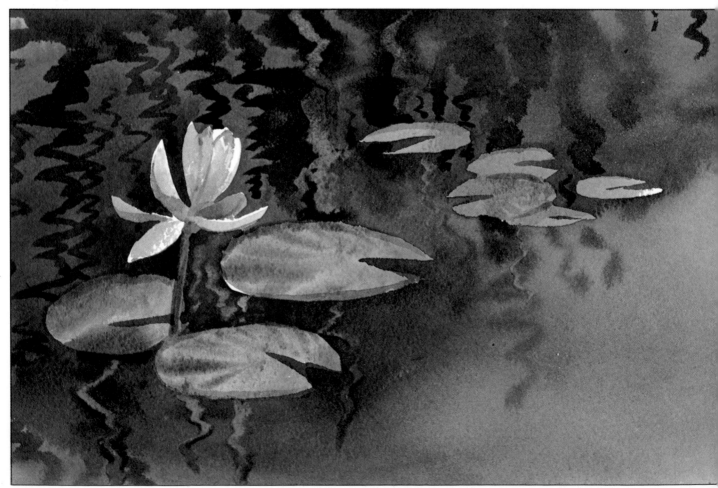

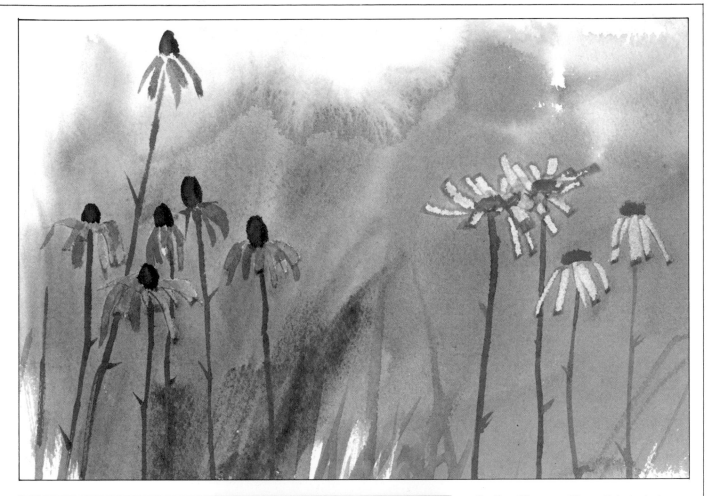

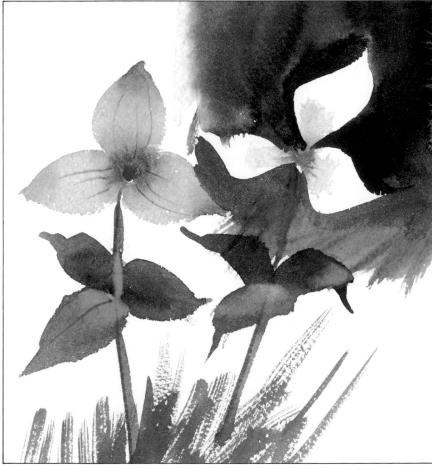

Fading Flowers. The artist started with a loose background wash of medium value, using raw sienna, French ultramarine, cerulean blue, burnt sienna, and sepia. He knifed out the shapes of the flower petals while the wash was still damp. Later, he glazed on the yellow of the brown-eyed susans and added their dark brown centers. He also placed the yellow centers on the daisies and finally, painted the tall stems on all the flowers. The background is simple, yet its colors and the suggestion of weeds and grasses emerging from it create a realistic impression.

Trillium. This sketch shows how the background values affect the relative values of certain flowers. White flowers such as the trillium look whiter against a dark background but appear pale gray against a light background. The artist has set the trillium against both light and dark backgrounds here, establishing its shape and structure with a subtle mixture of raw sienna, warm sepia, Antwerp blue, French ultramarine, and a touch of cadmium orange.

Painting Withered Blooms

The natural patterns of the flowers seemed to compose this painting, their diagonal movement giving it energy and an interesting variety of directional lines. What Richard Bolton wanted to do most in this painting was capture the overall feeling without getting too involved in detail.

So that he could work quickly, the artist first painted out the flowers and one or two of the leaves with masking fluid. Even in an uncomplicated study such as this, he found that each daisy was quite different from the others, varying from the overblown and ragged mature flower to the dried-up flower heads, which were rapidly going to seed. Each flower, at each stage, had its own points of interest.

Mr. Bolton treated the tangle of leaves in the background vigorously, using dark colors: deep, cool greens that would enhance and project the white flowers. This is a technique that he uses quite often. High contrast serves to enliven what could otherwise be a dull picture. Leaving some of the masked areas white against the cobalt and ultramarine blues gave added sparkle.

The largest and most vivid flower has careful though quick detailing at the center and an important contrasting shadow beneath it.

These withered flower heads were each treated slightly differently, with more or less highlight used as a means of varying the round centers of the flowers. The brown and torn petals were enlivened with a touch of cadmium orange and burnt sienna, contrasting against both very dark and very light backgrounds.

Lemon yellow against indigo and cobalt blue was tone down slightly here by adding a bit of sap green to the flower's center. Breaking up the edges with color gave a realistic, ragged look to the petal tips.

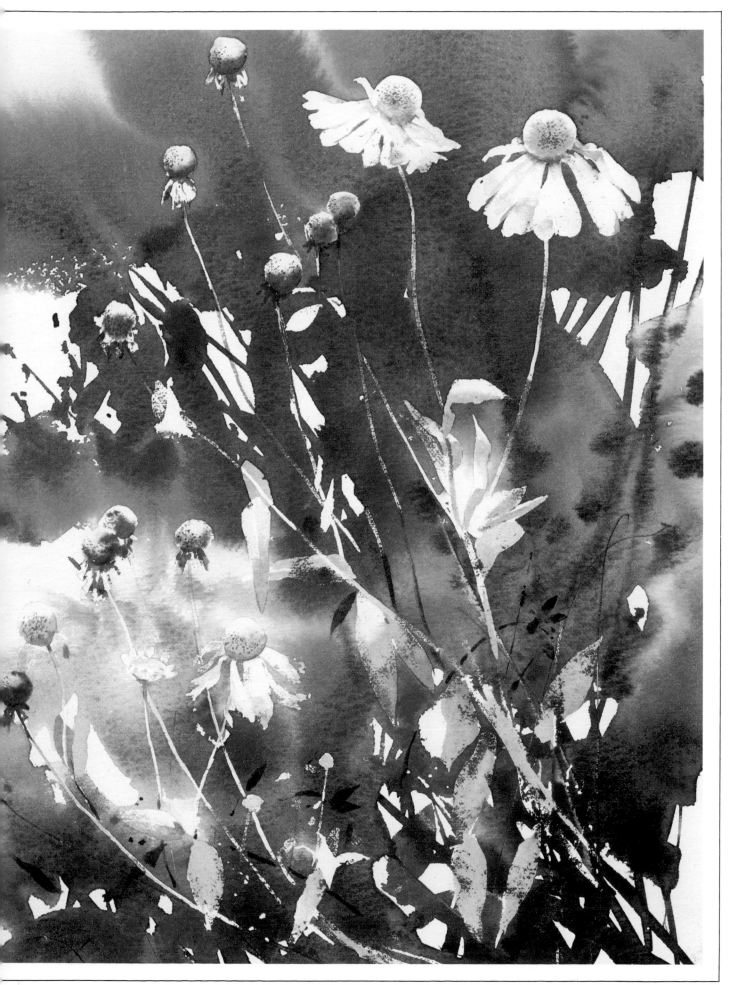

Unifying a Mixed Bouquet

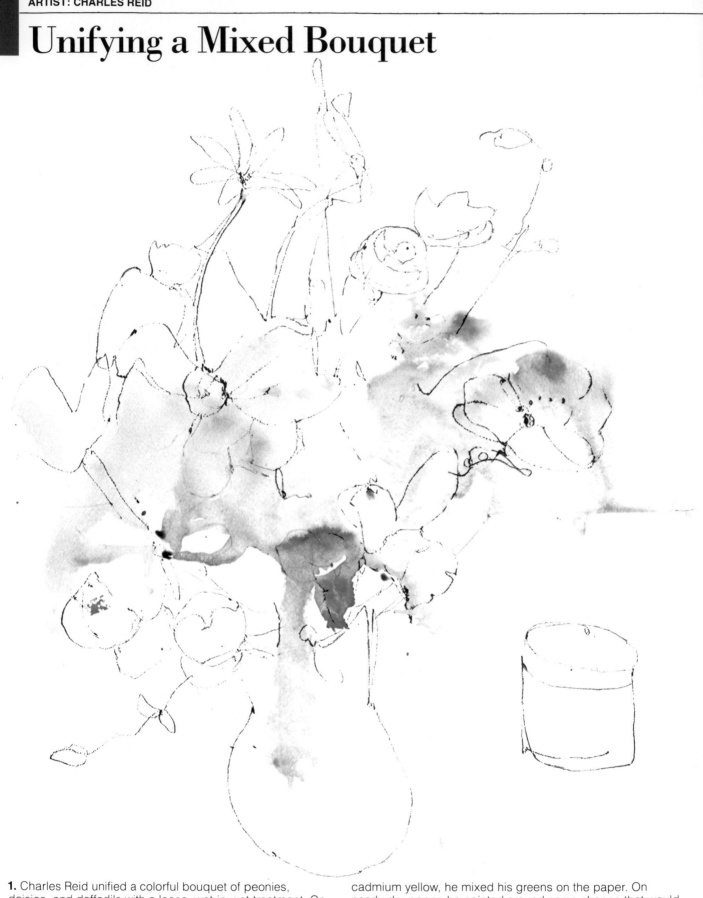

1. Charles Reid unified a colorful bouquet of peonies, daisies, and daffodils with a loose, wet-in-wet treatment. On predampened paper, he placed the very high key cadmium yellow pale on the left. Next he applied a mixture of alizarin crimson and ultramarine blue, which blended with the yellow on the paper. Adding diluted ultramarine blue to the fast-drying paper created a harder edge. With cerulean blue and cadmium yellow, he mixed his greens on the paper. On nearly dry paper, he painted around some shapes that would be white flowers. Redampening the paper to the right, he added more flowers with cadmium yellow and cadmium orange. He put in the cadmium red light flowers and added ultramarine blue and alizarin crimson to show the beginning of the vase.

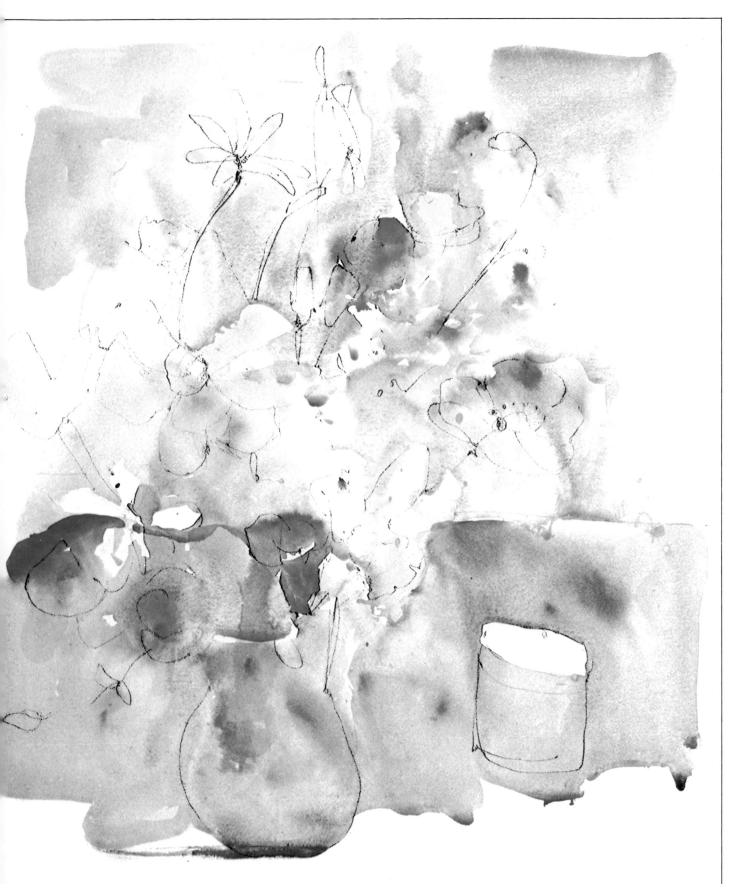

2. By now the paper was dry, and since he wanted fairly definite edges in some places, he didn't dampen the whole paper again. He worked a cool mixture of cadmium yellow pale, cerulean blue, and alizarin crimson over large areas in the upper section of the picture. As he worked, he added cadmium red light and cadmium yellow directly to the wet wash. Some bits of white paper showed through. He began to "find" various flowers by painting around their shapes with an overwash. Working his cool wash of alizarin crimson and cerulean blue into the lower section of the picture, he carried it across the vase and into the left-hand side. He applied some of the new colors wet-in-wet and others to dry paper, but he kept things as fluid as possible.

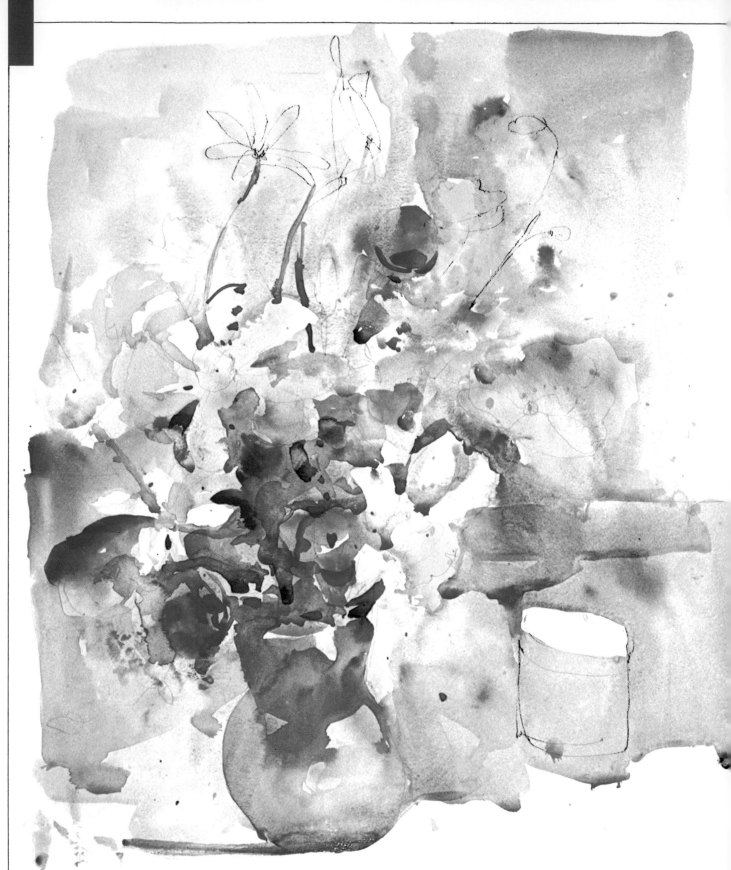

3. For the first time he added darks, using ultramarine blue and cadmium yellow for some greens in the center of the bouquet. He blotted and lightened this color right above the red flower in the center left, where it got too heavy. He worked cadmium yellow pale around a light purple flower on the right and picked out some details with ultramarine blue, cadmium yellow, and touch of alizarin crimson. Some color from the yellow flower flowed into this combination, but he didn't correct.

He brought the flowers into focus by finding the left boundary of the vase with a cool background wash of ultramarine blue, alizarin crimson, and cadmium yellow. He showed the warm dark on the vase with sap green and cadmium red, giving it a variety of hard and soft edges. Working down into the left side, he blended his darker wash with the cool gray. He defined more flowers with his green combination.

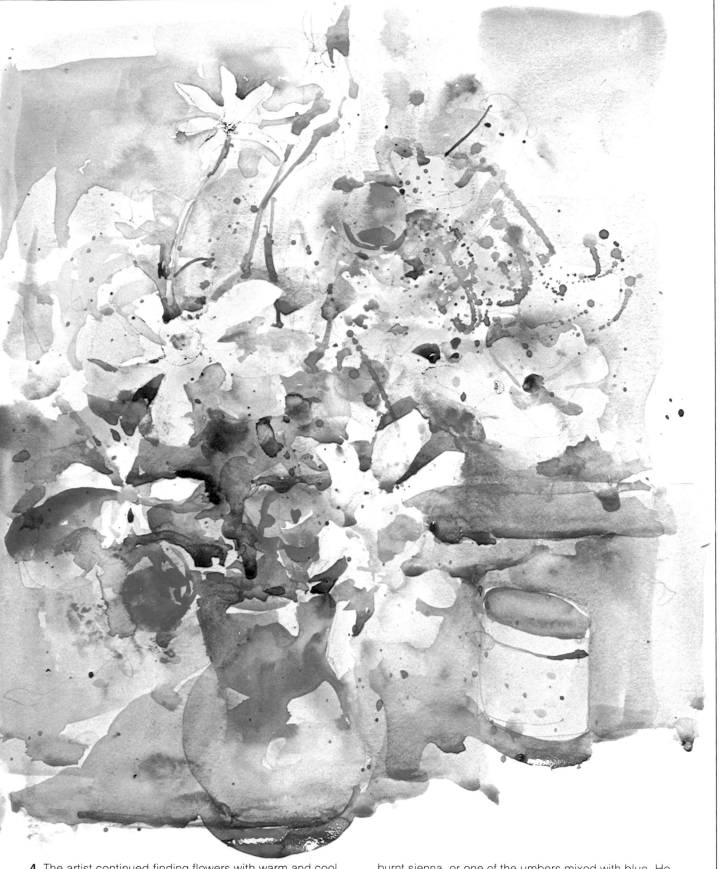

4. The artist continued finding flowers with warm and cool variations of his background color, but he didn't introduce any new colors. You can make any gray combination either warm or cool by using more warm or cool colors in combination. If he had wanted a really warm brownish gray, he wouldn't have used alizarin crimson, a yellow, and a blue; instead, he'd have gone to a green and red, or a blue and burnt sienna, or one of the umbers mixed with blue. He continued to work around color areas to create flowers. In this kind of painting you need not be a slave to your subject. The painting should take over and dictate what is to happen. Be sure to vary colors. Remember, by varying the ratios of your color combinations, you can come up with quite a different feeling in each mixture.

Painting Flowers Close Up

1. Charles Reid decided to paint some beautifully variegated tulips at close range, using a bit of drybrush for the fine striations of their petals. He made a quick drawing with a no. 2 office pencil on cold-pressed paper. Both the flower and the arrangement were simple, and he kept his drawing simple as well. Shape was the most important element here; the painting would have no meaning if the shapes were sloppy and generalized. Since the flower was very delicate, with pink edges changing to a light, warm color toward the center, the first wash he mixed on his palette consisted of cadmium yellow, a bit of cadmium orange, and a little alizarin crimson with quite a bit of water. The puddle of paint was diluted, but the wash would dry lighter; therefore, he made sure the puddle still had a feeling of definite color. Using his

no. 8 round sable brush, he began with the petal in the center and to the left, washing in the whole petal at once while making sure he kept the definite shapes. Then he mixed alizarin crimson and a little phthalo blue, which he dropped wet-in-wet around some of the edges of the petal. The center of the flower was too washed out, and so he dropped in some slightly diluted cadmium yellow wet-in-wet. He didn't want to go back over the lighter washes of this delicate flower with an overwash, and so he tried to complete each section as he went. He used a tissue to lift out color if it got too dark. He continued using the same color for new petals but added more blue. Again he dropped in some cadmium yellow wet-in-wet.

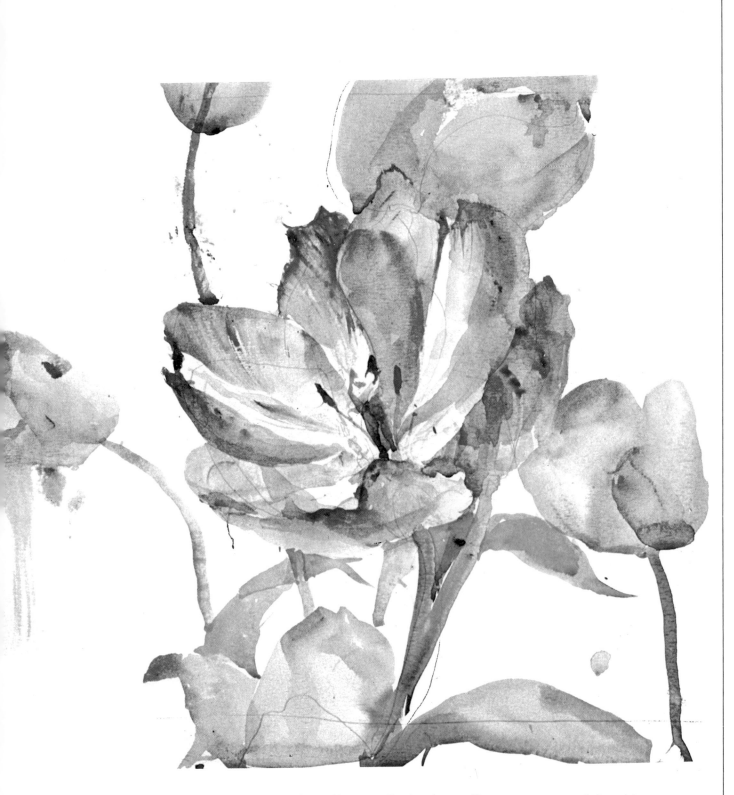

2. Although the artist didn't want to cover light values with overwashes, a few additional washes were necessary in darker sections such as the top petals, where a deeper pink was added to a lighter wash wet-in-wet. Now he began working with a drier brush, although the paper was still wet. He gave his brush a good shake before picking up some slightly diluted alizarin crimson. Then he blotted the brush lightly with a tissue before stroking in small details on the top petals. He added more flowers, doing quite a bit of mixing on the paper. The flower on the right, for example, was painted wet-in-wet with a combination of alizarin crimson and phthalo blue. Into this wet color he dropped bits of diluted blue and alizarin crimson. The greens were made by mixing ultramarine blue and cadmium yellow.

Mr. Reid was ready to apply the final drybrush details, which he would keep subtle so that they would not look overdone. With his no. 8 brush, he mixed a puddle of alizarin crimson and phthalo blue on the palette. He blotted the excess water from his brush with a tissue and then picked up more color from his palette. He shook the brush (he also could have blotted it again) so it would not be too wet and made the last few delicate, light strokes to show the texture of the petals.

Connecting Flowers to Their Surroundings

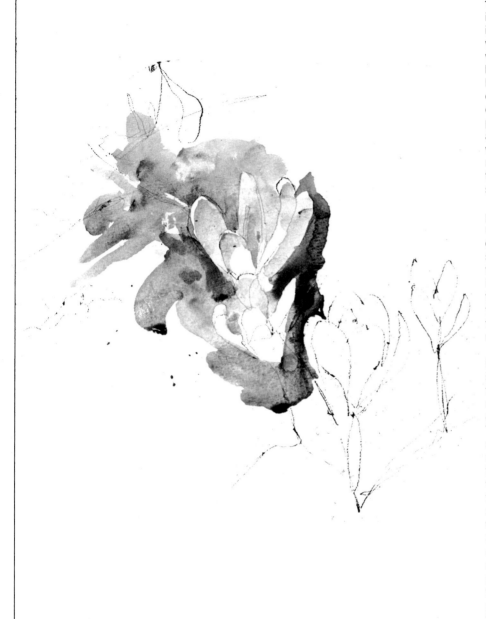

1. In this painting of crocuses springing up at winter's end, Charles Reid incorporated Luma opaque designer's white along with his transparent washes. Opaque pigment must be handled with care in a watercolor, and Mr. Reid generally restricts its use to corrections and small details. He cautions that large areas of opaque paint may make a painting look dry and labored, and if not well integrated with the transparent washes, may also result in an unpleasant combination of two separate painting ideas within the same picture.

Working on a sheet of 140-lb. cold-pressed paper, he sketched in a rough idea of the flowers with a no. 2 office pencil. His first thought was to start developing a connection between the flowers and their surroundings. Thus, he would carefully show the boundaries of some sections of the flowers, while in other places allowing the flowers and the background to merge.

Once he had drawn in the crocuses, he slowly began to add some shadows to them and work more into the background with a quiet green made up of raw sienna, cerulean blue, cadmium yellow, and alizarin crimson. The values in the top flower are very similar to adjoining background values, but the artist didn't try to isolate the flowers with dark surrounding values. Rather, he just spotted darks to set off the lighter flowers. He was still using the same colors he started with for the background, but he wasn't using them all at the same time. In some places he used only the blue and yellow when he wanted a stronger green. He also allowed definite color to show. For example, you can see pure cerulean blue in the left side of the lower crocus. He mixed a little cadmium yellow, alizarin crimson, and cerulean blue on his palette and then worked up from the pure cerulean blue to make the rest of the shadow section of the crocus. He used mostly his no. 8 brush.

2. Mr. Reid tried to create the effect of soft edges here by varying the value contrasts between flowers and background. A strong contrast between the values of two adjacent areas will give the impression of a hard edge, whereas two adjacent areas of similar value will give the impression of a softer edge. As he added darker values around the flowers, he was still careful to let the flowers breathe. He didn't want to mummify them by surrounding them with heavy darks. Notice that there is often a lighter strip between the flower and the darker values in the background, and that the artist introduced some light pieces of detail that run into the flowers. When overpainting, he left these light pieces untouched.

3. Mr. Reid added another crocus on the right and more background around the flowers. The ground was quite dark now, and he squinted often to keep the big value shapes in mind. He also looked at the picture from a distance or turned it upside down now and then. If it looked good, he knew he was on the right track. If you get into trouble with too many details, his advice is to switch to a bigger brush rather than a smaller one. Simplify, even if you destroy the freshness of an area. In this painting, the artist tried to keep his background color as fresh as possible by adding new color directly, actually mixing on the paper. You can see the ultramarine and cerulean blues and the alizarin crimson, and as he added cadmium yellow, the background in the upper right area became a warm gray. He also mixed the blues with cadmium yellow to get a relatively strong green. These color areas often don't blend perfectly but do retain their own identity. The values, however, are all about the same. In the lower right area Mr. Reid also added a bit of cadmium orange wet-in-wet, mixing it into the wet color on the paper. He didn't work in the new color; rather, he gently placed it.

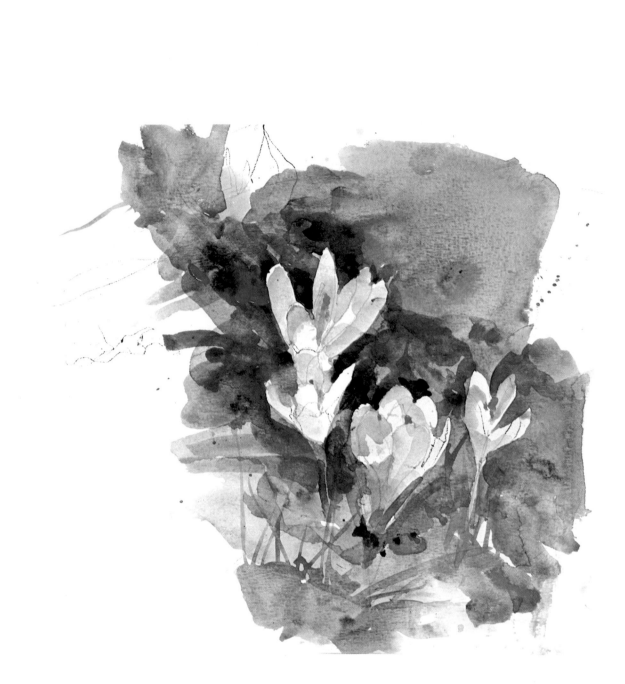

4. At this stage the artist was still working with transparent washes and hadn't used any opaque pigment, which he would save for the finishing details. Now he simply added some cool shadow wash to the two flowers in the lower right area, using mostly cerulean blue, a little quiet, unobtrusive cadmium yellow pale, and a little alizarin crimson. Cadmium orange mixed with a blue also would have worked, if carefully diluted. Alizarin crimson must also be diluted carefully when used in light areas. Cerulean blue, however, comes out of the tube in a relatively quiet state and can be used a bit more freely. The artist painted the stamens with cadmium orange, to which he added very little water plus a bit of raw sienna and cadmium yellow. He used his no. 6 brush for these small areas but quickly went back to a no. 8 brush. In painting the foreground grass, he started with the mass in the lower left area, using ultramarine blue and cadmium yellow. Then, with the color that was already on the paper, he drew upward strokes to form the individual blades of grass. If he needed new color, he added it to the original green section wet-in-wet and then continued drawing this color upward to form more blades of grass.

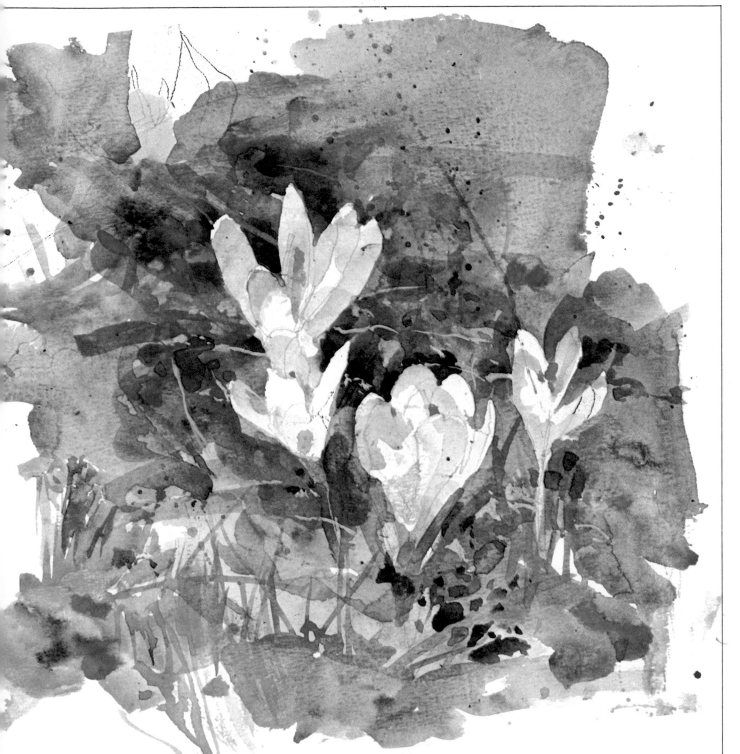

5. To finish up, he used the opaque white to correct some errors and add details. Occasionally he switched to a no. 9 brush for broad areas. Although they don't make a very dramatic difference in the painting, the minor corrections and details help the overall effect. Charles Reid expanded the background around the flowers using the same color but painting with both the no. 9 and no. 8 brushes. He was still spotting color about the painting in fairly limited areas, mixing most colors right on the paper and keeping all new areas in the same general value range. He added only a few really dark accents—and even these aren't as dark as they could be—which help direct the eye in a diagonal direction through the painting.

The artist wanted a covering white for the flowers, and so he didn't add water to the opaque paint but used it directly from the bottle. He restated some white areas in the flowers,

without overdoing it. With a no. 6 round sable brush, he added twigs and other small forms in the ground around the flowers. He mixed white on the palette with other colors— some of the warm gray stripes are fairly apparent. He didn't want chalky color that would look out of place. The opaque stripes help connect the light flowers with the background. In the lower right area, he used his opaque mixture to show some lighter ground through some blades of grass. In other places, he combined the opaque pigment with the green that he mixed from cerulean blue and cadmium yellow. Since Mr. Reid doesn't like the cloudy mixture that results from rinsing a brush containing opaque paint, he either uses a separate container of water for the opaques or—as he did in this instance—saves the application of opaque colors until the very end when all the transparent work has been done.

Defining White Blossoms

1. When Charles Reid painted some white narcissus, he encountered a problem that arises in painting white blossoms against a colored background. Should he paint the shadows in the flowers first and then add background colors and shadows, or paint the background completely around the white silhouette before adding the shadows? Either way, timing would be critical, for if an adjacent wash were not completely dry, background tone could seep into a flower. This can also give a flower life and form—a fortunate accident—if it is handled well.

The artist did a modified contour drawing on cold-pressed paper to locate the important shapes and then started in the upper left corner with a background wash of cerulean blue and alizarin crimson mixed with a bit of raw sienna. With this initial wash, he carefully outlined the shapes of the white flowers, adding colors wet-in-wet. He allowed some background color to flow into a section of the flower at the top left and then added a bit of cadmium yellow pale in the center, blotting very lightly with a tissue to keep things under control.

The artist worked in more flowers, using cerulean blue, alizarin crimson, and a bit of cadmium yellow. He was careful with their boundaries; note that the edges around them are fairly hard. This is because he allowed the shadow sections to dry before adding his background. In some places, however, wet washes were allowed to flow together.

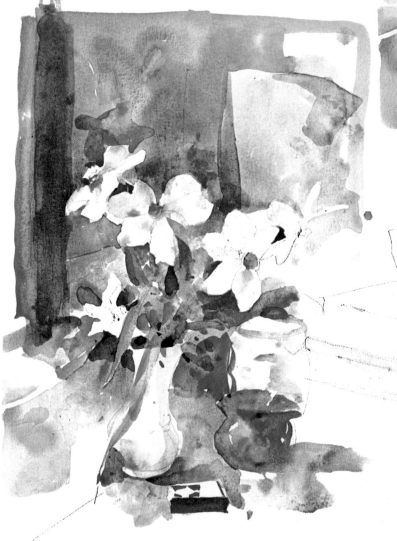

2. Mr. Reid painted some edges distinctly and left others unstated, isolating only the flower on the left with hard edges. Trying to keep air around the vase, he only spotted darks around it with cadmium red, raw sienna, and cadmium orange. He applied unmixed colors to the tabletop wet-in-wet, creating color changes. He added the window frame to the left with cadmium orange and raw sienna, allowing this to dry before painting its shadow section with a darker value made of alizarin crimson, ultramarine blue, and a touch of raw sienna. The leaves were painted a cool, delicate mixture of cerulean blue and cadmium yellow light, with sap green and cadmium red light for the darks. Next the artist added a small blue pitcher and a light-colored container with blue designs. He kept the edges in the light firm while losing the shadow sides. See how the shadow wash on the jar carries on out to the right. The artist left areas untouched to suggest highlights. While the pitcher was still damp, he added darker shadow sections using the same colors but less water, achieving a good blend between the cast shadow and the shadow wash on the pitcher.

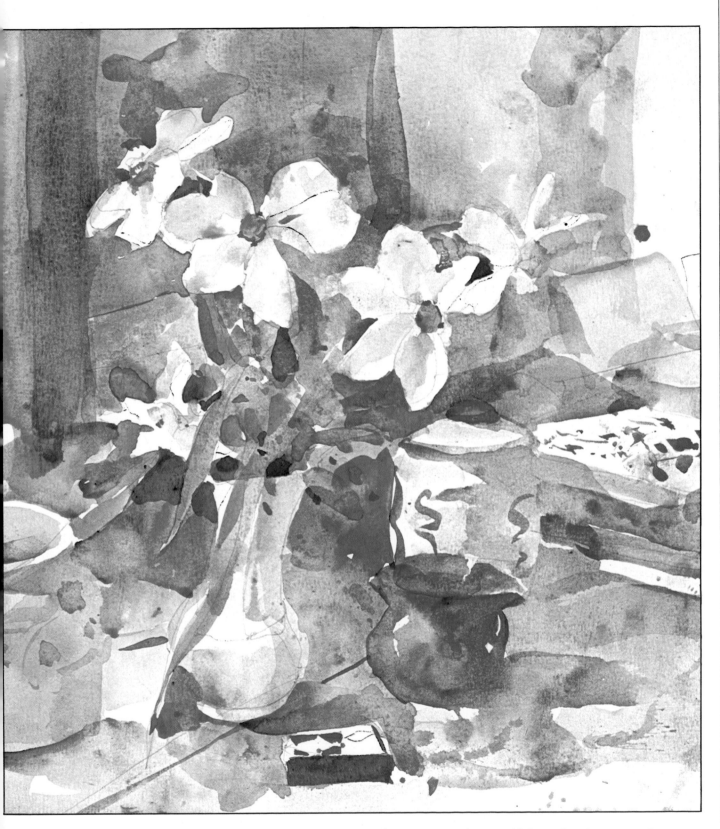

3. The final step was to finish various areas around the flowers and objects. If you compare the finished painting with how it looked in the previous stage, you'll see that the artist really did not do much refining. He also did not add many dark accents. He tried to get the sense of reality through controlling edges rather than through accenting darks. Note that on the white jar he combined the shadow on the jar with the books. The only real separation is in the blue book, where there is some contrast. In the final step, the

artist concentrated on combining rather than separating areas. For example, the values in the gray jar in the left foreground are very close to the light strip of tabletop, which in turn is almost the same value as the vase holding the flowers. This leads the eye in from the left side of the picture. In the same way, the cast shadow to the right of the vase leads over the top of the matchbox and connects with the small pitcher.

Retaining Accurate Local Color

1. When he painted a vibrant bouquet in side lighting, Charles Reid wanted to be sure that he did not lose the rich local color of the flowers. He did a compositional pencil drawing on his sheet of cold-pressed paper and then established the dark flowers with the same value of ultramarine blue and alizarin crimson. For tonal variety, he blotted some areas for the lighter values and then restated some of the darks. He worked around the top of the daisy and then, using alizarin crimson, ultramarine blue, and cadmium yellow, washed in a very light value for the shadow side of the daisy. While this was still wet, he continued with the purple, achieving a soft edge along the shadow side.

When the purples were dry, he added his greens, mixing ultramarine blue, cadmium yellow, and sap green on his palette. He added a touch of red to the lower left area and added red flowers with cadmium red. He added more greens, which combined with the reds for a softer edge in the shadow area. For these darker greens, he added cadmium red light to his basic mixture directly on the paper to achieve a transition from green to red. Finally, using alizarin crimson, ultramarine blue, and yellow ochre, he added the shadow at the top of the vase.

2. Since form is more important than color in a light object, Mr. Reid showed definite light and dark in the vase. He left a white highlight in the cool, light gray wash and then added an overwash, carrying it out into a cast shadow. He added a mixture of alizarin crimson and cadmium yellow pale to the left of the vase, and while this was still a little damp, he painted the ink bottle with sap green and cadmium red mixed on the paper. He added the bottle top with ultramarine blue, alizarin crimson, and some of the green mixture from the bottle.

The artist added more of the tabletop, giving each section a slightly different color feeling, and put a light wash over the drafting triangle. He painted the pencil wet-in-wet with cadmium orange and cadmium yellow, adding raw sienna for the point. When it was nearly dry, he put in the cast shadow with cerulean blue. He painted the watercolor box with the same value of ultramarine blue with a touch of cadmium orange and allowed it to dry before painting in shadows.

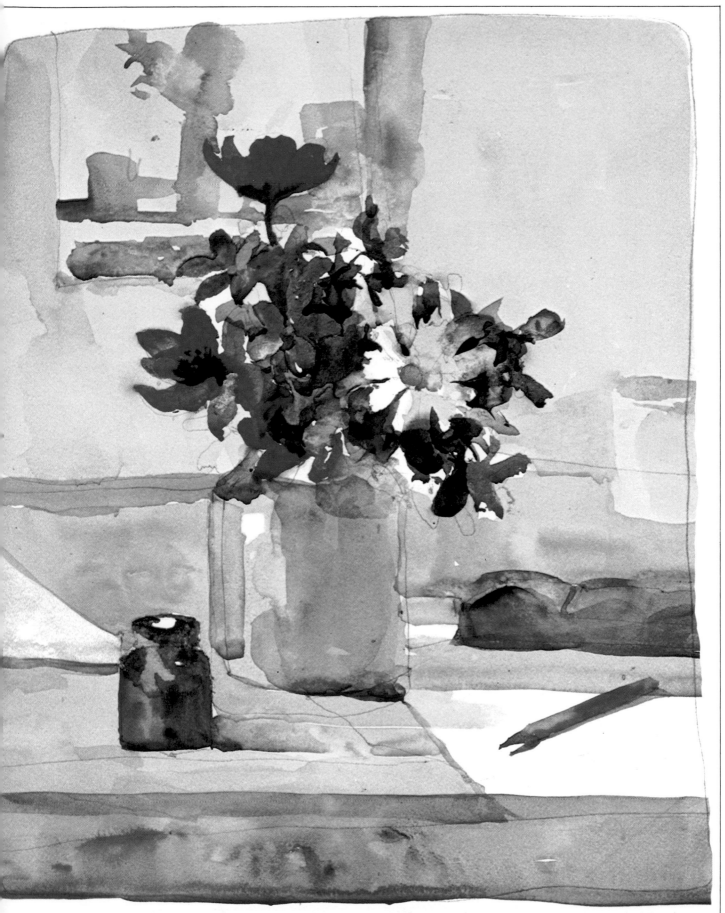

3. Finally the artist painted a little background color around the white container to the right of the vase and added a suggestion of a picture on the wall. He painted a darker strip of table edge in the foreground, adding a bit of almost every color he had used throughout the painting and mixing these right on the paper. Most of the lights in this painting were achieved by blotting rather than by painting them first and then adding shadows.

Painting a Bouquet in a Landscape

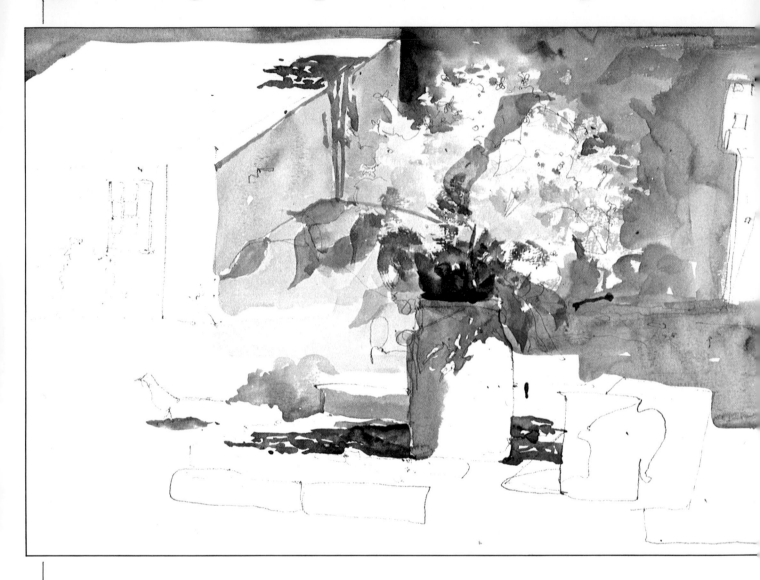

1. (Above) Charles Reid worked outdoors in strong sunlight to paint lilacs in a white container set against the landscape. He knew his chief problem would be the rapidly changing light, and so he outlined the shadow areas in his initial pencil drawing. Since it was important to locate the shadows before they changed too much, he worked from dark to light, beginning with a mixture of cerulean blue, ultramarine blue, and a little alizarin crimson for the shadow of the container. Hard edges in the top of the vase describe shadows cast by leaves. Working this wash down the left side of the vase, he let it flow into the bouquet and the table. He painted the leaves and the background greens with a light mixture of cadmium yellow pale, cadmium yellow, and cerulean blue, and with darker mixtures of sap green, cadmium yellow, and a little cadmium red light. With a deep blend of alizarin crimson, cadmium orange, and ultramarine blue, he established the cast shadow on the table. On the palette he mixed a very light wash of cadmium orange, cerulean blue, and alizarin crimson for the side of the studio on the right and added more cerulean to it on the paper. For the very light tones in the lilacs, he used cerulean blue, alizarin crimson, and a little cadmium yellow pale. He also used some drybrush around the flowers.

2. (Opposite page, top) Mr. Reid added more darks around the flowers: ultramarine blue, sap green, and cadmium yellow. For the studio he used alizarin crimson, ultramarine blue, and cerulean blue. He was working with no 8, no. 9, and no. 12 round sables, using the bigger sizes solely in the background and doing the tighter work with the no. 8 brush. To avoid putting in too many darks at this stage, he added only enough to assure a good value range.

3. (Opposite page, bottom) The artist worked some very light drybrush into the flowers with his no. 8 sable, mixing alizarin crimson and water on his palette and then blotting the brush to get it sufficiently dry before applying the color to the paper. He had to be careful not to go too dark in the white flowers. On the right Mr. Reid used alizarin crimson, diluted only with water, and some strong ultramarine blue in the tree. Then he dropped cadmium orange into this, wet-in-wet. He also used alizarin crimson and ultramarine blue around the window and alizarin crimson and cadmium orange along the roof line.

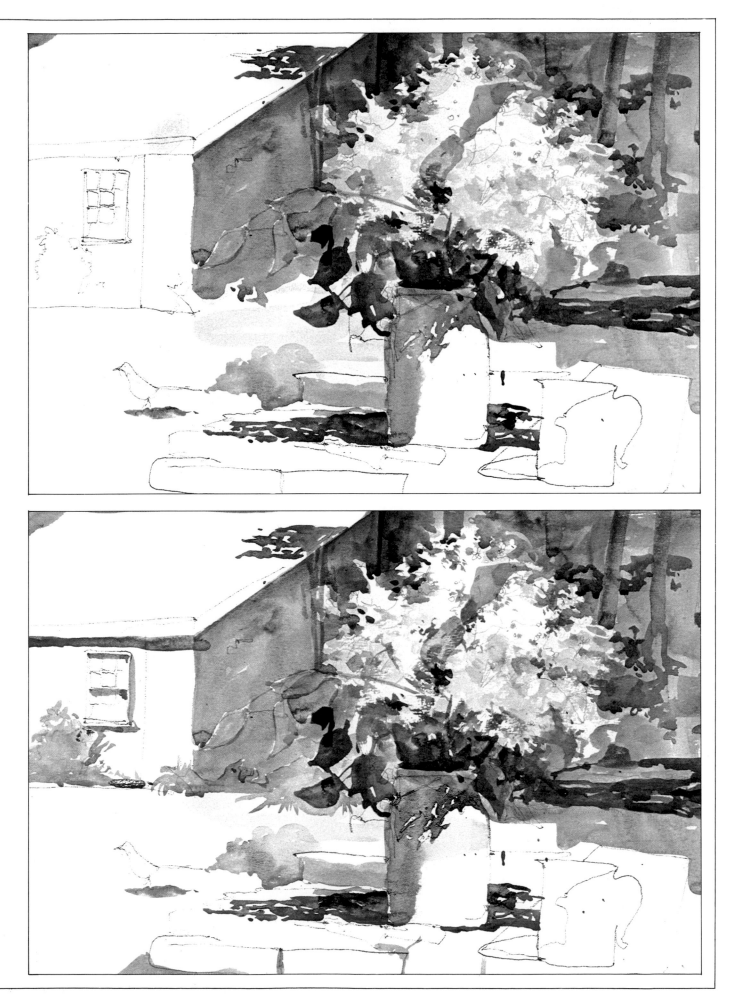

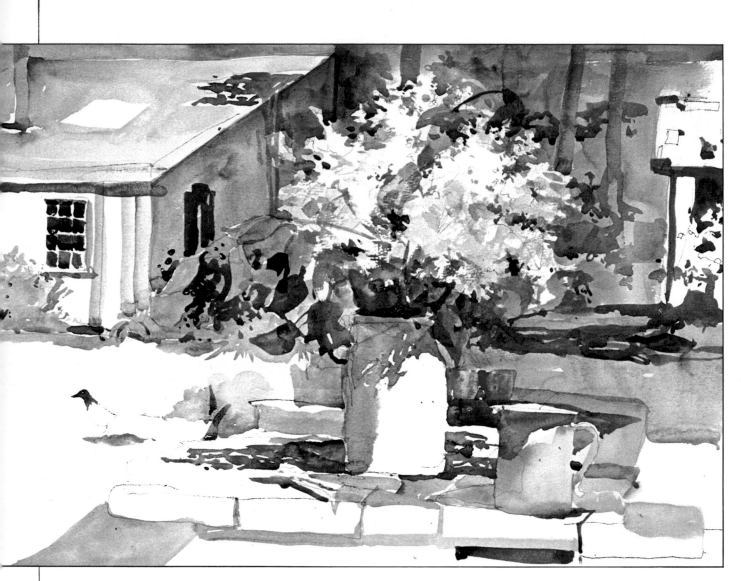

4. Now the artist added more darks and worked on the studio at the left. He did very little to the flowers but concentrated on the surroundings at this stage. For the table he started with darker accents and then added lighter washes when the darker values dried. Before adding the lights, he painted the shadow on the coffee cup first with ultramarine blue, alizarin crimson, and cadmium orange, carrying these colors out into the table. Note the color changes where he worked out from the cup to the table. He started with more blue and less of the other colors, but as he painted to the right, he added more orange and alizarin crimson. He used alizarin crimson, ultramarine blue, and orange in the windows of the studio. The orange accent was made with cadmium orange and cadmium red light.

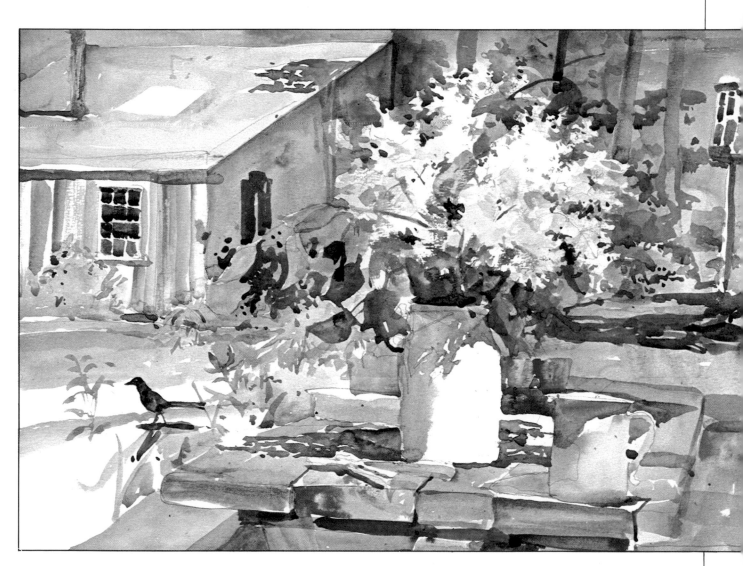

5. Next he added the blackbird. He had drawn the bird in his preliminary sketch, and the creature had stayed around the whole time he had been painting. Alizarin crimson, ultramarine blue, cadmium yellow, and cadmium orange were his colors for the tabletop, which he painted next. He used the same colors throughout the table but varied the quantity of individual colors in each section. Actually, he painted each slat of the table separately and allowed it to dry before adding an adjoining slat. Throughout the painting process, Mr. Reid's emphasis was on color. He tried to keep overwashes to a minimum, aiming for his darks with the first wash. He also concentrated on using more intense color in the necessary overwashes.

SEASCAPES

Waves breaking on a shore are the result of
energy released earlier somewhere at sea.
This energy moves the water outward in huge
swells—like the rings formed when a pebble
is dropped into a puddle. The swells move
out from under the froth churning at their
crests, and the froth flattens out and splits
up into lacy foam patterns that are picked up
by the following swell and tumbled again.
When the waves reach the shore, the angle
and shallowness of the ocean floor cause
them to roll forward and break against the
beach. If you understand how the sea's
energy shapes waves and causes breakers,
you will not be likely to paint foam on a wave
face where it does not belong or have your
waves breaking in the wrong direction
in your seascapes.

Breaker and Foam

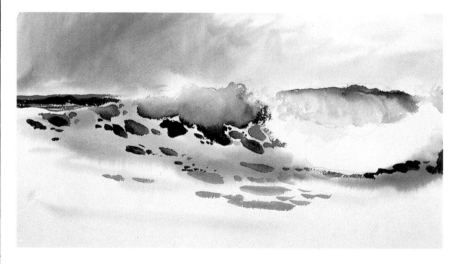

1. The artist began the painting by making a brief outline in pencil—the fewer marks, the better. Then he wet the paper with a sponge. Now he mixed cerulean blue with just enough raw sienna to gray it. (Although earth colors like raw sienna are neutral, they contain a bit of orange, which is the complement of blue and grays it.) With a 1-inch (2.5-cm) flat brush, the artist dipped into the mixture and began the sky. He started in the left-hand area and quickly washed the color across the paper, using diagonal strokes. Because the paper was wet, the brush lost color as it moved, and so the sky color gradually faded from dark to light. The artist was especially careful, however, to make the sky dark behind the area of foam. Then, with cerulean blue, he painted the shadow on the wave face; he darkened the area under the foam with ultramarine blue. Since the paper was still quite wet, he did not have to rewet it. He was careful not to tilt the board, and so the colors did not run.

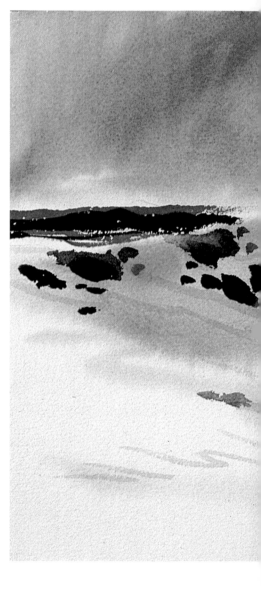

2. Before going on to the next stage, Mr. Robinson let the paper dry. As it was drying, he used his sponge to blot up any sky color that started to run down the paper into the wave foam. Although many different greens could have been used, this time he selected Hooker's green for the wave color. With a no. 12 round sable which had some water on it, he dipped into the green. Starting at the base of the wave and working upward, he first painted the holes in the foam, some small and some large. Then, when he got to the open part of the wave, he added water to his brush. He always adds more water as he works upward. The water thins the paint at each stage, fading the color and giving the impression of translucent water.

The artist also used Hooker's green to show the roll of the wave. Starting at the top of the wave with dark green, he added only water to the brush and gradually lightened the color where the wave goes down toward the foam. Then he underscored the foam with some dark green water to show depth.

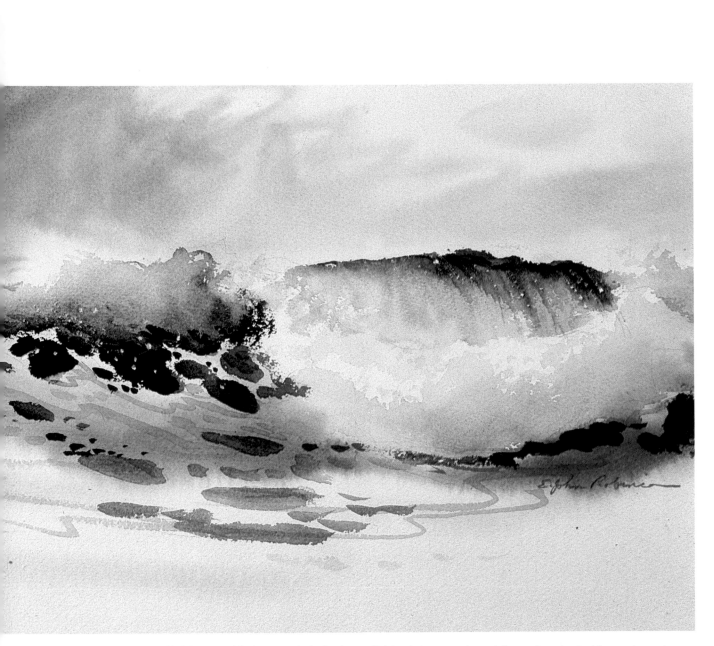

3. For this final stage, Mr. Robinson added some dark ripples to the wave with the tip of his no. 12 brush and made a few short scallops just above the foam patterns. He also completed the breaker foam by shading it. Starting at the bottom of the breaker, he painted the shadow with the no. 12 brush and cerulean blue. He painted upward on dry paper, adding water but no paint as he went. The blue shadow fades into the white paper well before it reaches the roll. He finished the wave by adding a few rippled lines of cerulean blue to the shadowed foam patterns and the foreground. He also nicked in a few highlights with the tip of his knife.

In learning to paint breakers, you may need to practice Mr. Robinson's procedures several times in order to feel comfortable with them. Frustration with poor results is a good sign that you should try again; just be persistent.

Breakers on a Rocky Beach

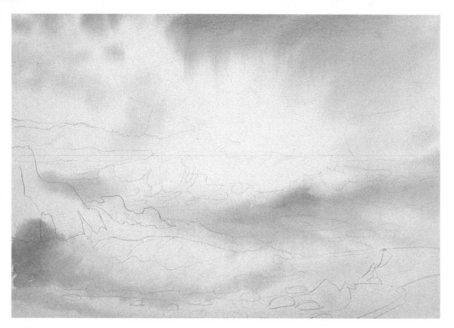

1. The artist began this painting of the New England coast with a light pencil drawing on his sheet of 300-lb. rough paper. He kept it as simple as possible. Then he wet the entire paper thoroughly with a sponge. Next he mixed the sky colors—cerulean blue with a touch of mauve. While the paper was still very wet, he quickly stroked on the color and then tilted the board to let the paint run. Where some of the sky color ran into the sea area, he left it. But he sponged up any color that covered the foam area. When the color had run enough to suit him, he straightened out the board and applied the same color to the shadow at the base of the wave and under the foreground rock.

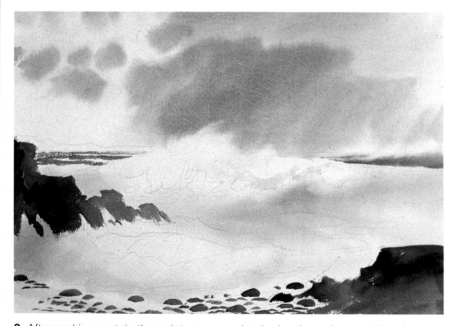

2. After making certain the paint was completely dry, the artist rewet the sky area. Switching his paint mixture from cerulean to ultramarine blue and a touch of mauve, and with the same brush, he painted the second set of clouds. He made them darker than the first group and placed them directly behind what would be the breaker foam. After the paper had dried a bit, he used the same mixture to work in a few background swells. While the rest of the paper was drying, he worked on the foreground rocks and beach. With a ¾-inch (2-cm) flat sable brush and raw sienna, he painted in the pebbles, boulders, and the major rocks on the beach. He made them a medium shade of sienna so he could overpaint the shadows later.

3. Now the artist painted the headland a combination of cerulean blue and viridian with a patch of yellow ochre for color. Notice that he also reflected these colors onto the sea. Next he began the major wave. For this he used a no. 12 round sable brush and watered-down paint on dry paper. As is his usual procedure when painting breaker foam, he began at the bottom of the wave with the darkest shade of the mixture, a combination of viridian and a touch of ultramarine blue. As he worked upward on the face of the wave, he lightened the mixture by adding more and more water until the top portion was nearly white. Then, with the same mixture, he punched dark holes in the mass of the surface foam and worked long lines of it into the foam until it trailed into clear water. He also painted a few broad lines of shadow into the surf to show the movement of the foam.

4. In this final step, the artist began by painting the collapsed wave in the foreground. He rewet the upper roll area and applied the paint—a mixture of viridian with a touch of ultramarine blue—with a no. 12 round sable brush. The color ran forward to the foam, and the artist sponged up any paint that would cover the foam. After this had dried a bit, he darkened the leading edge of the roll and increased the shadow under the foam. He used the same blue-green color as before.

To darken the rocks, Mr. Robinson used a ½-inch (1.3-cm) flat sable brush and burnt umber with a touch of ochre. He did not rewet the paper because he wanted to keep the texture derived earlier from drybrushing. Notice that he merely suggested cracks and crevices with a slightly darker paint, mostly burnt umber. He also used this umber to shadow the foreground pebbles and rocks.

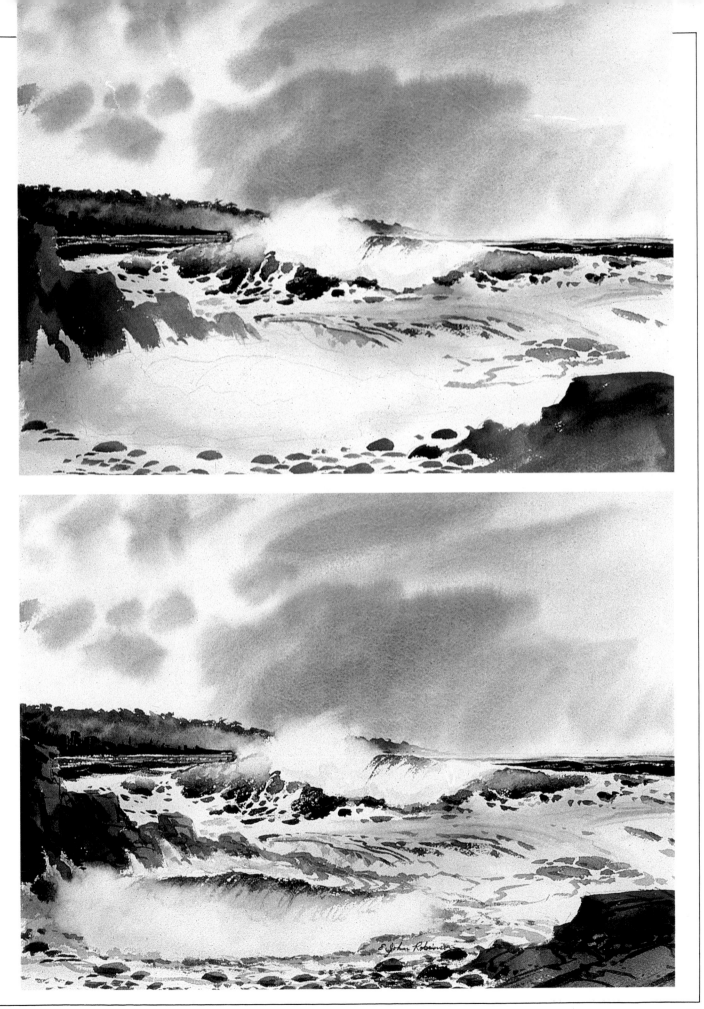

Powerful Ocean Waves

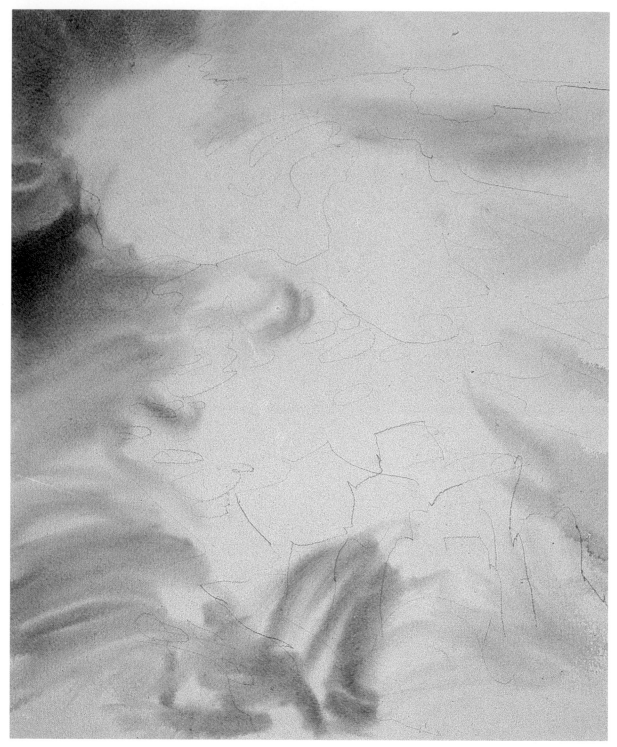

1. After penciling in the composition on 300-lb. Arches rag paper, using the fewest lines possible, the artist wet the rough surface of the paper with a sponge. He used a fair amount of water and tilted the board slightly downward so he could start at the top and work his way down without the lower sections drying out too soon.

With a 1-inch (2.5-cm) flat sable brush and a mixture of cerulean blue and Davy's gray, Mr. Robinson began the sky. (If you do not have Davy's gray, a touch of raw sienna will also take the edge off the blue.) Starting in the left-hand corner, the artist quickly whipped the brush in vertical strokes as he moved to the right. He allowed the color to

fade out a little past the middle of the paper.

Now he painted the shadows on the water in the same manner. Working the sky color downward on the left-hand side, he started with the darkest mixture and allowed it to fade somewhat as he proceeded. In this case, he used horizontal and slightly curved strokes to give a humped shape to the foreground. Then, adding a bit more cerulean blue to the mixture, he made a few strokes where the water spills from the rock and added a few faded patches of shadow slanting down on the right-hand side. Now he had painted the sky, the shadow beneath the wave, and most of the contours of the foreground.

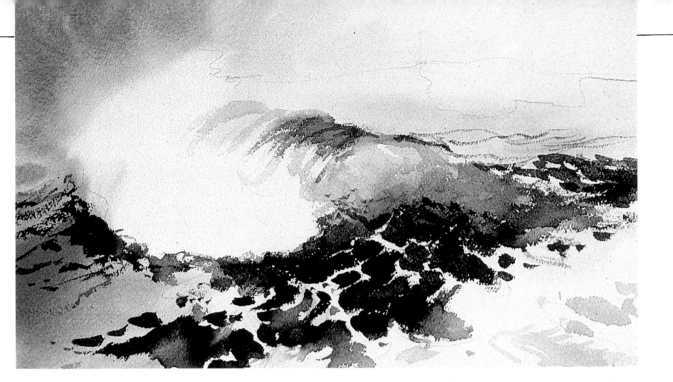

2. The artist allowed the paper to dry completely. Then he rewet only the top half of the wave face, mixed a bit of ultramarine blue into viridian green, and painted the wave, starting at the base of the wave with the darkest paint and working upward. When he reached the rewet area, he cleaned his brush and worked upward from the painted area into the water, merely moving the existing paint so that it would fade as it spread upward. Then he returned to the base of the wave and carefully painted the holes there, leaving some foam trails to climb up the wave face. He used a no. 12 round sable brush and the viridian mixture to paint the roll. Painting downward from the wave, he diluted the paint to lighten it as he painted the foam holes. The lighter color suggests that the water is mixed with foam below the surface, too. Notice the movement created by the angles of the holes.

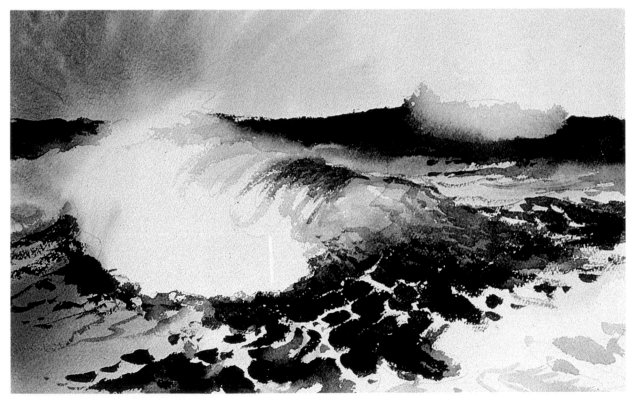

3. When the paint was dry, Mr. Robinson noticed the green had faded somewhat. So, with the point of a no. 8 sable brush, and the viridian and blue mixture he had used in the previous step, he worked in ripples at the base of the wave, leaving the translucent area clear. Then he painted the background wave. For this he mixed Prussian blue and viridian green because he wanted the wave to be very dark. When it was dry, he painted the foam with the same mixture, lightened with water.

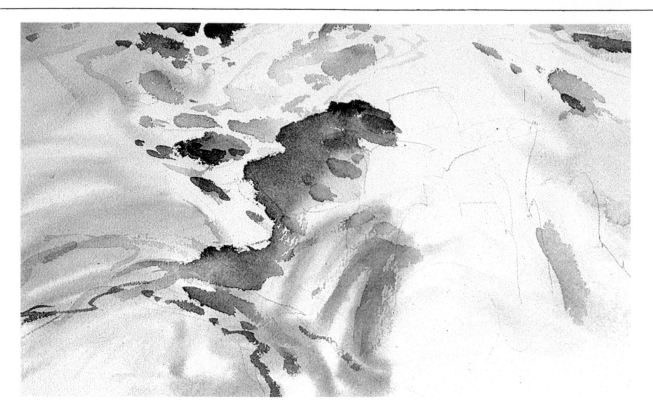

4. For the cast shadow in the foreground, the artist used the Prussian blue mixture with which he had painted the waves—but he added a touch of alizarin crimson to it because he wanted the foreground to appear warmer than the shadowed background. Again, he used a no. 8 round sable brush.

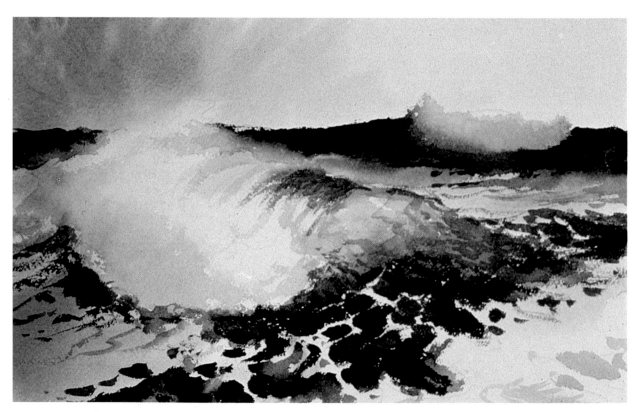

5. After making sure the paper was dry, the artist painted the shadow on the major breaker, using ultramarine blue with a tiny touch of alizarin crimson on his no. 12 round sable brush. Wetting the brush heavily, he applied the paint to the base of the foam and worked upward. At the top of the foam, where he wanted the edge to be soft, he used the side of the brush to gently scatter the paint over the surface of the paper. Then he decided to concentrate on the rock.

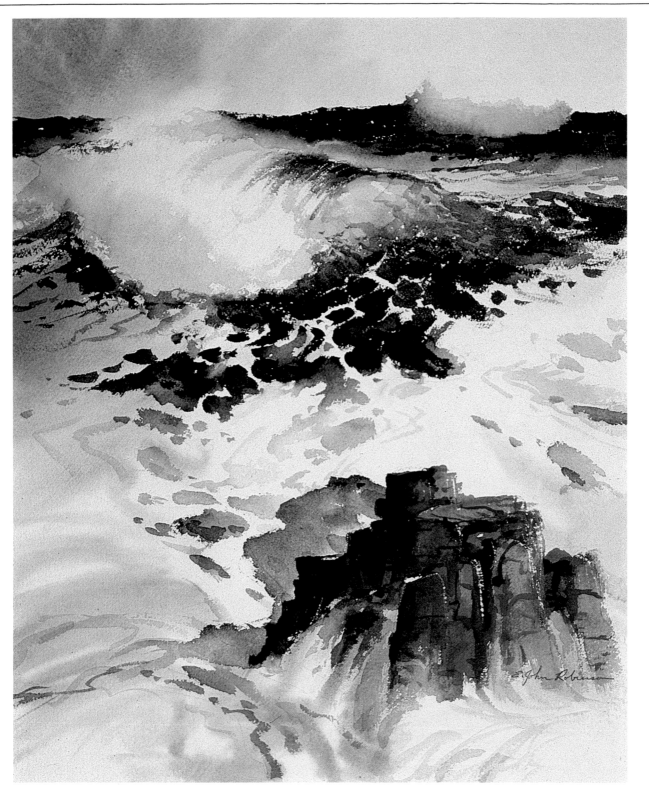

Rising Power, 22″ × 18″ (56 × 46 cm), by E. John Robinson

6. Mr. Robinson used a ½-inch (1.3-cm) flat brush to paint the base color of the rock. With a mixture of raw sienna and mauve, he painted the rock with vertical strokes. He was careful to paint around the water spills and to leave hard edges at the top and soft edges at the bottom, where the rock sits in the foam. While the paint was still wet, he added Prussian blue to the shadow side and then blended it by brushing it into the sienna and mauve.

With a darker mixture of mauve and Prussian blue and the ½-inch flat sable brush, the artist deepened the shadow on the rock. Then he faded the mixture with water and textured the now-dry rock with light shadow lines painted over the raw sienna base. When this had dried, he added thin cracks to the rock with burnt umber and the point of a no. 6 sable brush. Finally, he scratched a few sparkles into the wave face and into the right-hand side of the rock with his knife.

The artist now considered the painting finished. It is a simple composition containing a major wave, a secondary wave, and a major rock—a two-against-one scenario of a powerful sea against the land. All else has been kept minimal.

Index